web
design
index

Layout by Günter Beer & Sigurd Buchberger
(www.webdesignindex.org)
Cover and book design by Pepin van Roojen
CD Master by Sigurd Buchberger

Illustration page 3 by Dashiell Ponce de Leon
(www.flashlevel.com)

Introduction by Günter Beer and Pepin van Roojen

Translations:
LocTeam, Barcelona (German, Spanish, Italian, French
and Portuguese)
The Big Word (Chinese, Korean and Arabic)
Michie Yamakawa (Japanese)
Vladimir Nazorov (Russian)

With special thanks to Magda Garcia Masana
and Vladimir Nazarov.

ISBN 90 5768 093 9
The Pepin Press | Agile Rabbit Editions
Amsterdam & Singapore

The Pepin Press BV
P.O. Box 10349
1001 EH Amsterdam
The Netherlands

Tel +31 20 4202021
Fax +31 20 4201152
mail@pepinpress.com
www.pepinpress.com

10 9 8 7 6 5 4 3 2
2010 2009 2008 2007 2006

Manufactured in Singapore

web design index

6

Compiled & Edited by Günter Beer

THE PEPIN PRESS

AMSTERDAM & SINGAPORE

As usual, this annual Web Design Index offers an up-to-
date overview of developments in web design all over
the world. The current trend is towards simpler, subtler
designs, and more than half of the designs selected for
this volume have light backgrounds.

In programming, an important development is the increas-
ing use of CSS ('Cascading Style Sheets'), often in combi-
nation with Flash. In order to document this development,
we have included a spread (pages 164-165) with 6 designs
from www.csszengarden.com. This site, maintained by the
Canadian designer Dave Shea, displays the work of hun-
dreds of designers from all over the world, who have modi-
fied websites by changing the style sheets.

The captions in this book provide relevant information
about those involved in the design and programming and
are coded as follows:

D design
C coding
P production
A agency
M designer's contact address

A CD-ROM containing all the pages, arranged in the same
order as in the book, can be found inside the back cover.
It allows you to view each page on your computer with a
minimum of loading time, and to access the Internet in
order to browse the selected pages.

Submissions
The Pepin Press welcomes submissions and suggestions
for sites to be included in forthcoming editions of the Web
Design Index and related publications. Should you wish to
submit or recommend a design for consideration, please
use the submission form at www.webdesignindex.org.

The Pepin Press/Agile Rabbit Editions
The Pepin Press/Agile Rabbit Editions publishes a wide
range of books and CD-ROMs containing visual refer-
ence material and ready-to-use images for designers and
Internet applications, as well as high-resolution printed
media.

For more information, please visit www.pepinpress.com.

Wie gewohnt, bietet auch der Web Design Index dieses Jahres einen aktuellen Überblick über weltweite Entwicklungen im Webdesign. Der momentane Trend geht hin zu schlichteren, subtileren Designs und mehr als die Hälfte der für diesen Band ausgewählten Designs haben einen hellen Hintergrund.

Im Programmierbereich stellt die zunehmende Verwendung von CSS ('Cascading Style Sheets'), oftmals in Verbindung mit Flash, eine wichtige Entwicklung dar. Um diese Entwicklung zu belegen, haben wir 6 Designs von www. csszengarden.com (Seite 164 – 165) mit in den Index aufgenommen. Diese Website, die von dem kanadischen Designer Dave Shea unterhalten wird, zeigt die Arbeiten von hunderten von Webdesignern aus der ganzen Welt, die Webseiten durch Ändern der Style Sheets modifiziert haben.

Die Bildunterschriften in diesem Buch enthalten wichtige Angaben zu den für Design und Programmierung Verantwortlichen. Dabei werden folgende Codes verwendet:

D Design
C Code
P Produktion
A Agentur
M Kontaktaddresse

In der hinteren Umschlagseite befindet sich eine CD-ROM mit allen Seiten. Die Reihenfolge entspricht der Anordnung im Buch. So können Sie mit minimaler Ladezeit jede Seite auf dem Bildschirm betrachten oder die ausgewählten Seiten im Internet aufrufen.

Einreichungen
Pepin Press freut sich über Einreichungen und Vorschläge für zukünftige Ausgaben des Web Design Index und ähnliche Veröffentlichungen. Wenn Sie ein Design einreichen oder empfehlen möchten, verwenden Sie bitte das Teilnahmeformular auf www.webdesignindex.org.

The Pepin Press/Agile Rabbit Editions
The Pepin Press/Agile Rabbit Editions veröffentlicht eine breite Palette an Büchern und CD-ROMs mit visuellem Referenzmaterial und sofort verwendbaren Bildern für Designer, Internet-Applikationen sowie hoch auflösende Print-Medien.

Weitere Informationen entnehmen Sie bitte der Website www.pepinpress.com.

Comme tous les ans, l'édition de l'**Index de modèles de
sites Web** offre un panorama actualisé des développe-
ments de la conception de sites Web dans le monde enti-
er. La tendance actuelle va vers plus de simplicité pour
des designs plus subtils. A ce propos, plus de la moitié
des sites sélectionnés dans ce volume ont des fonds
clairs.

L'un des développements importants que connaît la pro-
grammation est le recours accru aux CSS (Cascading Style
Sheets, ou feuilles de styles en cascade), souvent avec
Flash. Pour illustrer cette évolution, nous avons inclus
à l'Index une double-page (pages 164-165) présentant 6
designs de www.csszengarden.com. Entretenu par le Web-
designer canadien Dave Shea, ce site présente le travail
de centaines de Web-designers du monde entier qui ont
transformé les sites Web en modifiant les feuilles de
styles.

Les légendes fournissent des informations sur ceux qui
ont participé au design et à la programmation des sites.
Elles sont codées comme suit :

D design
C codage
P production
A agence
M contact designer

La quatrième de couverture renferme un CD-ROM présent-
ant toutes les pages Web dans le même ordre que le livre.
Il permet de les visualiser à l'écran avec un temps de
chargement minimum et d'accéder à Internet pour navigu-
er sur les sites choisis.

Candidatures
The Pepin Press accueille toute proposition ou sugges-
tion de sites pour les prochaines éditions de l'Index de
modèles de sites Web et d'autres publications du même
ordre. Si vous souhaitez soumettre ou recommander un
site Web, vous pouvez remplir le formulaire de candidature
que vous trouverez à l'adresse www.webdesignindex.org.

The Pepin Press/Agile Rabbit Editions
Les éditions Pepin Press/Agile Rabbit publient un vaste
choix de livres et de CD-ROM reprenant des documents
visuels de référence et des images prêtes à l'emploi pour
l'usage des designers, pour les applications destinées à
l'Internet ainsi que tout support imprimé haute définition.

Pour en savoir plus rendez-vous sur www.pepinpress.com.

Come sempre, l'edizione annuale dell'Indice del Disegno
Web offre una panoramica aggiornata sulle ultime novità
del settore a livello mondiale. Le tendenze attuali vanno
verso creazioni più semplici e sottili, di fatto più della
metà degli esempi selezionati per questo volume presenta
degli sfondi sobri.

Un'importante novità nell'ambito della programmazione è il
crescente uso dei CSS ('Cascading Style Sheets') spesso
in combinazione con Flash. Per documentare tale tenden-
za, abbiamo incluso due pagine (164-165) con sei creazioni
tratte da www.csszengarden.com. Questo sito, curato dal
designer canadese Dave Shea, mostra le produzioni di
centinaia di creativi di tutto il mondo che hanno modifi-
cato delle pagine web cambiando i fogli di stile.

Le didascalie del libro forniscono informazioni utili sugli
autori e i programmatori preceduti dalle seguenti abbrevi-
azioni:

D design
C codifica
P produzione
A agenzia
M indirizzo di contatto del disegnatore

All'interno della copertina posteriore troverete un CD-ROM
che contiene tutte le pagine sistemate secondo l'ordine di
apparizione nel libro. Si caricano rapidamente e consen-
tono di accedere via Internet ai siti selezionati.

Candidature

Pepin Press vi invita a presentare le vostre candidature
e a proporre siti da includere nelle prossime edizioni
dell'Indice del Disegno Web e nelle relative pubblicazioni.
Se volete presentare o raccomandare una creazione,
potete accedere al modulo di candidatura nel sito www.
webdesignindex.org.

The Pepin Press/Agile Rabbit Editions

The Pepin Press/Agile Rabbit Editions pubblica una vasta
gamma di libri e CD-ROM con materiale informativo ed
immagini per designer, per applicazioni Internet, e anche
per mezzi stampa ad alta risoluzione.

Per ulteriori informazioni potete visitare il sito
www.pepinpress.com.

Como en ediciones anteriores, el Índice de diseño de páginas web muestra un panorama actualizado de todas las novedades en este sector a nivel mundial. La tendencia actual se centra en diseños cada vez más sencillos y sutiles, y más de la mitad de los seleccionados para este libro presentan fondos de color claro.

Uno de los avances más importantes en programación ha sido el uso cada vez más frecuente de CSS (hojas de estilo en cascada o Cascading Style Sheets), a menudo combinado con Flash. Para reflejar esta tendencia hemos incluido una doble página con seis diseños extraídos de www.csszengarden.com (páginas 164-165). Este sitio web, coordinado por el diseñador canadiense Dave Shea, muestra el trabajo de cientos de diseñadores de todo el mundo, que transforman los sitios web cambiando las hojas de estilo.

Los nombres de quienes han participado en el diseño y la programación de cada sitio se citan en los pies de foto de la siguiente manera:

D diseño
C codificación
P producción
A agencia
M dirección de contacto del diseñador

En el interior de la contracubierta encontrará un CD-ROM que contiene todas las páginas web, ordenadas según aparecen en este libro. Si lo desea, puede verlas en su ordenador (el tiempo de carga es mínimo) y acceder a Internet para explorar en su totalidad las páginas seleccionadas.

Sugerencias
Puede enviar a The Pepin Press aquellas direcciones de sitios web que considere recomendables para que las incluyamos en las próximas ediciones del Índice de páginas web y otros libros del mismo tema. Para remitirnos sus sugerencias, debe rellenar el formulario que encontrará en la página www.webdesignindex.org.

The Pepin Press/Agile Rabbit Editions
La editorial The Pepin Press/Agile Rabbit Editions publica una gran variedad de libros y CD-ROM con material de referencia visual e imágenes destinados a diseñadores, aplicaciones de Internet y formatos impresos de alta resolución.

Si desea obtener más información, visite www.pepinpress.com.

Como já vem sendo habitual, este Catálogo de Web Design anual proporciona uma visão geral actualizada dos desenvolvimentos do web design em todo o mundo. A tendência actual vai no sentido de designs mais simples e subtis, e mais de metade dos designs seleccionados para este volume têm fundos claros.

Em termos de programação, um desenvolvimento importante é a utilização crescente de CSS («Cascading Style Sheets», folhas de estilos em cascata), muitas vezes em conjunto com Flash. Para documentarmos este desenvolvimento, incluímos uma página dupla (páginas 164-165) com 6 designs de www.csszengarden.com. Este site, mantido pelo designer canadiano Dave Shea, apresenta o trabalho de centenas de designers de todo o mundo que modificaram web sites através da alteração das folhas de estilos.

As legendas neste livro fornecem informações relevantes sobre as pessoas envolvidas no design e na programação dos sites, sendo indicadas do seguinte modo:

D design
C codificação
P produção
A agência
A endereço de contacto do designer

No interior da contracapa, encontrará um CD-ROM com todas as páginas, organizadas pela mesma ordem do livro. O CD-ROM permite visualizá-las no seu computador, com um tempo de carregamento mínimo, e aceder à Internet para navegar nas páginas seleccionadas.

Envios

A Pepin Press agradece os envios e as sugestões de sites para inclusão em edições futuras do Catálogo de Web Design e publicações relacionadas. Caso pretenda enviar ou recomendar um design, aceda ao formulário para esse efeito em www.webdesignindex.org.

The Pepin Press/Agile Rabbit Editions

A The Pepin Press/Agile Rabbit Editions publica um vasto leque de livros e CD-ROM com material de consulta visual e imagens prontas a utilizar para designers, para aplicações de Internet, e suporte impresso de alta resolução.

Para mais informações, visite www.pepinpress.com.

Как всегда, данное ежегодное издание *Индекса Веб-Дизайна* включает в себя актуальный обзор достижений специалистов веб-дизайна со всего мира. Основная текущая тенденция заключается в преобладании относительно спокойного дизайна, в связи с чем, более половины представленных работ имеют легкие фоновые тона.

В веб-программировании важным направлением является все возрастающее применение языка CSS (Таблиц Каскадных Стилей/Cascading Style Sheets), часто в комбинации с Flash-средствами. Для того, чтобы отразить эту тенденцию, мы включили разворот (страницы 164-165) с 6 дизайнами из www.csszengarden.com. Этот сайт, поддерживаемый канадским веб-дизайнером Дейвом Шиа, собрал работы сотен дизайнеров со всего мира, которые создали свои оригинальные страницы только путем модификации таблиц стилей.

Подрисуночный текст содержит всю информацию о лицах и организациях, принимавших участие в проектировании и создании сайтов, что отражено следующим образом:

D дизайн
C программирование
P производство
A агентство
M адрес электронной почты дизайнера

Компакт-диск, находящийся в конверте в конце книги, полностью содержит все веб-страницы в соответствии со структурой исходной книги. Это позволяет Вам быстро загрузить и посмотреть интересующую Вас страницу, а при необходимости, осуществить доступ к ней в Интернете для более подробного изучения.

Подача на рассмотрение заявок

Издательство The Pepin Press приветствует Ваши заявки и предложения по включению сайтов в последующие издания книги *Индекс Веб-дизайна* и смежные публикации. Если Вы желаете подать на рассмотрение заявку или порекомендовать какой-либо дизайн, заполните, пожалуйста, бланк заявки на сайте www.webdesignindex.org.

Издательство The Pepin Press / Agile Rabbit Editions

Издательство The Pepin Press / Agile Rabbit Editions выпускает широкий спектр книг и компакт-дисков с визуальными справочниками и библиотеками готовых компьютерных изображений, предназначенных для дизайнеров, разработчиков Интернет-приложений и применимых в сфере высококачественной печати.

За дополнительной информацией просим обращаться на www.pepinpress.com

ウェブ・デザイン・インデックス　日本語

このWeb Design Index年鑑は、世界の最新のウェブ・デザインを収録。最近の
トレンドはよりシンプルで繊細なデザインで、収録作品の過半数が軽めの背景を
使用しています。

プログラミングにおける注目すべき傾向は、CSS(Cascading Style Sheets
キャスケイディング・スタイル・シーツ)をフラッシュと組み合わせて使用したデザイ
ンが増えつつある点です。例として、www.csszengarden.comの6つのデザ
インをスプレッド(164～165ページ)で紹介。カナダ人デザイナーのデイブ・シ
ェアが管理するこのサイトでは、スタイル・シートを変えることでコンテンツを調整
した数百人のデザイナーの作品を見ることができます。

この本の中のキャプションは、デザインとプログラミングに関係した情報で、省略
コードの意味は以下のとおりです。

D　　　デザイン
C　　　コーディング
P　　　プロダクション
A　　　エージェンシー
M　　　デザイナーのメール・アドレス

付録のCD-ROMには、ロケーション別に整理された全ページを収録。読者は、見た
いサイトに簡単にアクセスできます。

作品の応募について

ペピン・プレスでは、Web Design Index(ウェブ・デザイン・インデックス)次号
と関連出版物に掲載する作品を募集するとともに、推薦も受けつけています。応募
なさりたい方、推薦なさりたい方は、www.webdesignindex.orgにアクセス
して、所定の書式をご使用ください。

ペピン・プレス／アジャイレ・ラビット・エディションズ

ペピン・プレス／アジャイレ・ラビット・エディションズは、ビジュアル関連の本と
CD-ROMを出している出版社です。出版物には、ビジュアル参考素材と、デザイン
やインターネット・アプリケーション、高解像度の印刷媒体にすぐ使えるイメージ
が豊富に入っています。

弊社に関する詳細情報については、www.pepinpress.comにアクセスしてく
ださい。

《網頁設計索引》年刊自 2000 年誕生起現已發展成?同行業最重要的出版物之一，每年都會對網頁設計的最新趨勢給予準確概述。

網站可簡單到只有一頁，也可以設計為具有最新數位性能的複雜結構。《網頁設計索引》的篩選標準是根據設計品質、創意及效率 — 而不管複雜程度如何。因此在本書中，你可以找到所有可能的樣式和風格的實例。

每輯《網頁設計索引》都展示了 1002 個精彩的網頁。同時提供了每個網頁的 URL。網站設計和編程所用的代碼約定如下：

D	設計
C	編碼
P	製作
A	代理商
M	設計者的電郵地址

在本書的封底內頁，你會發現一張光碟，它包含了全書內容，其編排順序與本書一致。你可以在最短的時間內將其載入電腦進行瀏覽，也可以連線網際網路，瀏覽所選網站全文。

提 交

《網頁設計索引》每年出版一次。如果你希望在下一輯中提交或推薦網頁設計，請訪問 www.webdesignindex.org 填寫提交表。

網頁設計分類

除《網頁設計索引》外，The Pepin Press/Agile Rabbit Editions 還每年出版一輯《網頁設計分類》。每期推出約 600 個網站，依照行業、專業、職業等等分類編排，涵蓋各種可能的網頁設計方法。《網頁設計分類》可讓您快速查閱某特定領域的網頁設計標準。

The Pepin Press/Agile Rabbit Editions 出版社

The Pepin Press/Agile Rabbit Editions 出版了大量的書籍和光碟，為設計者、網際網路應用以及高清晰度的印刷媒體提供直觀的參考材料和圖片素材。

更多資訊請訪問 www.pepinpress.com。

2000년의 초판 발행 이후 매년 발행하는 *웹 디자인 인덱스*는 업계의 가장 중요한 출판물 중 하나로 발전하여 첨단 웹 디자인의 정확한 개요를 제공하고 있습니다.

웹사이트는 단순한 한 페이지짜리 레이아웃을 비롯하여 최신 디지털 기능을 갖춘 정교한 구조까지 갖추고 있습니다. *웹 디자인 인덱스*의 선택은 복잡성과는 상관 없이 디자인 품질, 혁신 및 효율성을 기초로 합니다.

따라서 이 책자에서는 생각할 수 있는 모든 형태와 스타일의 예를 볼 수 있습니다.
모든 *웹 디자인 인덱스*는 1002개의 뛰어난 웹 페이지를 제공합니다. 각 페이지에는 URL이 표시되어 있습니다. 웹사이트의 디자인 및 프로그램에 관련된 이름은 다음과 같이 표시합니다.

D 디자인
C 코딩
P 생산
A 에이전시
M 디자이너의 이메일 주소

뒷 표지의 안쪽에는 책 속의 위치에 따라 모든 페이지가 나열된 CD-ROM이 있습니다. 여러분은 모니터상에서 최소의 로딩 시간으로 내용을 볼 수 있으며, 인터넷에 액세스하여 선별된 전체 사이트를 검색할 수 있습니다.

제출
매년 완전한 *웹 디자인 인덱스*의 신판이 출판됩니다. 다음 판에 고려할 디자인을 제출 또는 추천하려면 www.webdesignindex.org에서 제출 양식에 액세스하십시오.

내용별 웹 디자인
웹 디자인 인덱스와 더불어 페핀 출판사/ 기민한 토끼그림 판은 *내용별 웹 디자인*을 매년 출판합니다. 이 시리즈의 책은 내용별(거래처, 직업, 적성별로 인정)로 나열하고 웹상에서 생각할 수 있는 모든 용도가 포함된 600개의 사이트가 있습니다. *내용별 웹 디자인*은 모든 분야에서 웹 디자인의 기준에 대한 개요를 제공합니다.

페핀 출판사/기민한 토끼그림 판
페핀 출판사/기민한 토끼그림 판은 인터넷 응용 프로그램과 고해상도 인쇄 매체를 위한 광범위한 분야의 서적과 가시적 참고 자료 및 디자인에 즉시 사용할 수 있는 이미지가 포함된 CD-ROM을 출판합니다.

자세한 내용은 www.pepinpress.com을 방문하십시오.

منذ طبعته الأولى في عام 2000، تطور "دليلٍ تصميمِ الشبكة" إلى واحد من أهم المطبوعات في مجاله، معطياً ـ عاماً بعد عامٍ ـ نظرة شاملة على أحدث ما وصلت إليه التقنية الحديثة في تصميمِ شبكة الإنترنيت.

وقد تتراوح مواقع الشبكة ما بين تصميمات مبسطة على صفحة واحدة، وبنيات متطورة تضم أحدث القدرات الرقمية. ويستند الانتقاء من "دليل تصميم الشبكة" إلى نوعية التصميم والابتكار والفاعلية بصرف النظر عن التشابك والتعقيد. لذلك ستجد في هذا الكتاب نماذج لكل ما يمكن تصوره من أشكال وأساليب.

ويقدم كل دليل لتصميم الشبكة 1002 صفحة إلكترونية على قدر من الروعة والجمال، مع الإشارة إلى URL في كل صفحة. وقد تم بيان أسماء من اشتركوا في تصميم وبرمجة المواقع كما يلي:

D	تصميم
C	تكويد
P	إنتاج
A	وكالة
M	عنوان البريد الإلكتروني للمصمم

وستجد في الغلاف الداخلي الخلفي "سي دي روم" يحتوى على جميع الصفحات مرتبة حسب مواقعها في هذا الكتاب. وبإمكانك الاطلاع عليها في جهاز الكمبيوتر الخاص بك بأقل فترة تحميل ممكنة، وتدخل إلى الإنترنيت كي تسبر أغوار الموقع المنتقى على الوجه الأكمل.

تقديم التصميمات أوالتوصيات

يجري كل عام نشر طبعة جديدة تماما من "دليل تصميم الشبكة". فإذا رغبت في تقديم تصميم أو التوصية به لتضمينه في الطبعة التالية، الرجا الدخول إلى استمارة التقديم على الموقع الإلكتروني التالي: www.webdesignindex.org.

تصميم الشبكة عن طريق المحتوى

بالإضافة إلى "دليل تصميم الشبكة" تقوم دار The Pepin Press/Agile Rabbit Editions بنشر الكتاب السنوي "تصميم الشبكة عن طريق المحتوى". وتضم مجلدات هذه السلسلة حوالي 600 موقع إلكتروني مرتبة حسب المحتوى (مؤهل حسب الحرفة، المهنة، الوظيفة .. إلخ). وتغطي جميع استعمالات الشبكة التي يمكن تصورها. ويوفر "تصميم الشبكة عن طريق المحتوى" نظرة سريعة وشاملة على مستوى تصميم الشبكة في أي حقل بعينه.

دار The Pepin Press/Agile Rabbit Editions

تتولى هذه الدار نشر مجموعة متنوعة من الكتب وأقراص "سي دي روم" مع مراجع مرئية وصور جاهزة للاستعمال للمصممين وتطبيقات الإنترنيت، هذا بالإضافة إلى وسائط مطبوعة كاملة الوضوح.

لمزيد من المعلومات الرجا زيارة: www.pepinpress.com.

quatro[8]

amar-te-ia
depois de estás deitada
olhava

SEARA.COM CARLOS CÉSAR PACHECO

www.diasclaros.com
D: carlos césar pacheco C: seara P: seara
A: seara M: info@seara.com

"(...) Bernhard Aichner liefert keine Erklärungen, er erzählt einfach.
Und das in einer radikal reduzierten Sprache, deren Schlichtheit und
Tempo man bei aller Inflation des Wortes einfach nur schön nennen kann."

(Matthias Krapf
6020 Stadtmagazin)

Termine Das Nötigste über das Glück Pissoir Babalon Daten Mail

www.bernhard-aichner.at
D: stefanie temml C: stefanie temml P: bernhard aichner
A: websen.at M: temml@websen.at

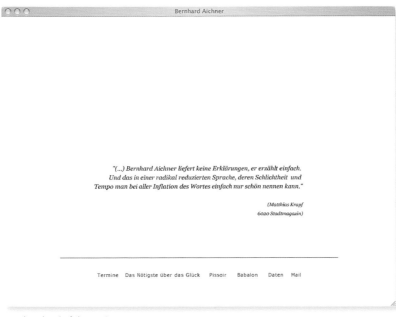

MISOS Estudio de Diseño

Hacemos aplicaciones Flash. Nos gusta diseñar. Nos comprometemos con la satisfacción del
cliente. Resolvemos problemas. Escuchamos atentamente. Somos gente creativa que entiende
la tecnología Web. Somos artistas, diseñadores, productores de multimedia y tecnólogos.

www.misos.com
D: lee hsu
A: misos.com M: nano_topia@hotmail.com

News · Visuals · Photography · Ab:straktum · Shop · Contact

we:sual. a project.

A journey into visual disturbance.
The desire to start from zero was
felt early on. We craved to function
entirely on intuition in hopes of
achieving a greater plane of knowledge
and enhancing our collective experience
by ignoring the rules as we had come
to know them.

Understanding context

welcome to
we:sual
a project

is necessary. Being completely open
to all that communicates allows us
to grow and learn from that experience.
Each moment is completely new,
unknown and exciting. The
ways we create may be weird,
unconventional and beyond all
the paths we have already walked,
but the messenger is not important
and his journey irrelevant.

"But I, being poor, have only my
dreams. I have spread my dreams
under your feet. Tread softly because
you tread on my dreams."

www.wesual.ch
U: ralph bühler
M: info@wesual.ch

koinè

**3.progettare e
promuovere la
qualità sociale**

**4.la gestione dei
servizi**

1.chi siamo

2.forma (e sostanza)

Koinè è una cooperativa sociale di tipo A
a mutualità prevalente che opera nel
campo della progettazione, della
gestione e della valutazione di servizi
sociali, socio educativi, assistenziali, di
promozione del benessere comunitario e
di empowerment delle persone esposte a
rischio di esclusione sociale. La
cooperativa è stata costituita nel 1993
ed ha concretamente avviato la sua
attività nella primavera dell'anno
successivo, conseguendo importanti
risultati sia in termini di apporto alla
costruzione di un nuovo sistema di
welfare locale sia in termini di creazione
di occupazione stabile e regolare.
Maggiori informazioni sulle
caratteristiche economiche, tecniche e
produttive di Koinè cooperativa sociale
di tipo A sono proposte nel documento
Presentazione tecnica della cooperativa.

In conformità e nel rispetto delle norme
vigenti, Koinè ha adottato l'insieme
delle norme che ne specificano la
identità e regolano il funzionamento
interno e la relazione tra la cooperativa,
i suoi soci e dipendenti, gli utenti dei
servizi, i portatori di interesse.
Operando il download dei files in
formato pdf sono prelevabili la versione
aggiornata alla riforma del diritto
societario dello **Statuto**, il **regolamento
interno**, il **codice etico e la
dichiarazione di missione** adottati, nel
tempo, dalla Assemblea Generale dei
soci, che è il massimo organo
deliberante della cooperativa.

Uno degli elementi distintivi di Koinè è
la attenzione posta al lavoro di
progettazione innovativa, che ha
permesso, nel tempo, di produrre
risultati importanti per il territorio e le
persone che lo inso vivono e, nel
contempo, di conoscere a promuovere
lo sviluppo della qualità sociale e la
innovazione delle politiche sociali e dei
modelli di servizio. Maggiori
informazioni sulle attività di
progettazione di Koinè possono essere
acquisite scaricando il documento
**Attività di progettazione e per lo
sviluppo della qualità sociale**

Del punto di vista dimensionale, della
numerosità dei servizi gestiti e degli
utenti serviti quotidianamente, Koinè è
diventata, nel tempo, la più grande
impresa sociale del territorio aretino ed
una delle maggiori imprese sociali della
Toscana. Nel documento **"Servizi ed
attività"** sono proposti in dettaglio i dati
sui servizi progettati e gestiti dalla
cooperativa.

**5.modello
organizzativo**

**6.politiche della
responsabilità sociale**

**7.assicurazione della
qualità dei servizi**

**8.economia
aziendale**

Con processi di elaborazione e
decisionali partecipati dai soci, Koinè si
è dotata di una forma organizzativa
molto particolare, che è funzionale ad
assicurare contemporaneamente la
partecipazione dei soci al governo della
impresa e la efficacia ed efficienza
gestionale. Il documento " **Modello
organizzativo di Koinè** " offre in
dettaglio un quadro delle logiche
organizzative e delle risorse umane della
azienda.

Portando a sintesi un lavoro molto
complesso sul tema del rispetto dei
principi di responsabilità sociale, nel
settembre 2002, Koinè è stata la prima
cooperativa sociale italiana ad aver
completato al SAI la certificazione etica
SA8000. In realtà, l'impegno di Koinè sul
versante della responsabilità sociale e
del colvelgimento attivo dei portatori
di interesse è testimoniato, oltre che
dalla certificazione etica SA8000, anche
dalla adozione di uno schema di
responsabilità sociale di cui è parte
integrante il " Bilancio di responsabilità
sociale ", che l'impresa produce
annualmente. Per chi fosse interessato
sono prelevabili le versioni integrali del
Bilancio sociale 2002, 2003 e 2004.

In funzione dell'assicurare ai clienti ed
ai committenti standard elevati e certi
di qualità dei servizi, la cooperativa si è
dotata ed attua un complesso sistema di
procedure di qualità. Già dal 2002 è
stata ottenuta la certificazione di
qualità Un En Iso 9001 : 2000 Vision per
le attività di progettazione e valutazione
della intera gamma dei servizi sociali,
educativi, assistenziali e socio
assistenziali gestiti da Koinè. Il
documento **"Politiche della qualità"**
offre maggiori dettagli sulle politiche di
qualità poste in essere da Koinè.

Una politica attenta all'uso delle risorse
è l'impegno sul versante della qualità
hanno permesso di costruire una impresa
solida dal punto di vista patrimoniale e
finanziario e, nel contempo,
significativa in termini di valori
economici prodotti. Il documento
"Economia aziendale" offre un quadro
preciso delle caratteristiche
economiche, finanziarie e patrimoniali
di Koinè.

www.koine.org
D: nextopen multimedia
M: info@nextopen.it

Dodo Arslan

Dodo Arslan | Design Studio © 2005 All Rights Reserved

Dodo Arslan has recently founded a studio
in various design consultancies.
developing projects for Deutsche Post,
and Zumtobel Staff's Mildes Licht IV
He then joined Continuum (Milan-Boston-Seoul)
and Voelkl; Samsung Pronta 1200 won
Voelkl Catapult and Zumtobel Staff's
He participated in Alessi's Metalwork Design
He was part of Stradivari Wood workshop,
of wood from Bosco Stradivari in Val di Fiemme,
He designed the logo for Pirelli Tires,
He teaches at the Scuola Italiana di Design
His sofas LowRes and Leudo Louge have been
SpHaus produces LowRes sofa and Apple
Dodo Arslan is now spending his time trying

in Milan after working for four years
He worked for Studio & Partners
British American Tobacco
which won the Design Plus Prize.
working for Motorola, Samsung, Hewlett Packard, Elan
the Good Design Award and the KIDA Grand Prize,
Mildes Licht IV were included in ADI Design Index.
workshop and Ikea's Home furnishing workshop.
a research project for selected types
those used by Stradivari for the famous violins.
for high performance tires "Pzero Rosso" and "Pzero Nero".
in Padova and the Istituto Europeo di Design in Milan.
published in the International Design Year Book
rocking armchair which won Young&Design's II Prize
to electrocute him self with his lamp prototypes.

481 pixel? cocktails? **profile** products press contact

www.arslan.it
D: dodo arslan C: andrea luxich P: andrea luxich
A: pangoo design M: andrea@pangoo.it

ryan pruger · adi ilfsfatz · donnen lomberger · ninetylko · zaelia bishop · fish tank · the head institute · kraitt.com · phoot · bsimple · kateandcamilla · sixhours · versusdsn · gocartrobot · morten nilsson · theunderlining · max boschini · eccentris · sacha dean biyan · yuri dojc · remain-silent · steve asparagus · mercurylines · trout · gizart · inorganism · plasticmoon · ray caesar · christina richards · lisa alisa · bending light · casa gontz · chloe derderian · joanna miklaszewska · fruhsnuck · sixtyoneskoyeight · madsteez · eye-cramps · matrconquist · seafairy · back2mine · the filth

HEAD

WELCOME TO THE HOME OF HEADMAGAZINE

This website requires the Flash plug-in.

Best viewed at 1024 x 768 pixels or greater.

A Broadband connection is highly recommended.

bircham gallery · bodycollector · clubsandwich · cobalt.revolter · coolstop · coudal · creative behaviour · crossmind · decibeldragon · deformat · design is kinky · 2foldcreative · abnormis · arhiva7 · bircham gallery · bodycollector · clubsandwich · cobalt.revolter · coolstop · coudal · creative behaviour · crossmind · decibeldragon · deformat · design is kinky · designloops · designradar · digital abstracts · digital refueler · dub · featured · female persuasion · fleshbot · freeoops · gouw · hallproject · hoard magazine · idea2design · imagesystem · linkas · linkdup · lounge72

www.headmagazine.co.uk
D: steven kraitt, nicolene hannan C: steven kraitt
A: head magazine M: info@headmagazine.co.uk

PWS | Pocket Web Site | Marcello Boschetti

HI,
MI NAME IS MARCELLO BOSCHETTI
I WAS BORN IN RIMINI IN 1973

THIS IS MY PWS
(POCKET WEB SITE)

SO ENJOY.

www.pictureballs.com
D: jim more
M: info@squidjoe.com

Mi Magazine

This is **Mi magazine** - Mi is the magazine in the magazine. As a modular medium, Mi works with elements of surprise and awakes curiosity. It does not address the reader directly, but breaks the linearity of information flow. The pages of Mi are published in international magazines. For the topic of the first issue we sent 10 Euros to outstanding artists, designers and photographers, asking them to create an idea worth 10 Euros. participating magazines: editors: media:

www.mi-magazine.com
D: oliver laric, christoph pringlinger, georg schnitzler, mareike queitsch
A: designmi magazine M: mail@rabbit-burrow.at

küng, arbeiten, portrait, kontakt

Migros Lastwagen | Galatea Quartett | Axon Partners | Powerbike | HBM BioVentures | Alpha
Associates | All Star Production | Yellow Tone | Anna's Best | Migros Mode | Migros Kulturprozent |
Telekurs | MGB Sponsoring | MGB Paul Greenwood | Migros Genossenschafts-Bund | Klubschule
Migros | Jacob Rohner | Weber Harbeke | Eclat Brand Matters | Julius Bär E-banking | Advigate |
Gretag | Conextrade | Swisscom | Upstairs Coiffure Bern | APG | Feldschlösschen | NZZ Grandplus |
The Coca-Cola Company | Winterthur International | Air Canada | SUVA pro | Randstad | Platti
Küchenbau | Publimedia | Reynolds Tobacco | Condomeria Zürich | Forbo Carpet | SUVA liv | Panasonic
Village Jazz Festival |

www.kimkueng.ch
D: kim küng C: thomas casanova P: peter ulululi
A: nexus - creative company M: contact@ncc.ch

SHIVAYA
shivaya concerts download

May 1st, 2005 : Mp3 added > Sunday draft (live Chato d'o) - 3:15
April 22nd, 2005 : Changed language to English for our non-french speaking friends
April 10 th, 2005 : Finally added the Coffee Video Clip

shivayamusic.free.fr
D: frederic pinault
M: f.pinault@laposte.net

2005 - **Fuoco amico** - Bad News - unmundofeliz.org

www.elylr.it
D: elena la regina C: francesco la regina P: elena la regina
M: ely@elylr.it

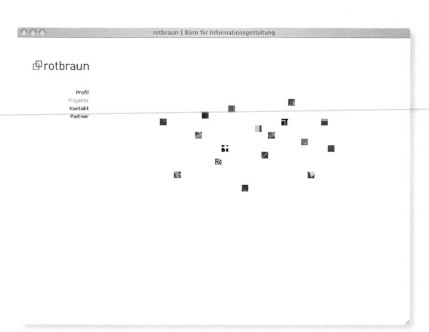

www.rotbraun.de
D: nora bilz, pia schneider
A: rotbraun M: nora@rotbraun.de

www.sekati.com
D: jason m. horwitz
M: hello@sekati.com

www.whitedot.fi
D: christian champagne C: christian champagne P: marjatta nissinen
A: vistakuva oy M: chris.champagne@vistakuva.fi

PERSON
PERSONAL
PERSONALIA
PERSONAL REPORT

Of course you can get more personal.
If you feel like it, you can **click here** to email a little background info and tell me who you are. I would like it to get to know you better personally. After all you can get to know me better too. If you prefer to talk to me in person, you can give me a call.
You will hear a voice talking back to you, which will often listen to what you want to tell.

webdesign by fpd

www.personaldomainname.nl
D: philia beroud **C:** eelco van collenburg **P:** eelco van collenburg
A: full service design **M:** personal@personaldomainname.nl

www.lamina.biz
D: juan francisco ruiz
A: lamina **M:** proyectos@lamina.biz

www.sponsorship.volvo.com/itsinthebag
D: gwen vanhee **C:** davy belmans **P:** gwen vanhee
A: meridian **M:** gwen@meridian.be

24

High Performance Vienna
Gesellschaft für angewandte Informationstechnologie GmbH

ɑ | philosophy | content 3 | product launch | roadmap | project | vienna |

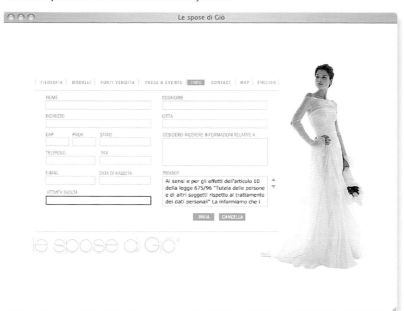

High Performance bietet als Spezialagentur umfassende Dienstleistungen für unternehmensinterne Produkteinführungen und ansprechende Informationssysteme im Vertriebsbereich an. Das Verständnis des Produktes als Basis, werden vertriebsrelevante Informationen unter Bedachtnahme lerntheoretischer Prozesse zur optimalen Darbeitung attraktiv gestaltet und verpackt.

the high-performance vienna offers consultative services for internal communication with focus on product launches. These services include campaigns, positioning-papers, sales-kits, demo materials, campaigns, salesinformation-platforms (roadmaps), local trainings and presentations. Within these activities we combine our understanding of the industry with graphic-design by paying regard to the processes of learning theory.

www.high-performance.at
D: catharina ballan, martin ernesto lotter, vit kocourek
A: .flussobjekte.net **M:** vit.kocourek@flussobjekte.net

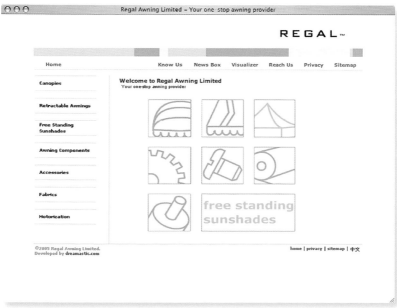

www.le-spose-di-gio.it
D: martin nedbal
M: martin.nedbal@graff.it

www.awnings.com.hk
D: brian choy
A: dreamastic limited **M:** brian@dreamastic.com

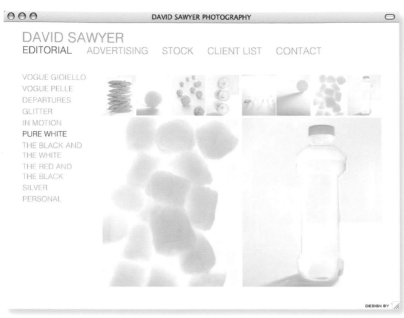

DAVID SAWYER

EDITORIAL ADVERTISING STOCK CLIENT LIST CONTACT

VOGUE GIOIELLO
VOGUE PELLE
DEPARTURES
GLITTER
IN MOTION
PURE WHITE
THE BLACK AND
THE WHITE
THE RED AND
THE BLACK
SILVER
PERSONAL

DESIGN BY

www.davidsawyer.net
U: alı tan ucer
A: visualxchange M: www.visualxchange.com

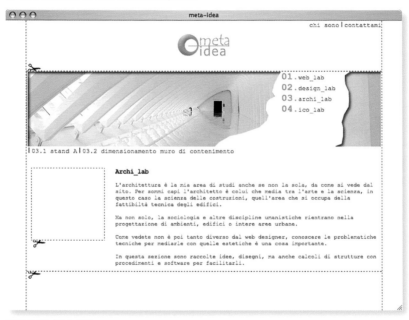

meta-idea

chi sono | contattami

01.web_lab
02.design_lab
03.archi_lab
04.ico_lab

|03.1 stand A|03.2 dimensionamento muro di contenimento

Archi_lab

L'architettura è la mia area di studi anche se non la sola, da come si vede dal sito. Per sommi capi l'architetto è colui che media tra l'arte e la scienza, in questo caso la scienza delle costruzioni, quell'area che si occupa della fattibiltà tecnica degli edifici.

Ma non solo, la sociologia e altre discipline umanistiche rientrano nella progettazione di ambienti, edifici o intere aree urbane.

Come vedete non è poi tanto diverso dal web designer, conoscere le problematiche tecniche per mediare con quelle estetiche è una cosa importante.

In questa sezione sono raccolte idee, disegni, ma anche calcoli di strutture con procedimenti e software per facilitarli.

www.meta-idea.com
D: meta-idea
A: meta-idea M: andrea.greco@meta-idea.com

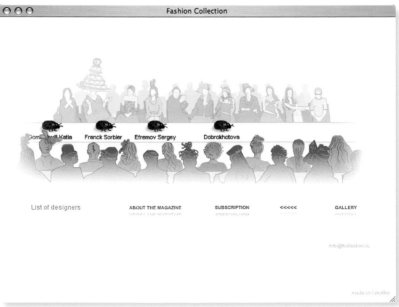

Fashion Collection

Katia Franck Sorbier Efremov Sergey Dobrokhotova

List of designers ABOUT THE MAGAZINE SUBSCRIPTION <<<<< GALLERY

info@fcollection.ru

made in lakotko

www.lakotko.ru/fc
D: sereja C: roman P: sereja
A: lakotko company M: lakotko@lakotko.ru

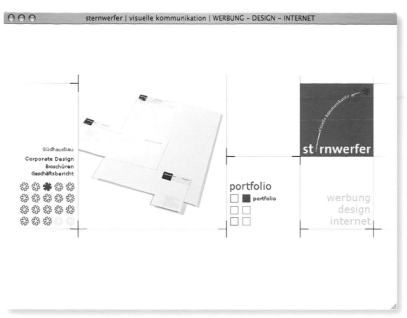

www.sternwerfer.de
D: harald huber **C:** igor ivankovic, sessler fabian **P:** harald huber
A: sternwerfer **M:** info@sternwerfer.de

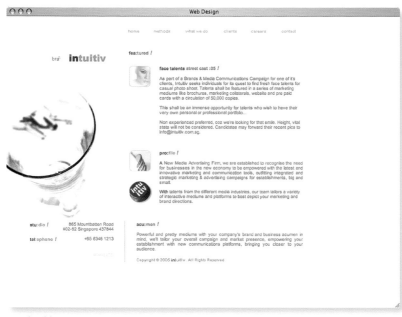

www.intuitiv.com.sg
D: j.h.
A: intuitiv **M:** chong@intuitiv.com.sg

www.energumene.com
P: weweje
M: bruno@energumene.com

David Schärer^{PR}

Erfahrung Schreibe **Projekte** News Persönliches Kontakt

Schärer stellt vor.
Schärer macht Marken PR
Schärer macht Mergers & Aquisitions.
Schärer ist Medienberater.
Schärer ist Rockstar.

SCHÄRER IST ROCKSTAR.

Gasoline Records, Basel und Zürich

PR-Kampagne und Storymarketing.

Um eine Fashionmarke aufzubauen, braucht man manchmal keinen Cent
für klassische Werbung auszugeben. Sofern man eine packende
Geschichte parat hat und die Klamotten von den richtigen Menschen
getragen werden. Gasoline Records macht T-Shirts von fiktiven
Rockbands. Und die Geschichte liefert genug Stoff für grosse
Medienaufmerksamkeit. In der Süddeutschen Zeitung, NEON, Blond,
Basler Zeitung, VIVA, Pro 7, Tages-Anzeiger, Annabelle und vielen mehr.

www.davidschaerer.ch
U: marc rinderknecht
A: kobebeef **M:** mr@kobebeef.ch

www.metodoasociados.com
D: david jover **C:** david jover **P:** miguel lucas
A: metodo asociados s.a. **M:** multimedia@metodoasociados.com

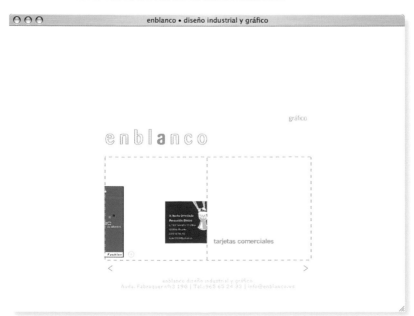

www.enblanco.ws
D: cristina guillen malluguiza, antonio iglesias
A: enblanco **M:** antonio@enblanco.ws

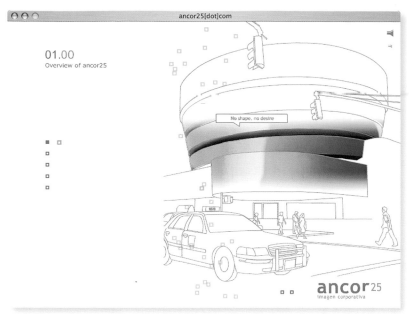

www.ancor25.com
D: david pinedo, maribel paez C: miquel lópez
A: ancor25 M: info@ancor25.com

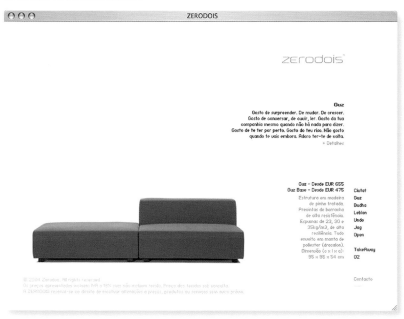

www.zerodois.com
D: raquel viana, ricardo alexandre, paulo lima
A: musaworklab M: raquel.viana@musacollective.com

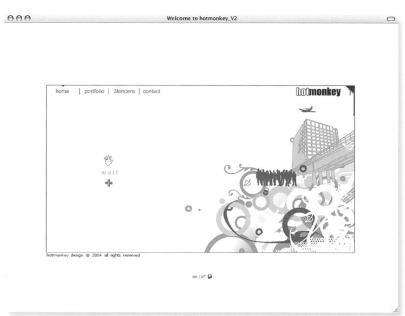

www.hotmonkeydesign.com
D: hotmonkey design
A: hotmonkey design M: info@hotmonkeydesign.com

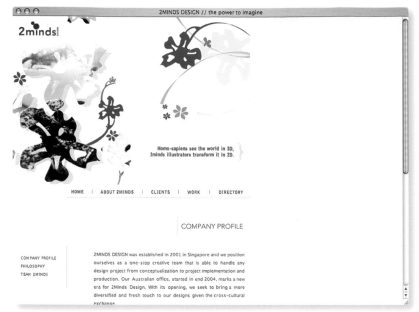

www.2mindsdesign.com
D: dawn C: james tan
A: 2minds design M: dawn.teo@2mindsdesign.com

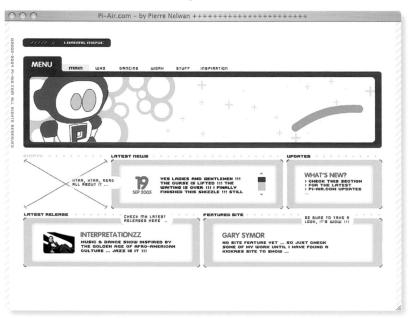

www.pi-air.com
D: pierre nelwan
A: pi-air M: info@pi-air.com

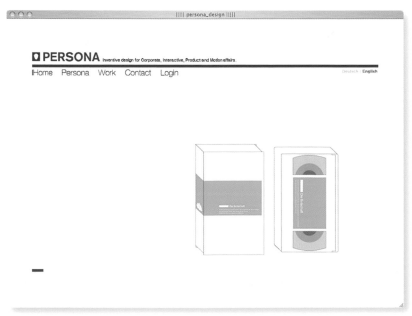

www.persona-design.com
D: alfredo picardi-rockenbach
A: persona design, gmbh M: picardi@persona-design.com

www.lasolitude.net
D: bernard david-cavaz C: chris gaillard P: bernard david-cavaz
A: bernard david-cavaz M: chris@chrisgaillard.com

uni.extrasmallstudio.com/labtixd04/
D: letizia bollini
A: extrasmallstudio M: bollini@extrasmallstudio.com

www.callitext.com
D: yannick scordia
A: selfstock M: yan@selfstock.com

www.stailfab.it
D: francesca aielli C: andrea nanni, caterina demarco
A: stailfab srl M: francesca@stailfab.it

www.box.hr
D: vjekoslav ivic
A: country of origin:croatia M: vjeko3@net.hr

www.minnim.tv/minnim.asp?lang=1
D: andreu colomer C: javier álvarez
A: :minnim M: contact@minnim.tv

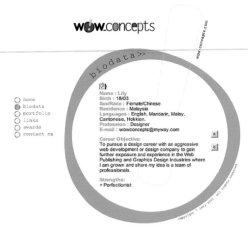

D: lily ng **P:** wow-concepts
A: wow-concepts **M:** suisui@myway.com

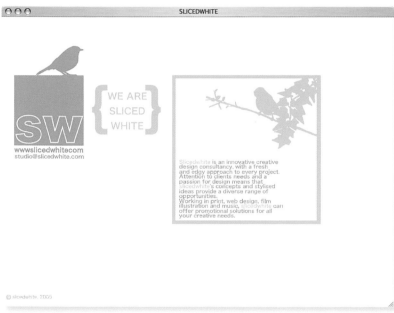

www.slicedwhite.com
D: howard fry
A: sliced white **M:** arkouda@hotmail.co.uk

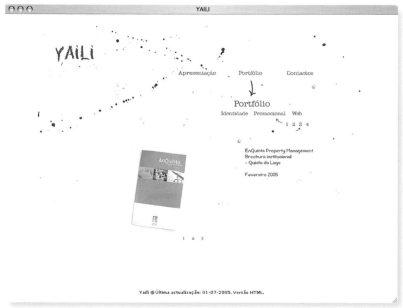

yaili.no.sapo.pt
D: inayaili leon
M: yaili@hotmail.com

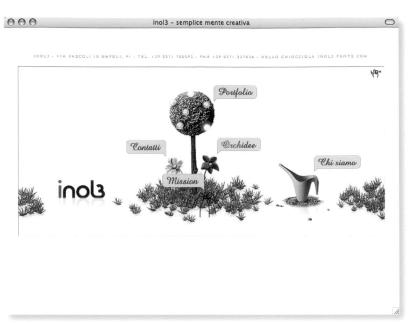

www.inol3.com
U: adriano antonini, cristiano ciocchetti, vito palagano
A: inol3 M: hello@inol3.com

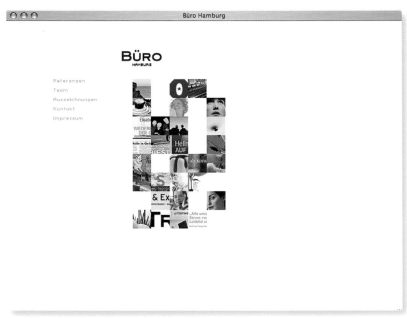

www.buero-hamburg.de
D: marcel dickhage, theis müller
A: v2a M: md@v2a.net

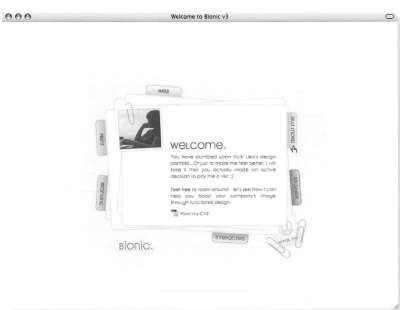

www.bionic-creative.com
D: vicki lew yi ling C: ming jie P: vicki lew yi ling
A: bionic creative M: vicki@bionic-creative.com

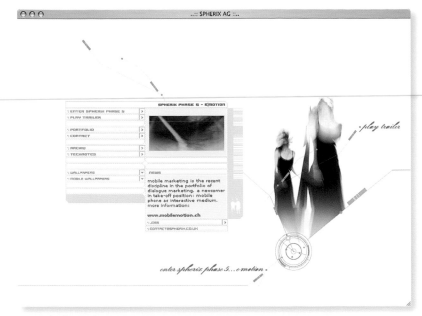

www.spherix.co.uk
D: spherix
A: spherix M: phase5@spherix.co.uk

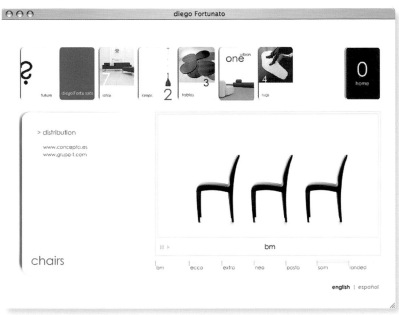

www.diegofortunato.com
D: karen yen C: pablo sánchez P: kings of mambo
A: kings of mambo M: www.kingsofmambo.com

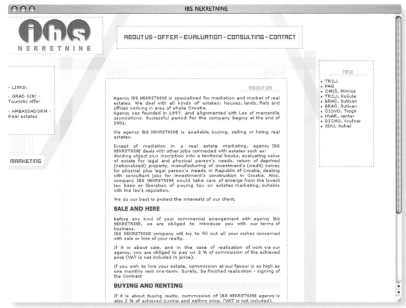

www.ibs-nekretnine.hr
D: ilija veselica
M: admin@ile85.com

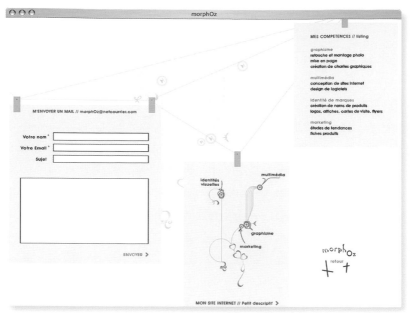

www.morphOz.org
D: anluine
A: morphoz M: morphoz@netcourrier.com

www.fanerem.com
D: eleazar rodríguez
A: fanerem M: eleazar@fanerem.com

www.cincuentaycinco.biz
D: oriol farré C: xavi royo P: xavi royo
A: xafdesign M: xroyo@cincuentaycinco.biz

illuskop

il|lu|skop, m, 1980; [illustrieren + suffix –skop]
_kommunikationsdesignstudent an der bergischen
universität wuppertal
_formkonstrukteur › www.formkonstrukt.com
_beatkonstrukteur

illugrafisch		transmit	jahr:
typografisch	ain't a damn thing changed	2004	
logografisch		bloomclub	
kinografisch			
phonografisch			

flyer und plakat
für die – ain't a
damn thing
changed –
hiphop party im
45rpm

Dimension in mm:

flyer
210 x 105

plakat
420 x 297

transmit auf
diesjähriger
buchmesse
in tokio
ausgestellt.

info@illuskop.de

www.illuskop.de
D: illuskop
M: info@illuskop.de

company services contact us
web and multimedia
3D design
IT solutions

Lovecraft's office... 1 2 3 4 5 6 7 8

3D design

language music

Copyright (C) 2005 Ohkaunit srl. All rights reserved

www.ohkaunit.com
D: luca rubinato
A: ohkaunit M: luca.rubinato@ohkaunit.com

Een advertentie die bestaat uit
een zwart/wit beeld en enkel een
in het oog springend kleuraccent,
de 'kauwgombel', die verwijst
naar het logo van blaupunkt, en
anderzijds de koptelefoon die
verwijst naar de producten van
het gerenomeerd
electronicabedrijf. Gerealiseerd in
het tweede jaar Plastische
Kunsten.

PORTFOLIO

ADVERTISING OTHER

// Hier kan je een kijkje
nemen in een selectie van de
werken die ik algelopen 3
jaar heb gemaakt. Ik hou me
voornamelijk bezig met
reclame/concept, maar ik
heb er ook enkele
experimentele werken
bijgevoegd...

//NEWSFLASH x

09/04
Finished the prototype
version of my site...Update
coming up soon!

12/05
Final version is online!! Keep
visiting my site for further
updates on my portfolio...

users.skynet.be/habbahoob
D: pieter lambert
M: habbahoo@hotmail.com

37

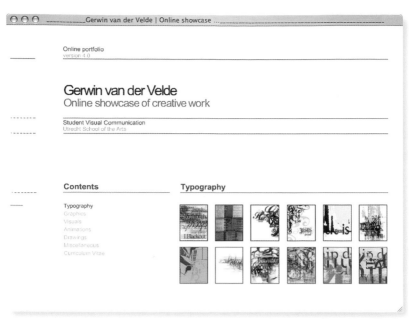

www.gkgvandervelde.nl
D: g.k.g. van der velde
M: contact@gkgvandervelde.nl

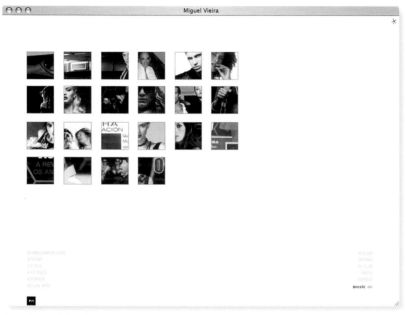

www.miguelvieira.pt
D: ricardo moutinho
M: rmoutinho@mail.telepac.pt

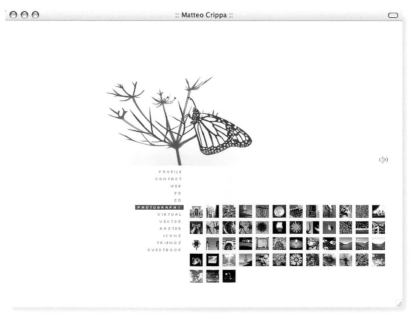

www.matteocrippa.com
D: matteo crippa
A: it's a personal portfolio M: info@matteocrippa.com

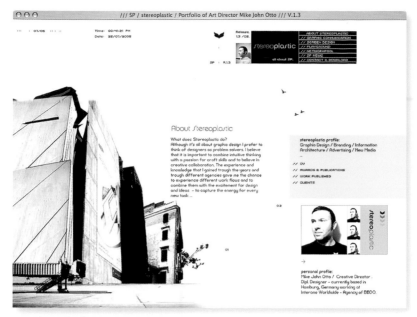

www.stereoplastic.com
D: mike john otto C: mike john otto, oliver hinrichs P: mike john otto

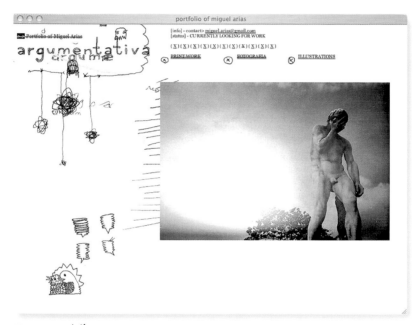

www.argumentativa.com
D: miguel arias
M: miguel.arias@gmail.com

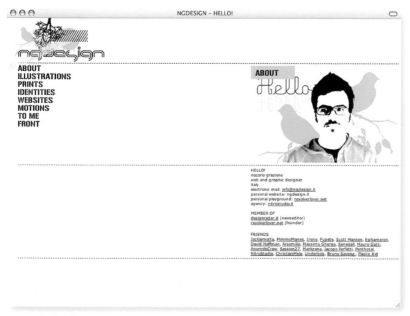

www.ngdesign.it
D: nazario graziano
M: me@ngdesign.it

CONTACT

Ruurd Somberg
Eric Schunselaar

@ info@somemountains.nl

🏢 Voorschoterlaan 117 B
NL - 3062 KL Rotterdam

✉ PO Box 4088
NL - 3006 AB Rotterdam

☎ +31 10 452 47 03

CONTACT

SOME
m o u n t a i n s

ABOUT US

Some Mountains specializes in investment, financing and acquisition strategies for medium sized companies.

We are a creative and critical partner of your business and combine a clear financial statement with a strong personal involvement. Some Mountains has a focus on deals between 1 and 10 million euro in a variety of companies.

The partners of Some Mountains, Ruurd Somberg and Eric Schunselaar, combine 15 years experience in private equity transactions.

ABOUT US

www.somemountains.nl
D: remoo do voc
A: just products M: remco@just-products.com

www.metacriacoes.com
D: bruno brás, vitor reis, carina martins C: vitor reis P: bruno brás
A: metacriações M: bbras@metacriacoes.com

www.falsoprimerministro.com.ar
D: pablo armanini
A: neu! M: pavlove@gmail.com

cpeach

Erstellt mit peach dem Content Management System von cpeach

www.cpeach.de
D: frank gebhard
A: cpeach M: frank.gebhard@cpeach.de

www.gent.cl
D: gent diseño
M: mauricio@gent.cl

www.estanfutura.com
D: ana carnicer C: benjamín núñez P: cdroig
A: cdroig M: maria@cdroig.com

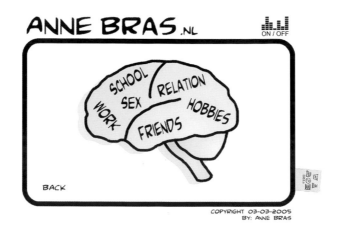

www.annebras.nl
D: anne bras
A: not yet M: its_like_god@hotmail.com

www.winney.com
D: alexandre scalvino C: alexandre scalvino P: kuntzel + deygas
A: add a dog M: addadog@wanadoo.fr

www.Beat13.co.uk
D: matt watkins, lucy mclauchlan C: karli watson, georgi marinov,
A: beat13 M: info@beat13.co.uk

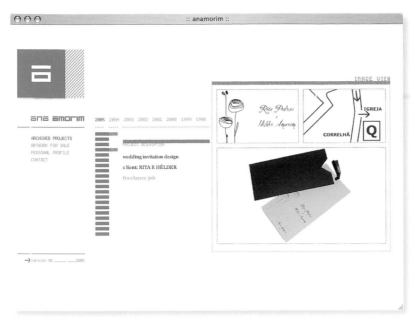

www.anamorim.com
D: ana amorim
A: anamorim design M: anamorim@anamorim.com

d999.org
D: matteo fait
A: d999 M: info@d999.org

www.artecomum.com
D: bruno alexandre cartaxeiro
M: feydrautha@gmail.com

www.tra-sos.org
D: núria badia comas
M: nuria@tra-sos.org

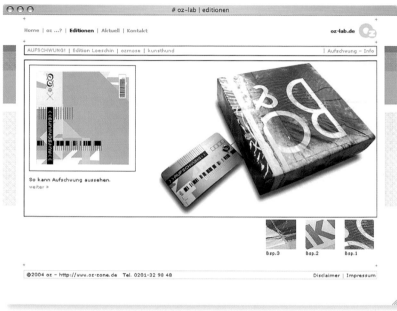

www.oz-lab.de/edition.htm
D: ka & chris brackmann C: ka brackmann P: oz-lab
A: oz design M: ka@oz-zone.de

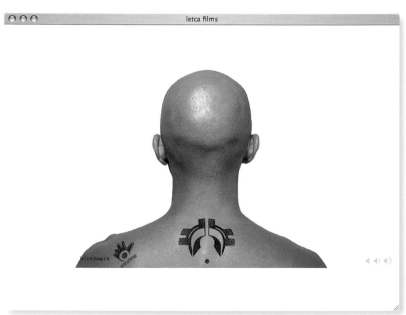

www.letca.com
D: abraham espinosa
A: aticas M: abraham@aticas.com

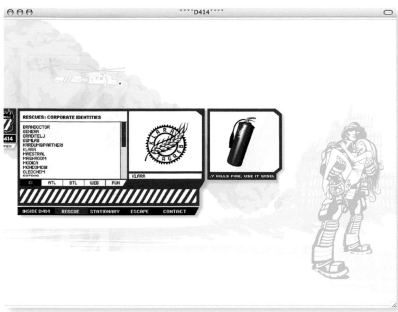

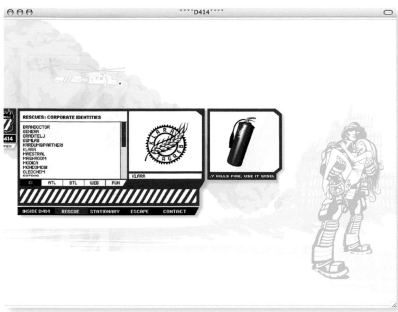



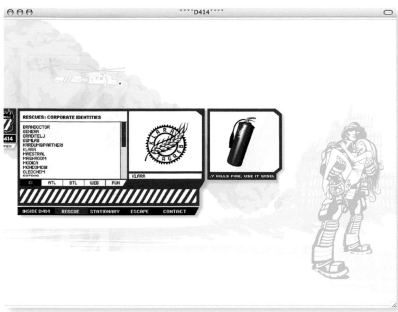

www.woestijnvis.be
D: leen de smedt
A: ballyhoo design M: info@ballyhoo.be

www.d414.net
D: sinisa suadar C: filip patcev P: darije juraj
A: d414 & zviz M: sinisa@d414.net

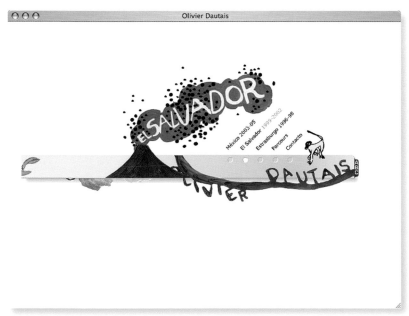

www.dautais.com
D: jean christophe lantier C: nicolas brignol P: olivier dautais
A: pop-shift M: jlantier@pop-shift.com

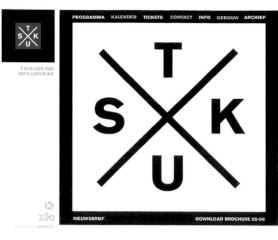

www.stuk.be
D: miech rolly C: kristöffer dams P. evan van liocum
A: stuk M: evan@theparkinglot.com

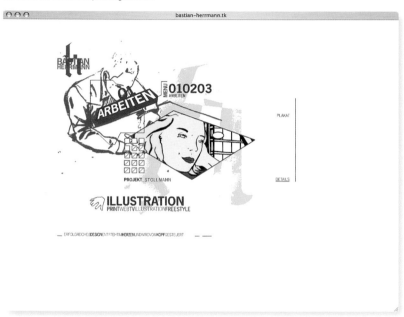

www.bastian-herrmann.tk
D: bastian herrmann
M: herrmann@bspot.de

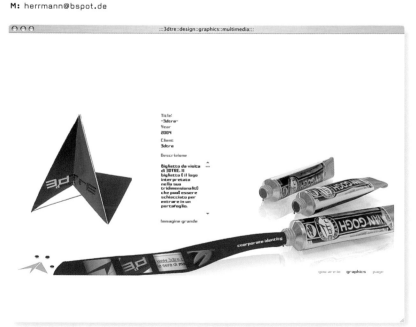

www.3dtre.com
D: riccardo marini
A: 3dtre M: riccardo@3dtre.com

www.grubor.co.yu
D: dejan n. grubor
A: grubor design factory M: info@grubor.co.yu

www.reginashoes.it
D: francesca aielli, pablo gallo C: andrea nanni
A: stailfab srl M: francesca@stailfab.it

www.melaniebrandt.de
D: melanie brandt
A: melanie brandt M: mail@melaniebrandt.de

www.artificialduckflavour.com
D: artificial duck flavour
A: artificial duck flavour M: mark@artificialduckflavour.com

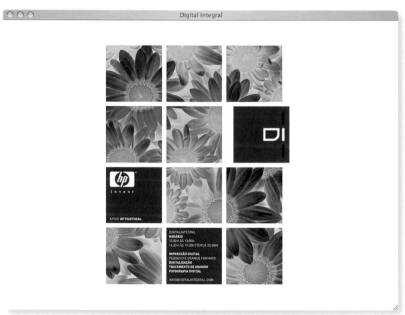

www.digitalintegral.com
D: digital integral C: fmtavares.net P: digital integral
A: fmtavares.net M: fmtavares.net/

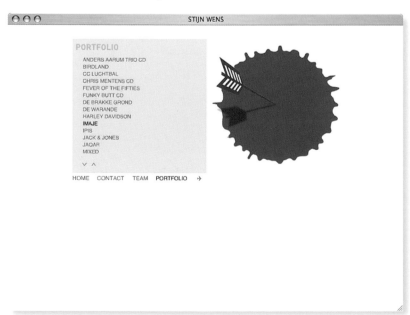

www.wens.be
D: stijn wens C: seb lemmens P: stijn wens
A: grigri M: info@grigri.be

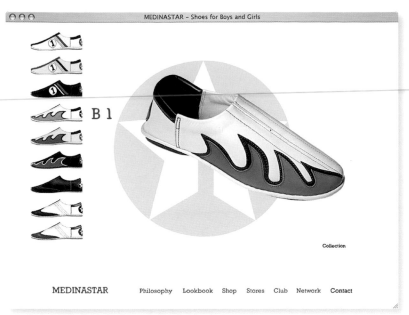

www.medinastar.com
D: armin von hodenberg
A: flashyweb M: info@flashyweb.de

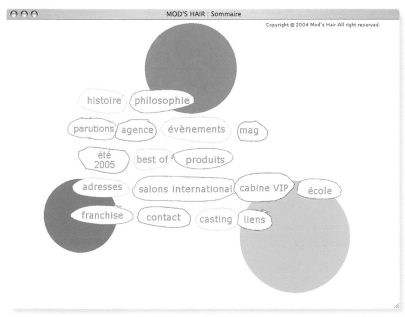

www.modshair.com
D: bonnet isabelle C: bonnet dominique P: bonnet dominique
A: avd-conseil M: dbonnet@avd-conseil.com

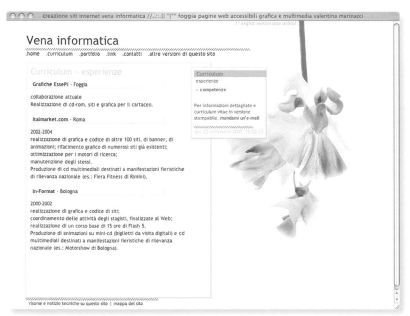

www.venainformatica.com
D: valentina marinacci
M: info@venainformatica.com

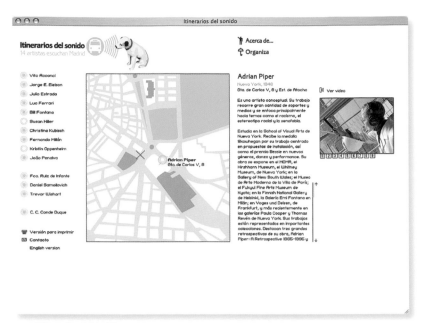

www.itinerariosdelsonido.org
D: miguel solak P: centro cultural conde duque - ayuntamiento de madrid
M: msolak@wanadoo.es

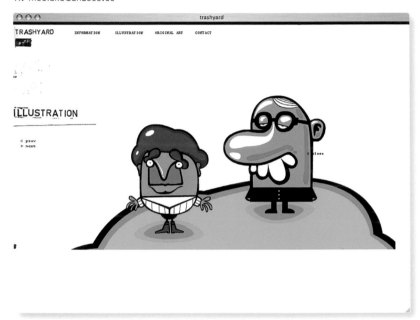

www.trashyard.de
D: daniel althausen
A: trashyard M: info@trashyard.de

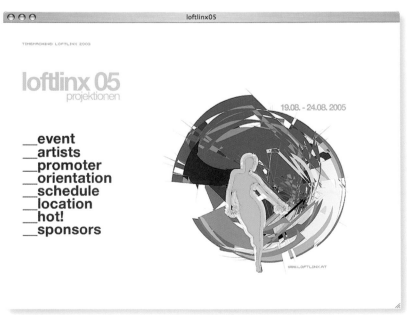

www.loftlinx.at
D: dietmar halbauer C: dietmar halbauer P: direct.design
A: direct.design M: dietmar.halbauer@chello.at

50

Design / Internet

Webgarten, eine kleine innovative WebDesign Firma in der Schweiz nahe Zürich. Spezialisiert auf das Erstellen von Websites für alle Firmen mit hohem Anspruch an Design, Originalität und Benutzerfreundlichkeit.

In diesem "Garten" wachsen neben Websites auch Banner und Screensaver zur Reife heran. Auf das Wesentliche reduziertes Design und einfache Benutzerführung ist unsere Stärke und unser Grundsatz. Weniger ist mehr.

Aktuelles

19.08.05: Von der Bellevue Asset Management in Küsnacht bekommen wir einen weiteren Auftrag. Es handelt sich um das Redesign bellevue.ch.
Mehr...

Portfolio bestellen

Bestellen Sie unsere neuen Unterlagen.
Mehr...

Empfehlen Sie uns

Sagen Sie auch Ihren Freunden über uns Bescheid. Webgarten könnte diese auch interessieren.
Mehr...

Email Newsletter

Abonnieren Sie jetzt unseren Newsletter. Dieser wird alle zwei Monate versendet und kann von Ihnen wieder abbestellt werden.
Mehr...

www.webgarten.ch
D: oliver schmid
A: webgarten gmbh M: oliver.schmid@webgarten.ch

Kuhrt | Büro für Kommunikation

BÜRO FÜR KOMMUNIKATION

Jede Kommunikation setzt sich aus verschiedenen Komponenten zusammen: Ein Sender verschlüsselt seine Nachricht in einem Medium, die von einem Empfänger entschlüsselt wird. Bleibt folgende Frage zu klären: Wer (Sender) teilt wem (Empfänger) was (Nachricht) mit welchem Effekt mit?

Antworten gibt: Das Büro für Kommunikation.

→ **Nicola Kuhrt**
Freie Journalistin für
Print- und Onlinemedien

→ **Nils Kuhrt**
Grafik-Designer und
Art Director

www.kuhrt.de
D: nils kuhrt
M: buero@kuhrt.de

CMFMEDIA

CMFMEDIA DESIGN FOR SCREEN AND PRINT, FOR YOU.

VIEW..

Various 1-inch Pinbadges

www.cmfmedia.co.uk
D: colin mcfarland
A: cmfmedia M: cmcfarland@gmail.com

www.tommybass.com
D: tommaso mezzavilla **C:** andrea luxich **P:** andrea luxich
A: pangoo design **M:** andrea@pangoo.it

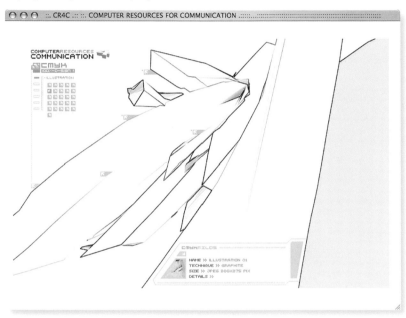

www.cr4c.com
D: carles ribot
M: carles@cr4c.com

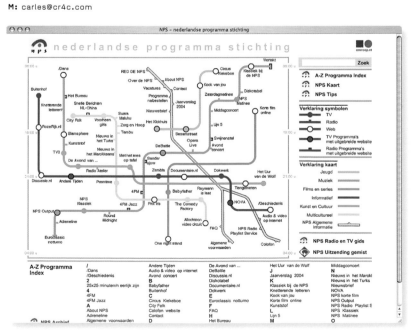

www.nps.nl
D: ingrid walschots **C:** hjalmar snoep **P:** ingrid walschots
A: nps **M:** ingrid.walschots@nps.nl

www.illustration-tw.com
D: tim weiffenbach C: peter stützel P: peter stützel
A: pixel&code M: peter@z2s.de

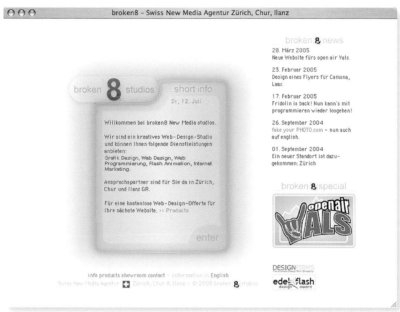

www.broken8.com
D: simurai C: fridolin P: jexs
A: broken 8 studios M: info@broken8.com

www.pavelsvoboda.net
D: tomáö brousil C: radek zigler
A: aluminium M: info@aluminium.cz

coyoteclub.net
D: hal C: hiroshi yokoi P: hiroshi yokoi
A: raf M: hy@raf-dl.com

www.mannherz-design.de
D: sonja radke, christina mannherz C: justus siebert
A: mediennetzwerk smart interactive M: info@smart-interactive.de

www.limepickle.net
D: mark jenkinson
A: limepickle limited M: mark@limepickle.net

→ WEBDESIGN
Konzeption und Erstellen von Internetseiten. Design, Coding und Validierung nach W3C Standards
→ DTP
Grafische Konzeption, Design und Produktionsabwicklung von Printprodukten
→ ILLUSTRATION & CI
Logotypen Signets Piktogramme Bleistiftzeichnungen

www.mirror-site.tk
D: dominik hruza
A: studio M: dominik.hruz@nextra.at

www.phormastudio.com
D: fresta marco C: valentino tombesi P: marco quintavalle
A: phorma studio s.r.l. M: info@phormastudio.com

ARGENTINA | ITALY | FRANCE | USA | SPAIN | AUSTRALIA | CHILE | AUSTRIA | NEW ZEALAND

www.mendozarestaurant.com
D: santiago sadous C: santiago sadous P: florencia sadous
A: 6_elements M: santesa2@fibertel.com.ar

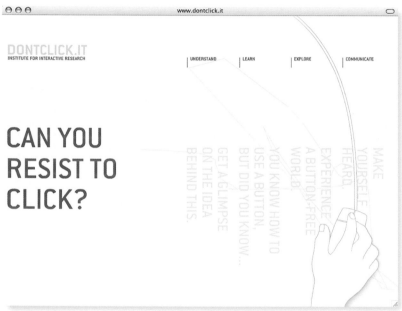

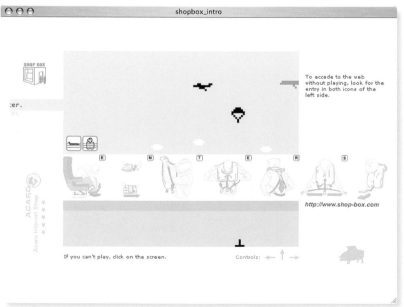

www.die-marke.at
D: juergen mellak **C:** juergen mellak **P:** kreativagentur cmm
A: kreativagentur c.m.m. | graz. **M:** juergen.mellak@cmm.at

www.dontclick.it
D: alex frank
A: lxfx interactive architecture **M:** dontclick@lxfx.de

www.shop-box.com
D: carlos garcía burgos **C:** fernando navarro **P:** acaro multimedia s.l.
A: acaro multimedia s.l. **M:** info@acaro.com

www.rubenaka.com
D: ruben baron romero
A: alter ebro M: moro@hotmail.co.uk

www.nexarquitectonica.com
D: adrián castro C: adc design agency P: nexa arquitectonica
A: adc design agency M: adri@adcdesign.net

www.swaplab.it
D: michele
A: swaplab M: info@swaplab.it

www.catlee.net
D: cat lee
A: pascal & associates M: rudy@pascalassociates.net

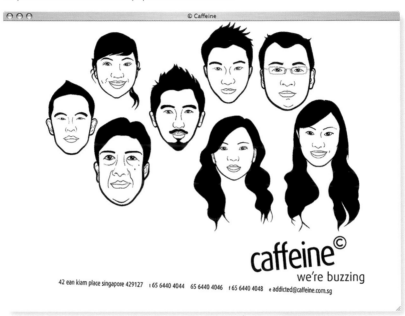

www.caffeine.com.sg
D: kalinda low P: joe chua
A: caffeine media pte ltd M: joe@caffeine.com.sg

www.sol.at/fam.ellmer
D: ellmer stefan
M: ellmer_stefan@lycos.at

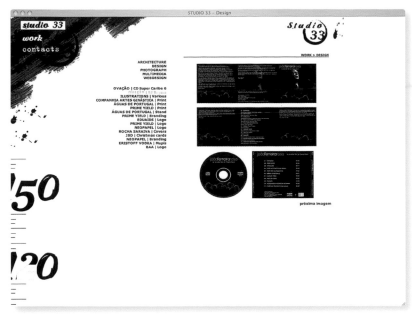

www.st-33.com
D: plinio gomes C: farid hider P: rodrigo silva
A: studio 33 M: geral@st-33.com

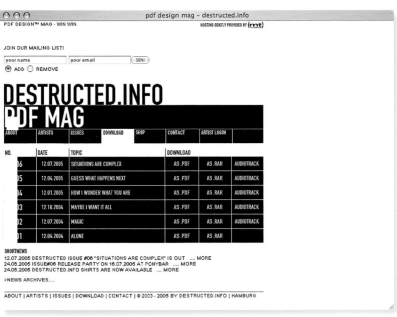

www.destructed.info
C: peer fischer P: philipp michaelis
A: zoozoozoo.net M: peer@zoozoozoo.net

www.supersal.it
D: supersal
A: supersal M: salvo_sal@libero.it

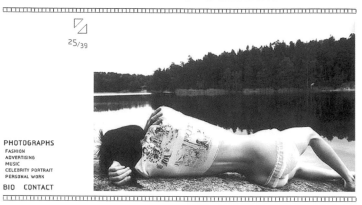

www.fabriziorainone.com
D: kimmo kuusisto
A: fabrizio rainone photography M: rainone@lineone.net

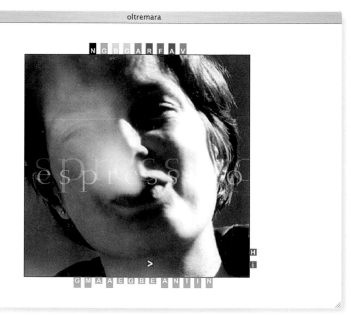

www.atelier-fuer-werbefotografie.de
D: a|w|sobott atelier für werbefotografie
A: a|w|sobott atelier für werbefotografie M: info@andre-sobott.de

www.oltremara.com
D: mara codalli
A: oltremara M: mara12@email.it

60

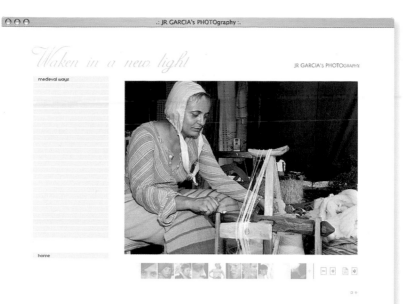

www.jrgarciaphoto.com/waken/waken.html
D: alexandre r. gomes C: alexandre r. gomes P: j.r.garcia
A: bürocratik M: alex@burocratik.com

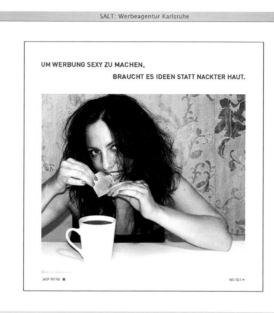

www.wa-salt.de
D: rabea hahn C: christoph noe P: salT: werbeagentur
A: salT: werbeagentur M: siever@wa-salt.de

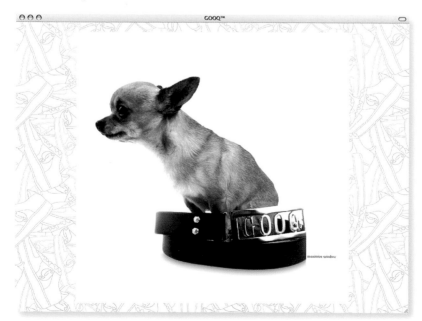

www.gooq.de
D: huy dieu
A: gooq M: huy@gooq.de

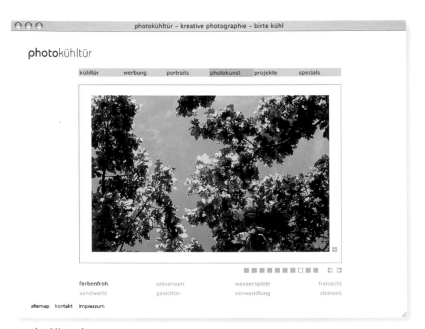

www.kuehltuer.de
D: dennis albrecht C: rené günther P: photokühltür - birte kuhl
A: s!gns® - studio für image & design M: contact@signs.de

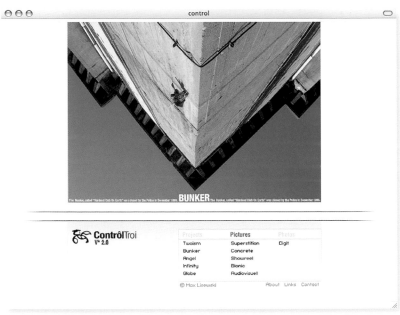

www.max.ctrl3.com
D: max lisewski
A: max lisewski M: max@ctrl3.com

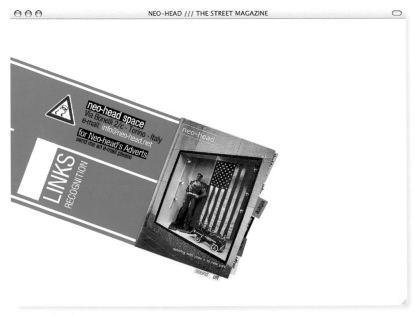

www.neo-head.net
D: fabio de gregorio, romina mattina C: fabio de gregorio P: advgroup
A: advgroup M: fabio.degregorio@advgroup.it

MOST-IK

mon panier

Qui sommes-nous ?

Accueil
Qui sommes-nous?
Questions & Réponses
Livraison
Votre compte
Contact

La **société neo style** est spécialisée dans la vente de tee-shirts sur internet pour le grand public et les professionnels.

Des tee-shirts de qualité : Nous achetons nos tee-shirts chez des fournisseurs reconnus et respectant une certaine éthique. Nos tee-shirts sont garantis 100% coton et ont un grammage minimum de 170 g.

Des dessins de qualité : nous fabriquons nous même les personnalisations. Nous prévoyons de sortir une nouvelle collection tous les six mois.

Un service client à votre écoute : nous vous proposons de nous contacter par e-mail à l'adresse suivante infos@most-ik.com. Nous vous garantissons une réponse dans les meilleurs délais. N'hésitez pas à nous contacter !

Notre société : MOST-IK est une marque déposée par la SARL NEO STYLE au capital de 8 000 euros, immatriculée au registre du commerce et des sociétés de Bordeaux sous le RCS BORDEAUX 478 588 817. Son siège social est situé Zone artisanale - 207, Allées des deux poteaux - 33127 Saint Jean D'illac et le service client 79, rue maurice 33300 Bordeaux.

W3C CSS W3C HTML XDI

www.most-ik.com
D: elodie bailly **C:** stéphan
M: weblody@weblody.com

_selected works

_photos

_information architecture

_contact & info

MARCO ESTEBAN CALZOLARI
NEW MEDIA DESIGNER

Say something: esteban@marcocalzolari.it

www.marcocalzolari.it
D: marco esteban calzolari
M: esteban@marcocalzolari.it

Sábado 23 Julio, 2005
Barcelona , España

englishforbiz
IN-COMPANY LANGUAGE TRAINING

Metodología
y Estrategia

El programa de estudios se personaliza para adaptarlo a las necesidades de cada cliente/empresa. Se ejercitan conceptos básicos como: escribir un informe, presentar un producto, analizar estadísticas, diseñar una estrategia, y muchos más. La mayoría de los que se acercan a **English for biz** ya han estudiado el idioma y se han sentido frustrados por la falta de resultados tangibles. El objetivo entonces es usar una metodología que enseñe a combinar de diferentes maneras las palabras ya aprendidas. Por ejemplo, palabras en inglés como *company* y *run* se pueden rescatar del vocabulario conocido para crear una nueva frase muy común: *run a company*. La asociación de palabras más que la palabra en sí misma, empiezan a formar un repertorio de frases típicas y modismos que facilitan la comunicación natural y fluida y motivan al estudiante a seguir tomando clases.

QUIENES SOMOS
METODOLOGIA Y ESTRATEGIA
INGLES PARA EMPRESARIOS
INGLES DIRECTIVOS DE EMPRESA
INGLES COMO SEGUNDO IDIOMA
INGLES INTENSIVO DE UN MES

CONTACTO
HOME

[copyright english for biz s.l. | 2004 design by ADC DESIGN AGENCY]

www.englishforbiz.com
D: adrián castro **C:** adc design agency **P:** efb
A: adc design agency **M:** adri@adcdesign.net

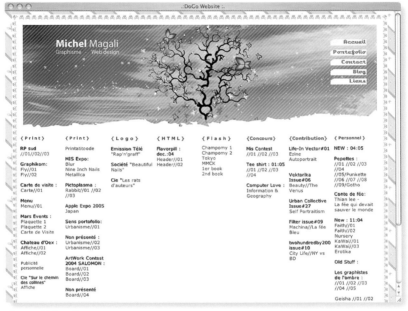

www.sineticaindustries.com
D: hangar design group
A: hangar design group **M:** hdg@hangar.it

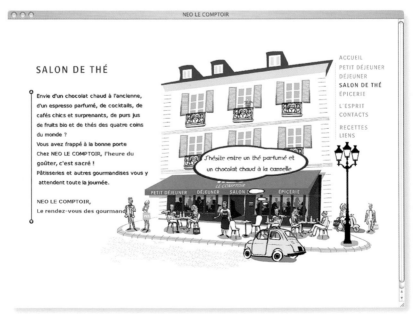

dogoworld.free.fr
D: magali michel
M: magali.michel@neuf.fr

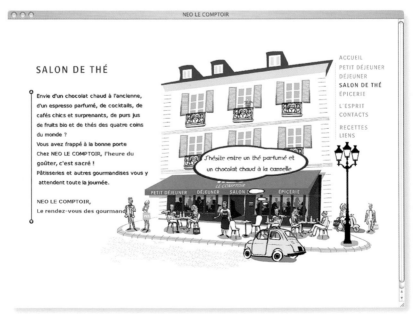

www.neolecomptoir.com
D: sebastien pondruel **C:** sebastien pondruel **P:** arnaud bonneville
A: neo le comptoir **M:** s.pondruel@wanadoo.fr

www.sascha-gutzeit.de
D: lars volke C: lars volke P: sascha gutzeit
A: lars volke M: volke@talentwurf.de

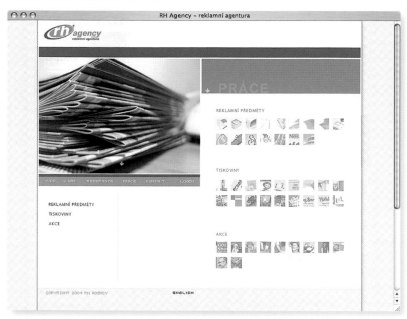

www.rhagency.cz
D: attila torok
M: attila@torok.sk

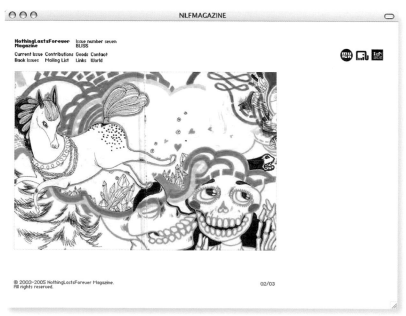

www.nlfmagazine.com
D: musaworklab
A: musaworklab M: contact@nlfmagazine.com

37c.dk
D: 37c
A: 37c M: thomas@37c.dk

eldes.com
D: eldes de paula
A: eldes studio M: eldes@eldes.com

www.enova.com.br
D: silvio eduardo teles dos santos C: pedro paulo de mello filho
A: enova interactive M: pedro@enova.com.br

www.sallyanderson.me.uk
D: sally anderson
M: sallyandersonuk@gmail.com

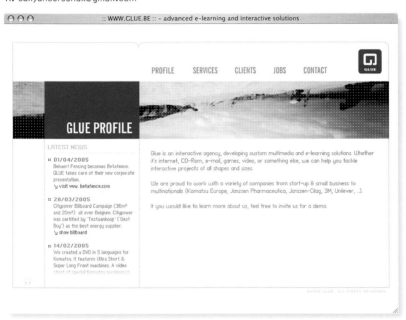

www.glue.be
D: glue
A: glue M: koen@glue.be

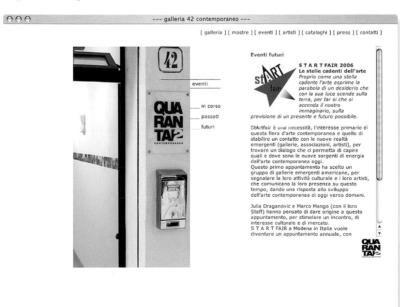

www.galleria42.it
D: alice pignatti C: alice pignatti P: marco mango
A: open agency M: ciriali@libero.it

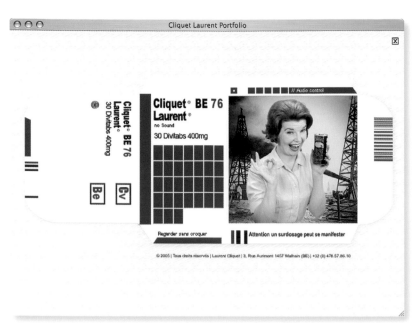

www.cliquet.be
D: cliquet laurent C: laurent cliquet P: boukalail
A: boukalail M: www.boukalail.com

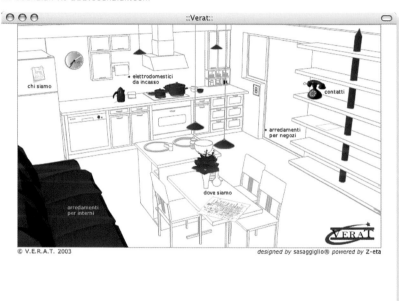

www.verat.it
D: alessandro giglio C: alessandro giglio P: verat spa
A: adduma communication M: alessandro.giglio@adduma.it

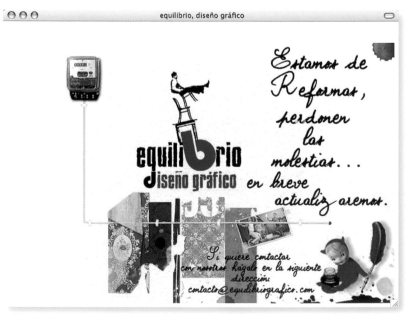

www.equilibriografico.com
D: bernardo jiménez tomán, marta corcho tarifa
A: equilibrio diseño gráfico M: bernardoll@auna.com

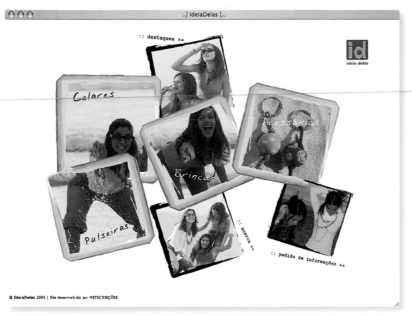

www.ideiadelas.com
D: metacriações C: vitor reis e diogo roque P: bruno brás
A: metacriações M: bbras@metacriacoes.com

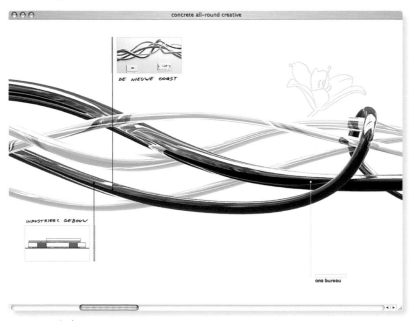

www.concrete.be
D: pieter lesage & alexander crolla C: pieter lesage
A: concrete M: pieter@concrete.be

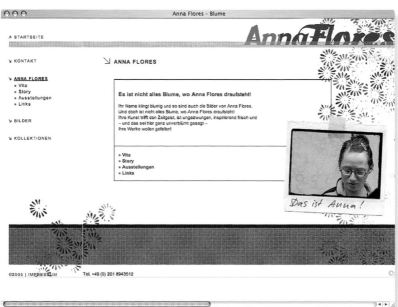

www.annaflores.de
D: katrin brackmann C: k. brackmann
A: oz M: ka@oz-zone.de

www.bmuellers.ch
D: steve henseler
A: cubegrafik M: steve@cubegrafik.com

icebeat.bitacoras.com
D: daniel mota
A: daniel mota M: daniel.mota@gmail.com

www.iberflor.com
D: complejo creativo
A: complejo creativo M: produccion@complejocreativo.com

www.johnagesilas.com
D: pierre nelwan
A: pi-air M: info@pi-air.com

www.nodecaff.com
D: stefania bojano C: fabio murra
M: info@nodecaff.com

www.duos.be
D: stefanie sobry
A: figraph M: stefanie.sobry@pandora.be

www.dolcevitaproductions.net
D: abraham espinosa
A: aticas M: abraham@aticas.com

essence.at
D: grabherr, heinrich
A: essence M: philippovich@essence.at

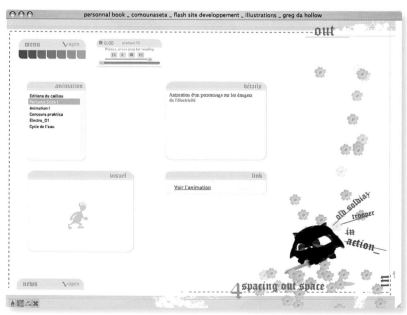

www.comounaseta.com
D: greg picquet
A: comounaseta M: postmaster@comounaseta.com

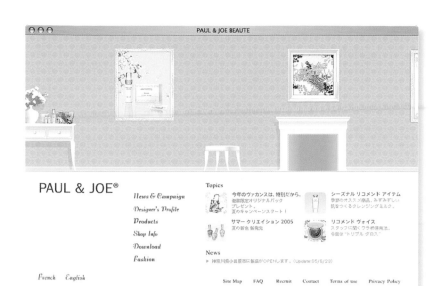

www.paul-joe-beaute.com
D: takaaki yagi
A: form::process M: info@form-process.com

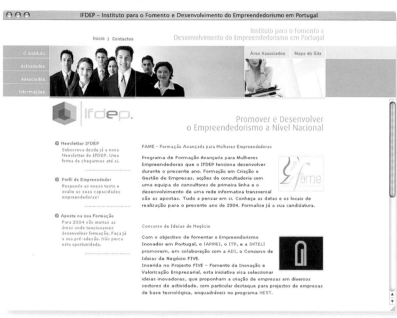

www.ifdep.pt
D: filipe cavaco C: alexandre ribeiro gomes P: gws
M: alex@burocratik.com

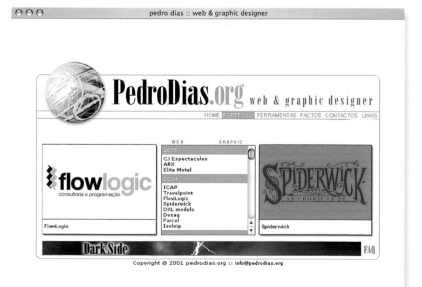

www.pedrodias.org
D: pedro dias
M: e-mail@pedrodias.net

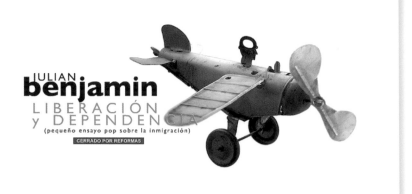

JULIAN
benjamin
LIBERACIÓN
y DEPENDENCIA
(pequeño ensayo pop sobre la inmigración)
CERRADO POR REFORMAS

CONTACTO
JULIANBENJAMIN@MAGACLICK.COM

www.julianbenjamin.com.ar
D: magali piterman
A: magaclick M: www.magaclick.com

RONDO Braunschweig - Restaurant im Kleinen Haus

Theater-Restaurant im Kleinen Haus

RONDO

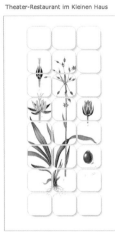

Die Küche

Unsere Küche bietet eine reiche Auswahl an köstlichen Speisen. Zum Mittag eine kleine Mittagskarte, zum Abend eine größere und sehr leckere Abendkarte.

Neben Suppen, Hauptgängen mit Fisch und Fleisch und köstlichen Desserts bieten wir ein reichhaltiges Spektrum an kleinen Gerichten -eine leichte Küche mit mediterranen Akzenten.

Dazu servieren wir Ihnen gerne ein kühles Bier vom Fass (Feldschlösschen oder Duckstein). Bevorzugen Sie Wein, dann bieten wir Ihnen Qualitätsweine aus Österreich, Italien und Deutschland.

Übrigens: wir wechseln unsere Karte etwa alle zwei Monate - vielleicht auch ein Anreiz für Sie, öfter das Theater und das RONDO zu besuchen.

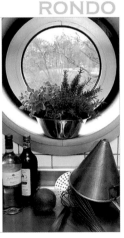

Restaurant Rondo Magnitorwall 18 38100 Braunschweig 0531/1234595 eMail: info@rondo-bs.de Impressum

www.rondo-bs.de
D: frank gebhard
A: cpeach M: www.cpeach.de

nebuRX . diario de viaje

nebuR**X**

... Blog . BlogFile . Friends . Links . Search . Email ...

Libertad

, escrito por nebuRX
viernes 08 de julio de 2005 a las 02:02

Libertad... una mirada negra que derrocha melancolía.... libertad... alas que revolotean contra el metal... lo vi en su mirada... quería volar libre... vivir poco y sentir mucho... poder ver el mundo desde arriba y escoger la rama donde posarse.... pero apocado a su pequeña prisión... solo podía esperar ser víctima de 90 cm cuadrados de alambre... sus hermanos revoloteaban más fuerte... y al volver la madre con la comida... el no probó bocado... quizás mañana.. su libertad sea el regreso al desconocido mundo de la no existencia...

Pasan muchas cosas en el mundo... pero miremos las cosas desde lejos... creo que alguien comenzó las cosas de manera errónea. y de manera errónea suceden sus consecuencias...

www.neburx.com
D: ruben sanchez fernandez
A: factoria norte M: ruben@factorianorte.com

74

www.multitudo.net
D: ricardo ferreira
A: mutitudo M: design@multitudo.net

HOTEL GRAN FIESTA -- beta001 --

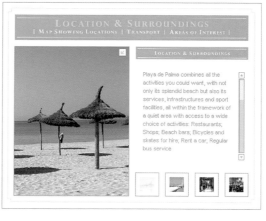

www.hotelgranfiesta.org
D: carles
M: carles@cr4c.com

2iddea – Creacion de Paginas web y Diseño,Donde las ideas nacen

www.ziddea.com
D: ziddea sl
A: ziddea sl M: julio@ziddea.com

WEBSEN.AT
21092005

Wir sind
eine Webagentur in Tirol, Austria.
www.websen.at wurde vor 5 Jahren gegründet.Unser Schwerpunkt
liegt bei Komplettlösungen für das Internet. Wir bieten Content
Management, zuverlässige Contentwartung, barrierefreies
Webdesign, SEO - Suchmaschinenoptimierung und individuelle
Programmierung.

Kontakt unter
Stefanie Temml
Georg Bucher Str. 25 d
A - 6094 Axams
temml@websen.at
+43 (0) 676 600 30 53

Referenzen unter
www.gasthof-weiss.com
www.kunstauktion.cc
www.stchristoph.at
www.tanzsommer.at
www.bernhard-aichner.at
www.high-speed-machining.at
www.fotowerk-aichner.at
www.bierstindl.at
www.jobshop.at
www.cielaroque.at
www.3heiligen.at
www.tmc-consulting.org
www.casa-linda.at
www.kemater-alm.at
www.vladimir.estragon.at

Firmenwortlaut (WKO)
AGB

www.websen.at
D: stefanie temml
A: websen.at M: temml@websen.at

Allen Venables

ALLEN VENABLES
PHOTOGRAPHY

MATTHEW VENABLES

SITE BULLDOG

01. 02. 03. 1.
HOTELS INDUSTRY PEOPLE 2. 3. 4. 5. 6. 7. 8. 9. 10.
04. 05.
PLACES EXTRAS

www.allenvenables.com
D: ren spiteri
A: bulldog M: info@virtualbulldog.com

Papillon: Mobilier contemporain/ Contemporary furniture

PAPILLON
MOBILIER CONTEMPORAIN
CONTEMPORARY FURNITURE

PRESENTATION
CUSTOM-MADE
COLLECTION PAPILLON TABLES
TEAM
PRIZES AND MENTIONS
PRESS KIT
CONTACT

PAPILLON TABLES
PROTOTYPES

1st Prize : New Product Category of the Designer's Gallery at the 2004 SIDIM (Salon
International de Design Intérieur de Montréal)

The piece of furniture that inaugurates the PAPILLON creations is a dining table built
entirely of steel. Its unique character, beyond its sturdiness, is to allow cooking at the
table with an integrated burner. Two extra hollow spaces can also be used as food
warmers for the dishes, or simply as candle holders.

PAPILLON is counter-current to rapid consumption, loss of cooking abilities and over-
consumption of energy. Its tables, inspired by the slow-food movement, value a simple
and nutritional cuisine that is prepared and shared with family or amongst friends.

The second generation of tables will soon be available.

© PAPILLON 2004

www.papillonconcept.com
D: eloise camire
A: modules.ca M: eloise@modules.ca

S:R:US design zastoupení . kontakt . showroom . galerie . english version

Sirius Design

Dlouhá 32, 110 00 Praha 1
tel.: 222 319 536, 222 319 548
fax: 222 319 555
E - mail: info@sirius-design.cz

Certifikát ISO:
Komplexní řešení interiérů

Design Capitol Internet Publisher
© 2002 All rights reserved

Firma Unitec Consulting, a.s. provozuje galerii Sirius v Dlouhé ulici v Praze 1 na Starém Městě.

V nádherných prostorách s masivními gotickými klenbami a vysokými stropy, bychom našli některé části (především sklepy s rozsáhlou galerií světel), které se dochovaly ještě původně ze 14. století. Designový nábytek, svítidla a jiné interiérové části a doplňky se v těchto prostorách vyjímají lépe, než kdekoliv jinde. Součástí je také stálá výstava obrazů akademické architektky a významné novodobé malířky paní Ewy Nemoudry.

Firma Unitec Consulting, a.s. se může za své dlouholeté působení pochlubit nemalým výčtem navržených a realizovaných interiérů. K těm nejznámějším patří určitě Expo 58 v Praze, osvětlení v Anežském klášteře, Lucemburského velvyslanectví, restaurace Kampa park a další.

Firma spolupracuje se dvěma renomovanými architekty, kteří se podílejí na plánování interiérových celků a kuchyní Bulthaup, jejímž partnerem firma Unitec v České republice je. Dále se účastní řady výstav v České republice i v zahraničí, na kterých vystavuje skvosty moderního designu, které byste v České republice jen těžko našli.

Prodejní galerie svítidel a nábytku Sirius design

E - mail:info@sirius-design.cz
Po-St: 9-18, Čt: 9-19, Pá: 9-18, So: 10-16

www.sirius-design.cz
D: josef cejnar
A: capitol internet publisher s.r.o. M: josef.cejnar@capitol.cz

tela.digital

ENGLISH VERSION

soluções à sua medida

Está satisfeito com a solução informática na sua empresa?

A Tela Digital fornece-lhe um serviço de qualidade orientado para satisfazer as suas necessidades reais.

Consulte-nos! Faremos uma avaliação séria e iremos propor-lhe a solução que melhor se ajusta a si, pelo preço justo.

Diga-nos o que pretende, peça um orçamento!

orçamento on-line

E-Mail: info@teladigital.pt

open manager

Experimente a nossa demo do open*manager*, veja as suas capacidades e vantagens para uma rápida actualização do seu site.

os nossos produtos

EMPRESA EQUIPA SERVIÇOS PRODUTOS PORTFOLIO PARCERIAS CONTACTOS

Copyright © 2002-2005 tela.digital, sistemas de informação, lda

POWERED BY
Content Server 2.1
tela.digital

www.teladigital.pt
D: pedro dias C: marco roberto P: pedro dias
A: tela digital M: pedro.dias@teladigital.pt

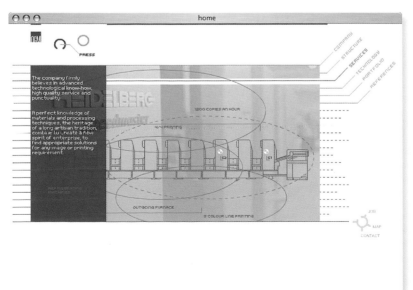

PRESS

The company firmly believes in advanced technological know-how, high quality service and punctuality.

A perfect knowledge of materials and processing techniques, the heritage of a long artisan tradition, combine to create a new spirit of enterprise, to find appropriate solutions for any image or printing requirement.

COMPANY
STRUCTURE
SERVICES
TECHNOLOGY
PORTFOLIO
REFERENCES

JOB
MAP
CONTACT

www.ogm.it
D: hangar design group
A: hangar design group M: hdg@hangar.it

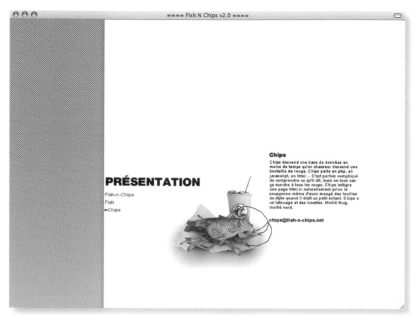

www.fish-n-chips.net
D: simon frankart C: sean lempère
A: fish-n-chips M: contact@fish-n-chips.net

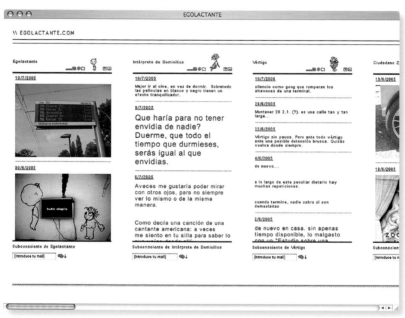

www.egolactante.com
D: rubén cárdenas C: marian ballarín P: javier peñafiel
A: oddcity M: djlashit@oddcity.com

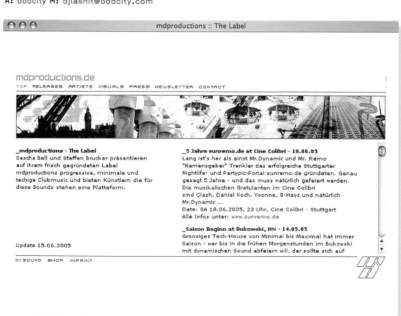

www.mdproductions.de
D: joe landen
A: twinpix media lab M: info@twinpix.de

www.misprintedtype.com
D: eduardo recife C: mickey P: eduardo recife
M: recifed@terra,com.br

www.bodegaslaus.com
D: román salvà C: ismael gejo P: román salvà
A: salvà estudi M: www.salva-estudi.com

www.nathalie-erb.com
D: nathalie erb
M: contact@nathalie-erb.com

music.webpunt.nl
D: p.j.h.m. hendrikx
A: webpunt.nl M: p.hendrikx@webpunt.nl

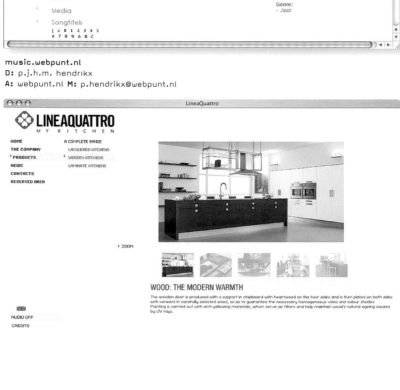

www.lineaquattro.com
D: ilaria mauric C: alessio michelini P: creso srl
A: lineaquattro M: ilariamauric@tele2.it

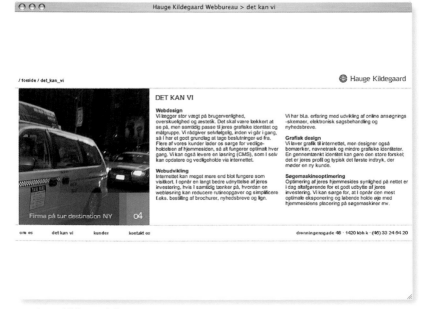

www.haugekildegaard.dk
D: andreas kildegaard petersen C: jon hauge hansen
A: hauge kildegaard | webdesign M: info@haugekildegaard.dk

01 unternehmen
02 referenzen
03 eigentümer
04 ...ster
05 kontakt
06 links

gehen sie auf die überholspur.

Gutes Marketing braucht Mut.

Ein Bild aus dem Motorsport erklärt den Effekt den wir
meinen: Die Ideallinie ist die Spur, auf der man einen Kurs
am schnellsten und sichersten umfahren kann.
Diese Ideallinie hat nur einen Nachteil.
Weil alle sie benutzen, kann man auf ihr nicht überholen.
Wer überholen will, muss auf die Kampflinie ausweichen,
die schmutziger und riskanter ist.
Aber die einzige Chance, nach vorne zu kommen.

city report
Marketing + Research

www.city-report.com
D: annett bob C: christian mörl P: globe media
A: city report M: fao@city-report.de

VOLKER BOEHM PORTFOLIO

VITA | SEIN / KÖNNEN / WISSEN geboren im januar 1979
PROJEKTE
KONTAKT aufgewachsen in dresden, gewohnt in rostock,

VBOEHM04 lebt, studiert und arbeitet in weimar und berlin

 ist nicht verheiratet aber in festen händen und damit sehr zufrieden,
 ist auch noch kein papa, möchte es aber irgendwann sein

 liest gern, reist gern, raucht zuviel, kocht gern und geht danach ins kino

www.boehmvolker.de
D: volker boehm
M: volker@boehmvolker.de

Portfolio || Sami Mikonheimo ||

Entrance For
Exhibition Area.

2004
Student competition entry.
Entrance for exhibition area. How
to use old concrete storages as
an entrance to house far.
Cooperation with Mia Salonen

Upper category

www.student.oulu.fi/~samikonh
D: sami mikonheimo
A: smi M: samikonh@paju.oulu.fi

barcelona.webpunt.nl
D: p.j.h.m. hendrikx
A: webpunt.nl M: p.hendrikx@webpunt.nl

jumahe.free.fr
D: julien mahe
M: jumahe@free.fr

bor-land.com/complicado/
D: joão mascarenhas
M: joao.mascarenhas@gmail.com

WARUM ZIEHEN
FRAUEN & MÄN
IHRE PULLOVER
UNTERSCHIEDLIC
AUS?

www.touchee.de
D: walter mössler
A: touchee M: info@touchee.de

www.starsandbananas.com
D: michael knufinke, anita cosic, stephan kottek
A: stars and bananas design M: knufinke@starsandbananas.com

www.arteinpittura.it
C: alfredo esposito P: ciro vecchiarini
A: koine M: info@studiokoine.it

Momenteel rollen 14 flappen van de pers voor de Kindercharter, een participatieproject.
De illustraties zijn van Lien Geeroms en voor de vormgeving stond ik in.

VERS V/D PERS

PORTFOLIO **AFFICHES**

MARLIES.be

visuele communicatie
typografie
vormgeving

Contact info@marlies.be 27/06/05 **Kindercharter 2006** ↓ Kies Categorie ↓

1 → I

JIP-AFFICHE
Baan-affiche voor Jongeren
Informatiepunt Gent.
Invalshoek: Steek je licht op in het
JIP.
2004

www.marlies.be
D: marlies nachtergaele **C:** dany heyndels
A: marlies - visuele communicatie **M:** info@danyheyndels.be

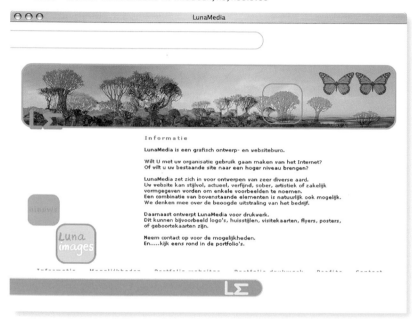

www.lunamedia.nl
D: cecile maenen
A: lunamedia **M:** info@lunamedia.nl

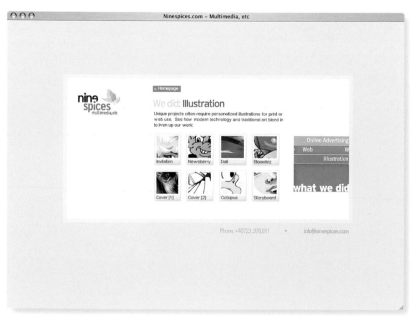

www.ninespices.com
D: mihai fanache
A: ninespices **M:** mihai@ninespices.com

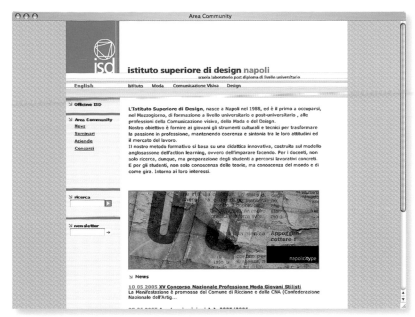

isdnapoli.it
D: francesco e. guida, valentina sacco, nicola scotto di carlo
A: studioguida M: feguida@studioguida.net

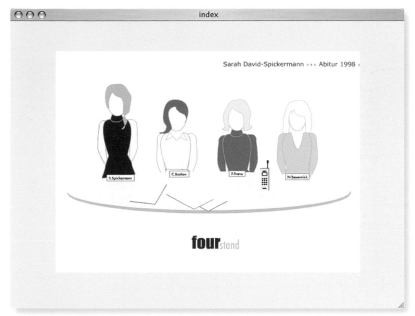

www.fourstand.de
D: sarah david-spickermann, friederike franz, nadine bewernick
M: sarah.david@gmx.de

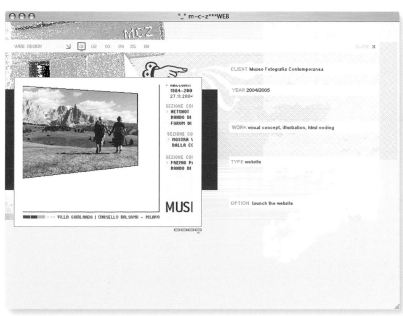

www.m-c-z.net
D: manuela consuelo zavattaro
A: manuela consuelo zavattaro M: manu@m-c-z.net

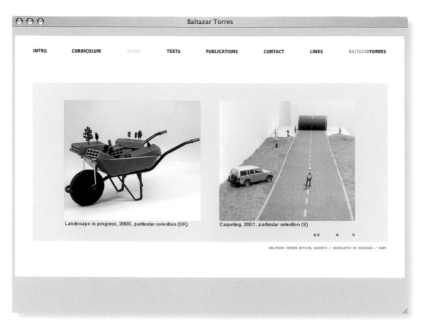

www.baltazartorres.com
D: nuno horta
A: baltazar torres M: baltazar.torres@mail.telepac.pt

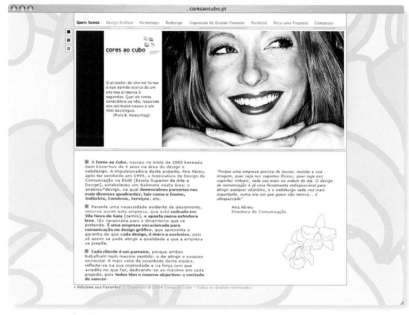

www.coresaocubo.pt
D: ana abreu
A: cores ao cubo M: helderdias@coresaocubo.pt

www.nora-bibel.de
D: guido wortmann
A: kl47 M: mail@kl47.de

■■■ britta welle
 photographie | multimediadesign ■■■

photographie	kreatives portrait	photographie
firmen unternehmensdarstellung **privat** hochzeitsphotographie ■ portraitphotographie im freien oder auf wunsch bei ihnen zu hause (auch bewerbungsphotos und passbilder) **freie arbeiten** verschiedenes modephotographie	 <<	

leistungen | kontakt | impressum | home

www.brittawelle.de
D: britta welle
A: britta welle photographie | multimediadesign M: info@brittawelle.de

www.soniacarvalho.com
D: nuno horta
A: sonia carvalho M: spcarvalho5@hotmail.com

www.photoshoptennis.co.uk
D: andy vinnicombe
M: andy.v@zen.co.uk

www.dral.net
D: alessio nunzi
M: drags_ammersot@dral.net

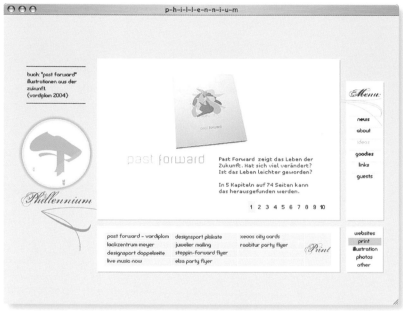

www.phillennium.com
D: philipp zurmöhle
A: phillennium M: mail@phillennium.com

www.s2art.de
D: christian baptist
M: webmaster@s2art.de

www.dicamusica.it
D: anna laura millacci C: anna laura millacci P: dicamusica srl
A: alami multimedia M: info@alamimultimedia.com

www.joppart.com
D: micha neroucheff
A: contient des eléments interactifs M: info@elementsinteractifs.com

www.envoy.to
D: thierry loa
A: hellohello M: htt://www.hellohello.bz

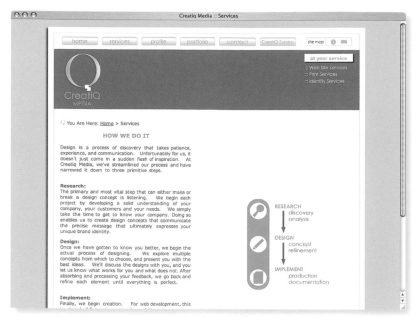

www.creatiqmedia.com
D: peter venero
A: creatiq media M: pvenero@creatiqmedia.com

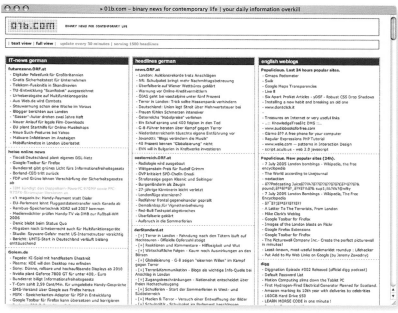

01b.com
D: thomas marban
A: werk3at M: thomas@marban.at

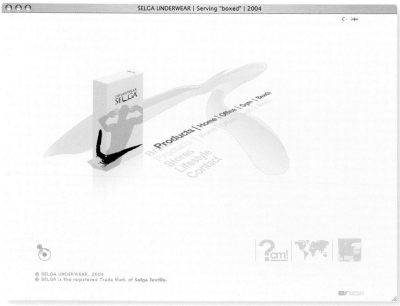

www.selgaunderwear.com
D: 2fresh
A: 2fresh M: contact@2fresh.com

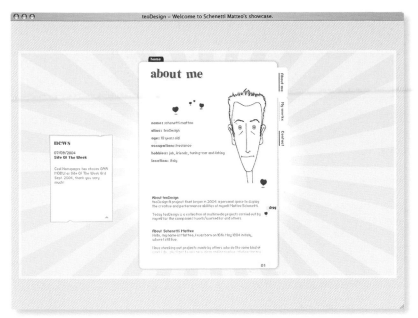

www.teodesign.com
D: schenetti matteo
M: info@teodesign.com

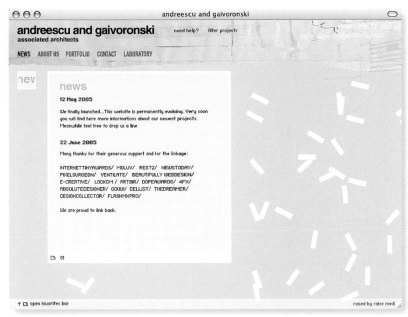

www.mistersaxman.com
D: regina tschöpe C: bernd kneib P: bernd kneib
A: ragbird M: mail@ragbird.com

www.klubismus.cz
D: mireque kodesh
A: klubismus M: kodesh@klubismus.cz

www.tamnev.com
D: boyan tamnev
M: boyan@tamnev.com

www.nicolasbovesse.com
C: nicolas & tom bovesse
A: nicolas bovesse M: mail@nicolasbovesse.com

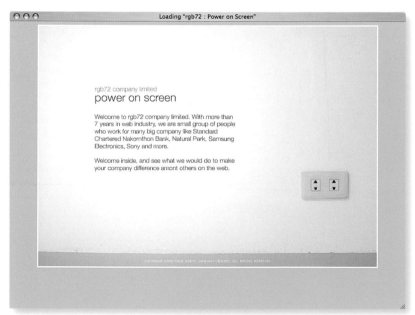

www.rgb72.com
D: sittipong sirimaskasem C: worrawut suksungworn
A: rgb72 M: sittipong@rgb72.com

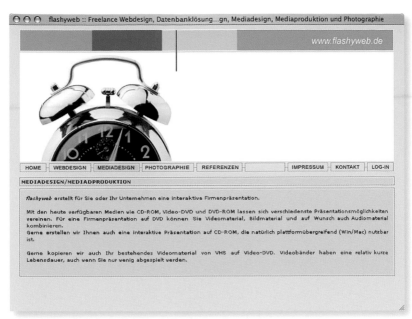

www.flashyweb.de
D: armin von hodenberg
A: flashyweb M: info@flashyweb.de

www.dinamicprocessing.com
D: diego vallarin
A: dinamic processing M: diego@dinamicprocessing.com

www.bubanj.com
D: ivana bubanj
A: ivana bubanj M: ivana@bubanj.com

93

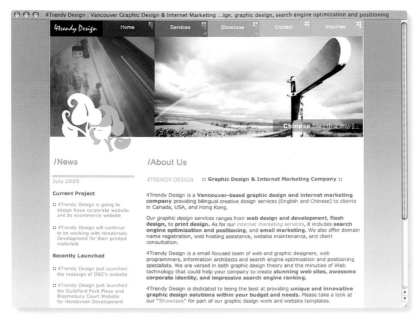

www.4trendy.com
D: elaine wong C: elaine wong, pauline lai, lisa yu
A: 4trendy design M: lisa@4trendy.com

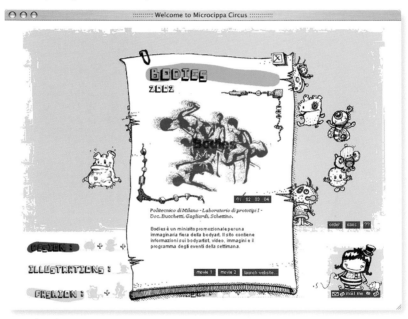

www.microcippa.com
D: joyce bonafini
A: cicciapalla corp. M: lemiecose@cicciapalla.com

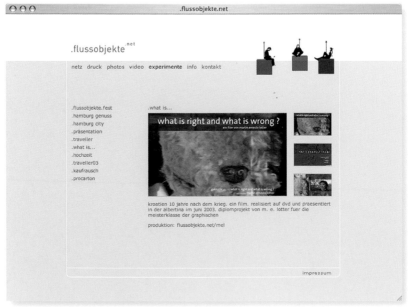

www.flussobjekte.net
D: catharina ballan C: vit kocourek P: .flussobjekte.net
A: .flussobjekte.net M: vit.kocourek@flussobjekte.net

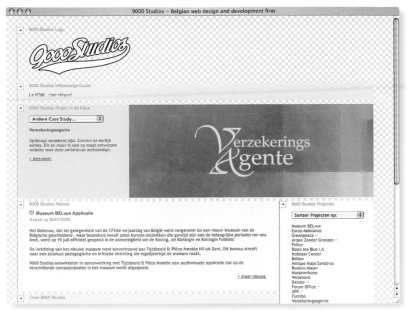

www.9000studios.com
D: 9000 studios
A: 9000 studios M: info@9000studios.com

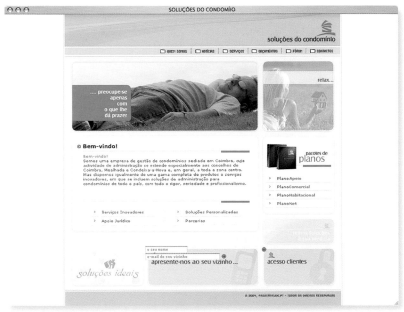

www.solucoesdocondominio.pt
D: filipecavaco, alexandre r. gomes C: alexandre r. gomes P: frontatitude
M: alex@gws.pt

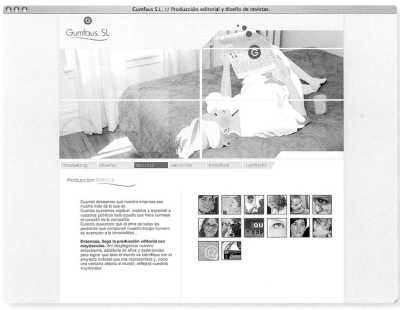

www.gumfaus.com
D: joan lafulla, albert font C: joan lafulla P: albert font
A: gumfaus s.l. M: info@gumfaus.com

Our mission is to be simple.
We're young, creative and inovative bunch of workaholics working across channels - web, motion, print, photography. We don't like to talk, we produce. If you need more details or if u interested in some kind of collaboration please do not hesitate to contact us on mail and we will give u offer that u can not refuse :)

www.rootylicious.com
D: rootylicious.inc
A: rootylicious.inc M: info@rootylicious.com

www.man-free.it
D: alessandro manfredi
A: man-free M: info@man-free.it

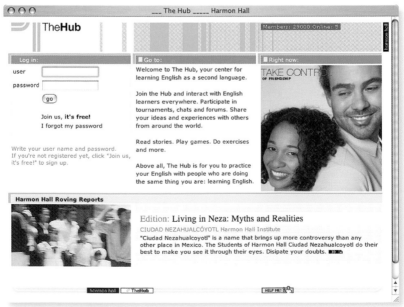

thehub.harmonhall.com
D: marcello conta C: richard stoutner
A: sparafucile\mashica M: marcello@spr-msh.com

VITAMIN 2 AG Werbung und Kommunikation - Dätenwilenstrasse 8a - Postfach 2290 - CH-9001 St. Gallen - Telefon +41 71 227 30 70 - Telefax +41 71 227 30 71

www.vitamin2.ch
D: sandro fischer
A: vitamin2 M: fischer@vitamin2.ch

Benvenuti nel sito di SDE – Studiodesign!

www.lostudiodesign.biz
D: filippo masi C: marco badi P: marco badi, filippo masi
A: webhouse project M: info@webhousepro.it

Palmerita Portafolio Dani Martí Creativo Interactivo

www.palmerita.com
D: dani martí
A: dani martí M: dani@mardelcoral.com

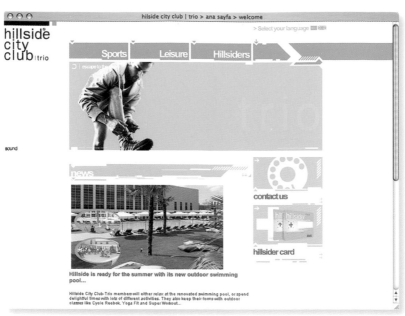

www.hillside.com.tr/HillsideCityClubTrio/
D: 2fresh C: 2fresh, developi
A: 2fresh M: contact@2fresh.com

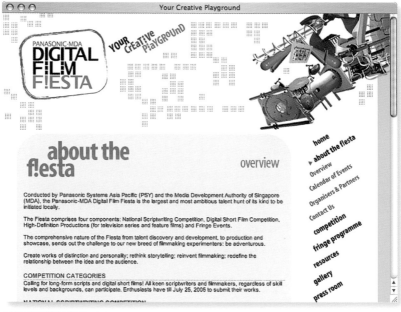

www.digitalfilmfiesta.com
D: joanne ang C: tracy bay P: joe chua
A: caffeine media M: joe@caffeine.com.sg

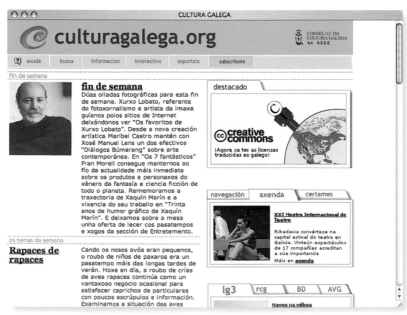

www.culturagalega.org
D: miguel alonso P: manuel gago
A: consello da cultura galega M: director@culturagalega.org

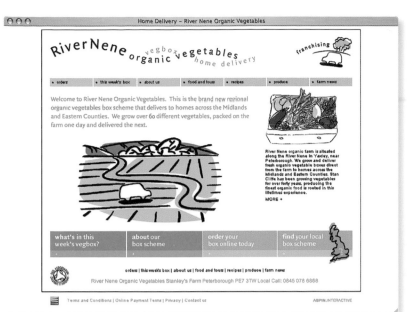

www.rivernene.co.uk
D: nathan kingstone C: david morley P: adam gorse
A: aspin interactive M: marcusp@aspin.co.uk

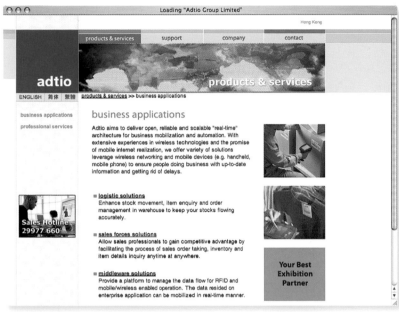

www.adtio.com
D: joseph chau
A: adtio group limited M: joseph.chau@adtio.com

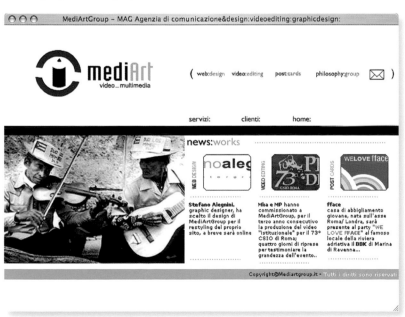

www.mediartgroup.it
D: luca de luca, piero borgia P: luca de luca, piero borgia, ernesto loiero
A: mediartgroup.it M: luca@mediartgroup.it

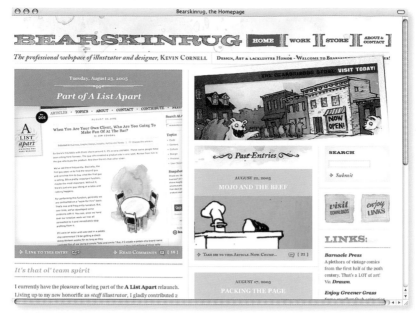

www.bearskinrug.co.uk
D: kevin cornell
A: bearskinrug.co.uk M: wdi@bearskinrug.co.uk

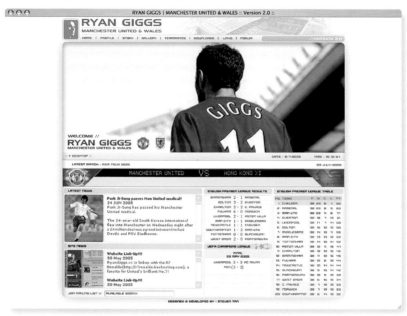

www.ryangiggs.cc/v2/
D: steven tan
M: webmaster@stevennet.cc

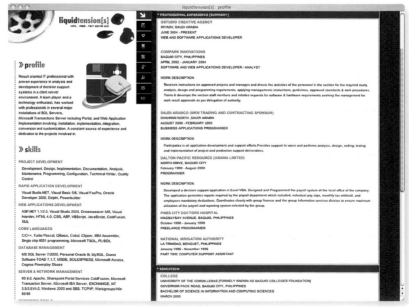

www.liquidtensions.com
D: francis oca
A: compark M: natalie_acoba@yahoo.com

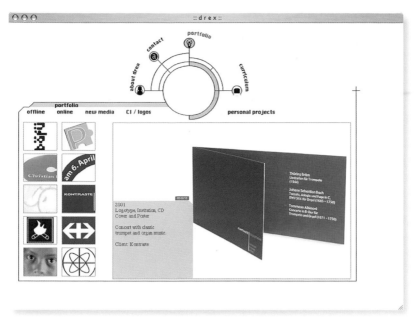

www.drex.ch
D: andrea cruz gonzalez
M: drex@iteso.mx

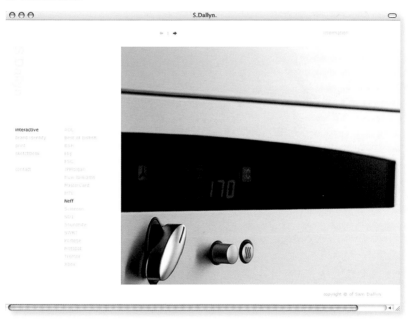

www.samdallyn.co.uk
D: sam dallyn C: brendan lynch P: sam dallyn
M: samdallyn@hotmail.com

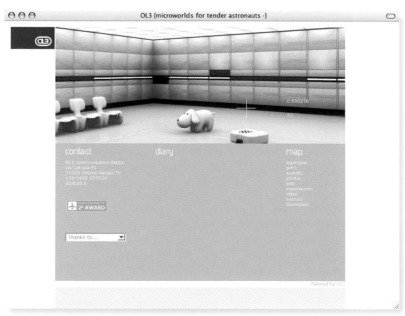

www.ol3.it
D: michele scarpulla, michela casagrande
A: ol3 communicative design M: ol3@ol3.it

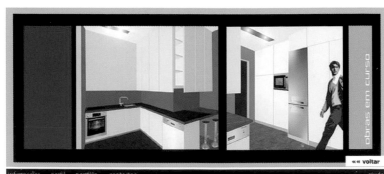

www.brunoparente.com
D: paulo afonso C: paulo afonso P: arquitecto bruno parente
A: semmais.com M: paulo.afonso@semmais.com

www.haselmayer.org
D: holisticdesign
A: holisticdesign M: info@holisticdesign.de

www.suburbstore.com
D: tayo abiodun C: guy kilty
A: 44media M: ty@44media.com

www.webwords.nl
C: nelleke de boer
A: webwords M: info@webwords.nl

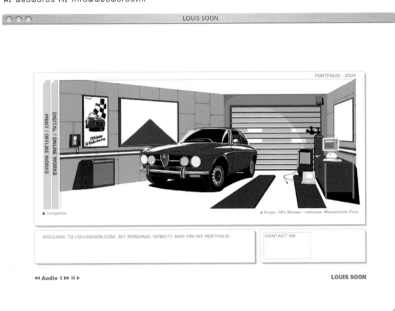

www.freewebs.com/mockngbrd
D: louis soon
M: louissoon@yahoo.com

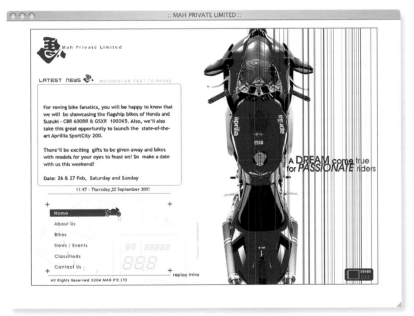

www.mah.com.sg
D: thomas ee
A: breworks design & communications M: thomas.ee@breworks.com

www.ragde.com
D: edgar ferdez
A: rgd M: info@ragde.net

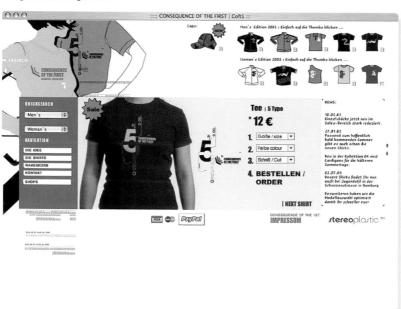

www.coft1.com
D: mike john otto
A: stereoplastic // urban influenced media // sp

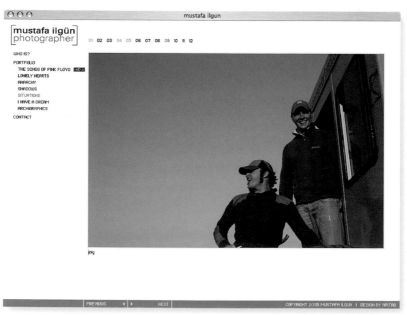

www.mustafailgun.com
D: ozhan binici
A: aritab M: www.aritab.com

104

www.ctrler.com
D: carolina alcalá C: borja g. haedler P: ctrler
A: el equipo e M: iaxonline@hotmail.com

www.mediafabrica.cz
D: lukas sudacki C: lukas sudacki, daniel dostalik P: lukas sudacki
A: mediafabrica M: sudacki@mediafabrica.cz

second_stage.baby-4-face.com
D: oberngruber jürgen
M: juergen.oberngruber@fh-hagenberg.at

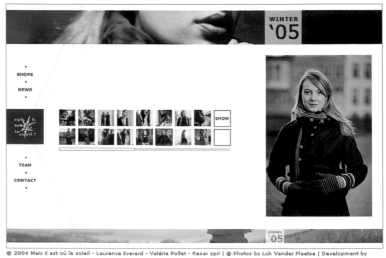

www.ousoleil.com
D: micha neroucheff
A: contient des éléments interactifs M: info@elementsinteractifs.com

www.quer-denker.com
D: antje weber, hanno denker P: querdenker
A: querdenker M: hanno@quer-denker.com

www.fraumaier.de
D: nico hensel C: nico hensel P: katrin maier
A: fraumaier M: service@fraumaier.de

www.hangar17.net
D: jonathan hobson
A: hangar17 new media M: info@hangar17.co.uk

www.mauriciogalasso.com.br
D: mauricio galasso
M: mauriciogalasso@terra.com.br

www.marcellogiordani.com
D: catherine herberstein C: kevin lahoda P: catherine herberstein
A: lenny's studio M: thegiordaniclub@cox.net

www.fernandocomet.com
D: fernando saez comet
A: fernandocomet M: fernandocomet@hotmail.com

www.visualestudio.net
D: maria lujan C: maria lujan, luis lujan P: maria lujan
A: v15u4l M: servicios@visualestudio.net

www.arioch.it
D: giulia barbieri C: alessio bottiroli P: alessio bottiroli
A: doc-tech M: a.bottiroli@doc-tech.com

www.atmosferas.net
D: ana carvalho C: rodolfo coelho P: sofia oliveira
A: atmosferas.net M: info@atmosferas.net

www.amonitorspento.org
D: mauro minnone
A: amonitorspento M: crew@amonitorspento.org

www.singermorning.com
D: maria fernandez
M: maria@singermorning.com

www.sendos.net
D: sendos
A: sendos M: info@sendos.net

www.telemoveis.com
D: marta fernandez C: helder ribeiro P: vítor magalhães
A: webware M: marta@infopulse.pt

www.loworks.org
D: haruki higashi
A: loworks M: low@loworks.org

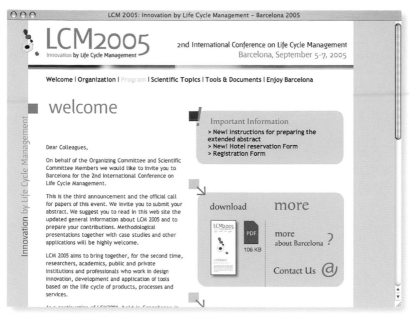

www.lcm2005.org
D: maría ripoll cera
A: sinapsis conocimiento y comunicación M: info@sinapsis.es

www.integendeel.nl
D: caspar claasen
A: integendeel M: cmclaasen@hotmail.com

www.keasone.de
D: alexander hahn
A: keasone.de M: info@keasone.de

www.gaukler-studios.de
D: oliver storm
A: seven.eleven.media M: www.711media.de

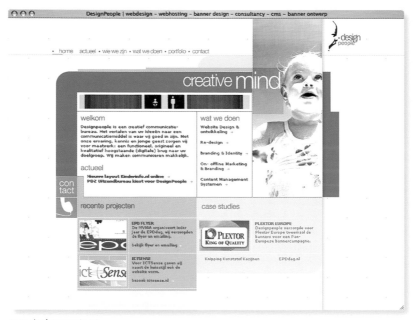

www.designpeople.nl
D: wietse vonk
A: designpeople M: wietse@designpeople.nl

www.stevennet.cc
D: steven tan
M: webmaster@stevennet.cc

www.morelesslab.com
D: marco zingoni, attilio guerreschi C: marco zingoni
A: morelesslab M: marco@morelesslab.com

www.chemical-design.com
D: stephen smith
A: chemical-design M: ssmith@chemical-design.com

www.journel-frasher.de
D: christian klein
A: ceka mediadesign M: www.ceka-media.net

www.accionchile.cl
D: javier bonifaz C: yuri dekovic P: javier bonifaz
A: acción M: yurideko@hotmail.com

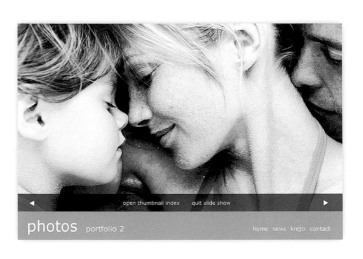

www.uwekrejci.com
D: jan persiel C: matthias mach P: matthias mach
A: persiel design M: post@schoengeist.de

espacio.menos1.com
D: mario gutiérrez cru C: maite camacho pérez
A: ma+ (arte.diseño) M: info@estudiomamas.com

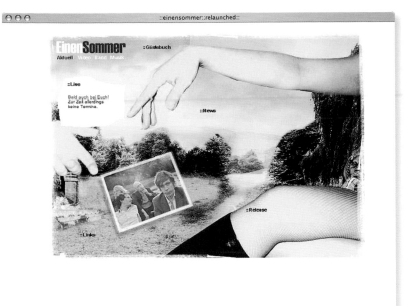

www.einensommer.de
D: tim fischer
A: tim fischer design M: info@timtalent.de

www.stylism.nl
D: djordi luymes C: björn ophof P: djordi luymes
A: stylism M: info@stylism.nl

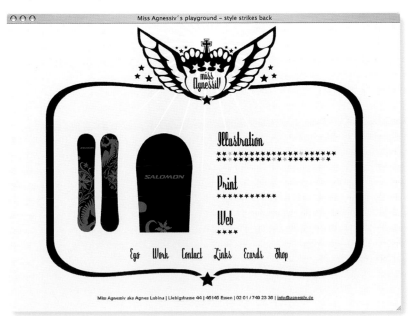

www.agnessiv.de
D: agnes lubina
M: info@agnessiv.de

www.web-tics.de
D: sigrid graeve
A: web-tics M: info@web-tics.de

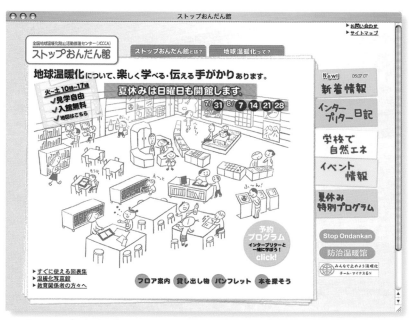

www.jccca.org/ondankan/
D: yumi ito
M: icyo@js6.so-net.ne.jp

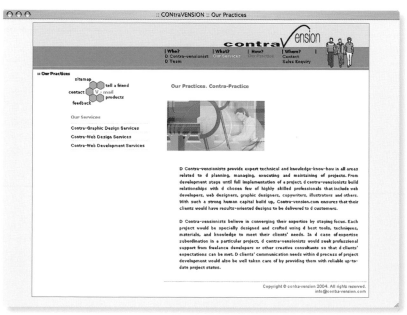

www.contra-vension.com
D: osiris C: conan P: osiris
A: contra-vension M: osiris@contra-vension.com

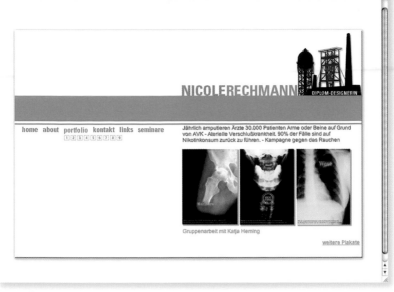

www.rechmann.net
D: nicole rechmann C: nicole rechmann/ patrick cramer
A: rechmann.net M: info@rechmann.net

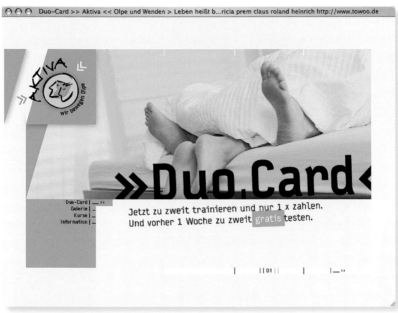

www.aktiva-olpe.de
D: patricia prem, claus roland heinrich
A: towoo werbeagentur heinrichplusprem M: hallo@towoo.de

www.colorblind.be
D: hans spooren
M: hans@colorblind.be

minimundos.tk
D: tania navas
M: lady_oruba@hotmail.com

www.egocrew.com/12huevosfritos
D: jorge negrotti
M: bielo@egocrew.com

www.meltingpop.it
D: angelo semeraro P: kidd2
A: hellobeebee \ emotionaldesign M: tenshi@hellobeebee.com

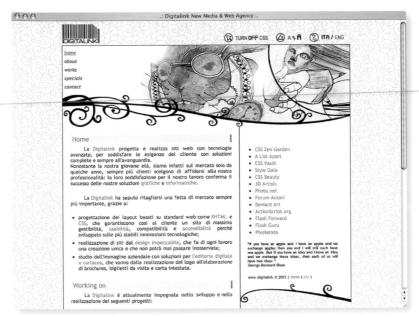

www.digitalink.it
D: antonio cella, daniela gelsomino C: gianluigi ricciardi P: digitalink
A: digitalink M: www.digitalink.it

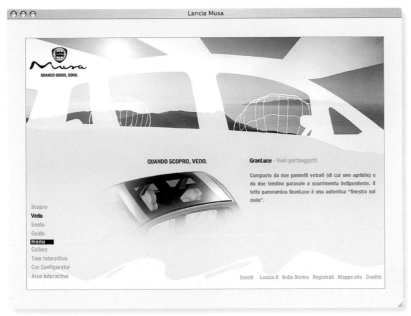

www.lanciamusa.it
D: clementina peracino, davide cortese, luca perli
A: testawebedv M: pietro.bonada@testawebedv.it

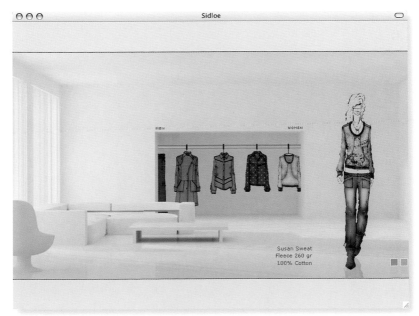

www.sidloe.com
D: amal auckloo, lionel de bollardière C: amal auckloo P: sidloe

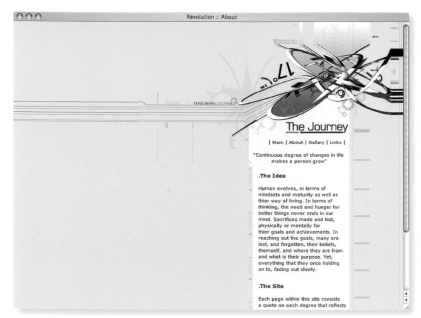

www.oneduasan.com/revo
D: mervin ng man meng
A: oneduasan M: air_bug@musicxpress.zzn.com

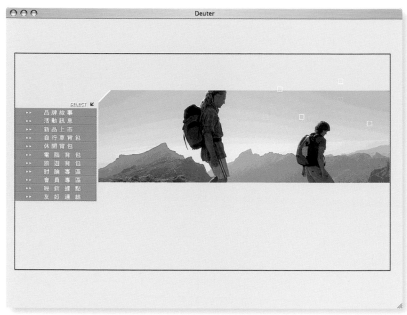

www.atunas.com.tw/deuter
D: hao C: bunboy P: tonic
A: lesson multimedia technology co.,ltd M: tonic@lesson.com.tw

www.anilyanik.com
D: anil yanik
M: info@anilyanik.com

360degreez.net
D: 360°
A: 360° **M:** marek@360degreez.net

www.dododesign.se
D: dejan
A: dododesign **M:** dejan.mauzer@berghs.se

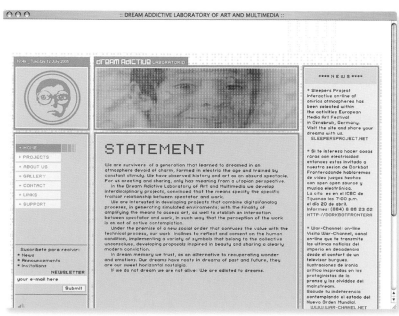

www.dreamaddictive.com
D: carmen gonzalez
A: dream addictive **M:** lesli@dreamaddictive.com

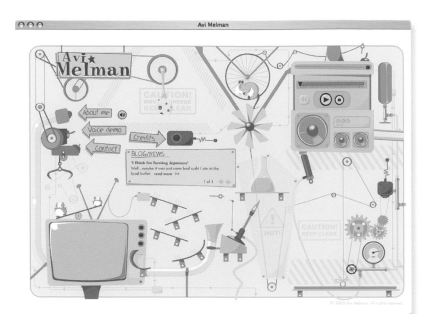

www.avimelman.com
D: sebastian gronemeyer
A: independent.blue M: sebastian@independentblue.com

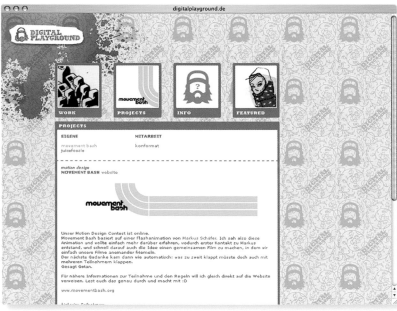

www.digitalplayground.de
D: michael fuchs
M: me@digitalplayground.de

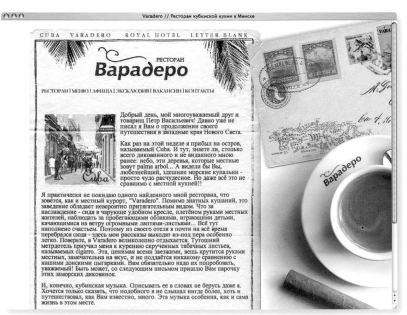

www.varadero.by
D: activemedia
A: activemedia M: denis@active.by

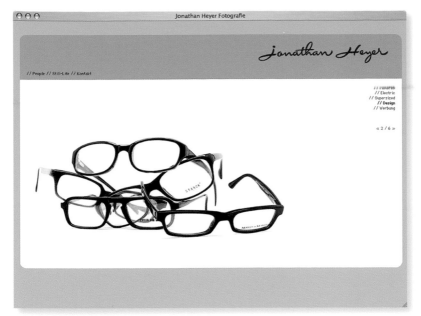

www.jonathanheyer.ch
D: marc rinderknecht
A: kobebeef M: mr@kobebeef.ch

www.serrote.com
D: susana vilela, nuno neves C: susana vilela
A: serrote M: nuno-neves@lycos.com

www.eliace.net
D: anton bensdorp, johannes hogebrink C: michel smitshuizen
A: ultrafris M: anton@ultrafris.nl

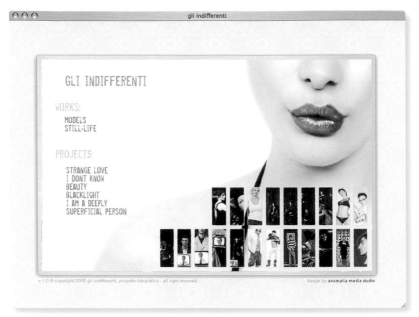

www.gliindifferenti.com
D: marco rocca C: giovanni ghirardi P: simone nervi
A: anomalia media studio M: info@anomalia.cc

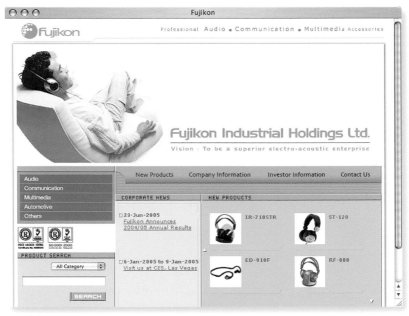

www.fujikon.com
D: sam lau C: henry kwan P: davy ma
A: media explorer ltd. M: sam@me.com.hk

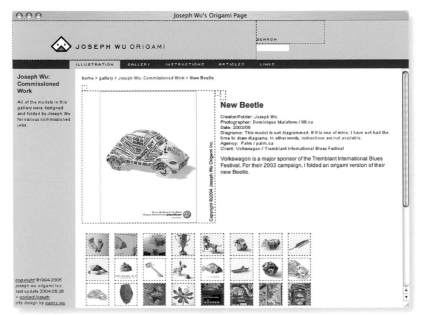

www.origami.as
D: nancy wu P: joseph wu
A: myrdesign.nl M: info@myrdesign.nl

www.aixede.ch
D: manuela burkart C: alexandra zvekan P: aixede
A: aixede gmbh M: contact@aixede.ch

www.warrenheise.com
D: warren heise
A: warren heise illustration M: info@warrenheise.com

www.logita.hr
D: pavic lovorka
A: logita M: lovorka@logita.hr

www.derekscholte.nl
D: derekscholte.nl
A: derekscholte.nl **M:** info@derekscholte.nl

www.naive.it
D: marco fresta, marco quintavalle **C:** marco fresta **P:** marco fresta
A: phorma studio design **M:** info@phormastudio.com

www.pingusdesign.com
D: kike rodriguez lopez
A: pingusdesign **M:** info@pingusdesign.com

www.abinitio.be
D: christophe carbonnery
M: studio@arcolan.com

www.christiandannunzio.com
D: christián d'annunzio
A: d'annunzio M: info@christiandannunzio.com

www.brainsworks.com
D: guglielmo paradisi
M: kintaro.gug@tiscali.it

www.talvai.com
D: josé cardoso C: miguel carvalho P: comunick
A: comunick M: support@comunick.com

www.touch.net.hk
D: sharon chan C: kenneth ho P: dion sze
A: eureka digital ltd M: kelly@eureka-digital.com

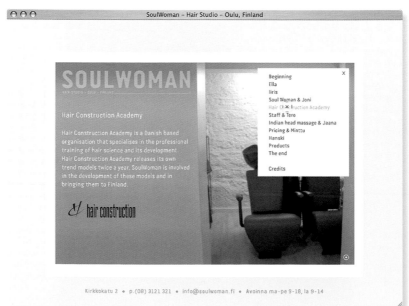

www.soulwoman.fi
D: tuomas mujunen C: juha suni
A: ilmiantajat M: juha.suni@ilmiantajat.fi

www.ezoon.de
D: seidel, mirko
A: .ezoon.de M: seidel@ezoon.de

www.stampedesolution.com
D: yumeko
A: stampedesolution sdn bhd M: yumeko529@gmail.com

www.teba.de
D: katrin brackmann C: kontrollfeld
A: oz M: ka@oz-zone.de

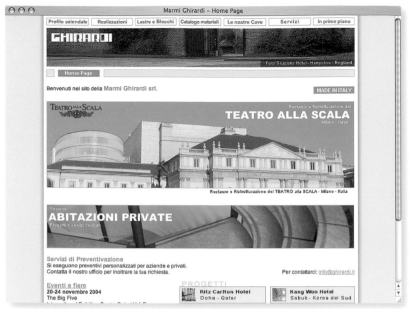

www.ghirardi.it
D: giovanni ghirardi C: marco rocca
A: marmi ghirardi srl M: info@anomalia.cc

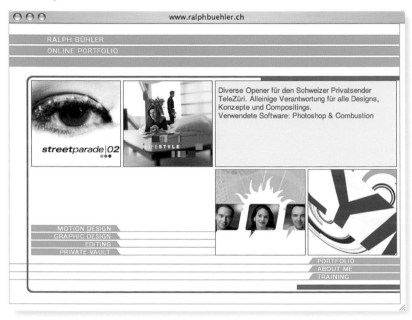

www.ralphbuehler.ch
D: ralph bühler
M: info@ralphbuehler.ch

www.mobshot.de
D: ali rastagar C: hannes hoess
M: hallo@rastagar.de

www.woquini.it
D: lorenza zanni
A: lorenza zanni M: doppiazeta@libero.it

www.salon91.com
D: stefan schröter, joscha rüdel P: salon91 media network
A: salon91 media network M: kontakt@salon91.com

www.berger-bau.de
D: florian aichhorn C: daniel pieper P: kuse.de
A: kuse.de M: flo@kuse.de

www.ab19.it
D: mariano cigliano C: alfredo de vitu
A: netvolution srl M: francescaconte@ab19.it

www.mambo-moebel.de
D: pablo páez
A: medienpark M: paez@medienpark.net

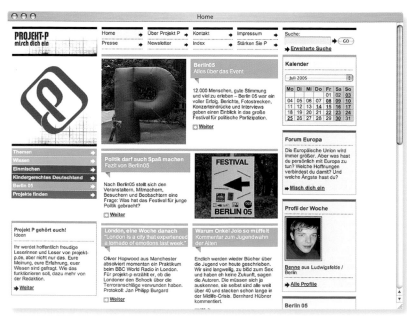

www.projekt-p.de
D: silke krieg P: eva eschenbruch
A: frog unstable media M: www.frog .de

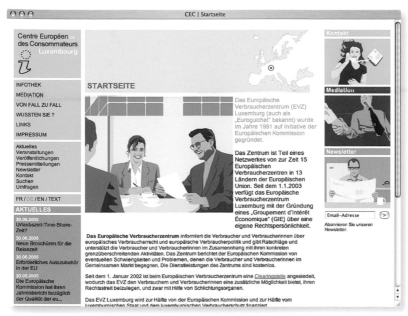

www.euroguichet.lu
D: laurent daubach C: viktor dick P: centre européen des consommateurs
A: bizart M: laurentdaubach@bizart.lu

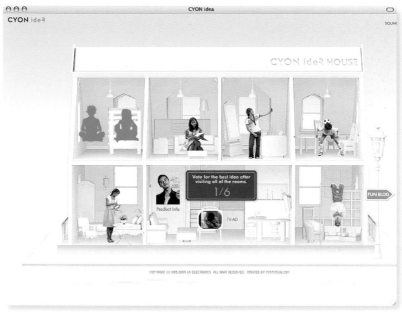

www.cyon.co.kr/good/popup/cyonidea/en/index.jsp
D: euna seol, hyunbok jung, jakyung koo, yonghyun kim, yoonhong kim
A: postvisual.com M: info@postvisual.com

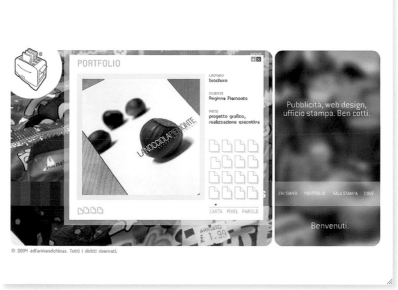

www.adfarm.it
C: conversa
A: adfarmandchicas srl M: daniele.amedeo@adfarm.it

133

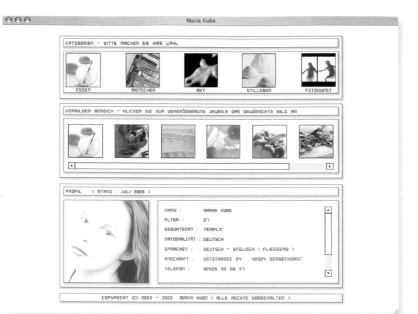

www.mariakube.de
D: richard summers
M: info@mariakube.de

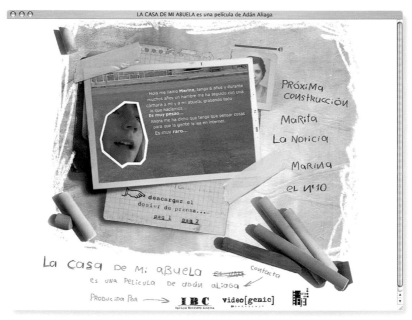

www.lacasademiabuela.info
D: miguel esteve, leire ferreiro
A: kamestudio M: info@kamestudio.com

coffee.creation.com.tw
P: fone
A: presco M: wingerliao@pchome.com.tw

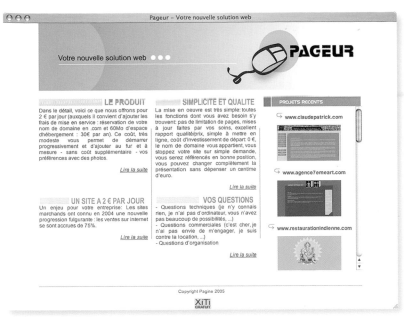

www.pageur.com
D: florence lissarrague C: jean-camille martin P: francois ducrocq
A: pagine M: flissarrague@pagine.fr

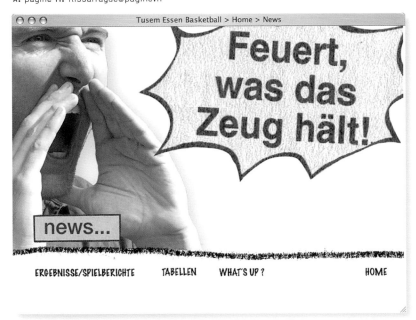

www.tusem-basketball.de/_html/home.html
D: uli voßen
M: uli@tusem-basketball.de

www.jka-karate-bremen.de
D: melanie stöter, dennis albrecht C: melanie stöter P: dennis albrecht
A: jka karate bund bremen e.v. M: webmaster@jka-karate-bremen.de

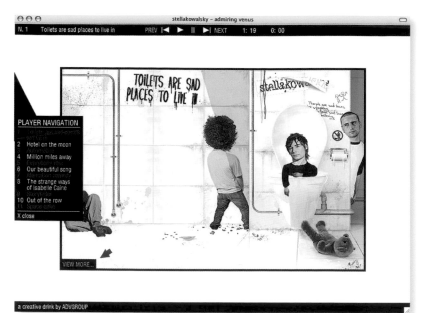

www.stellakowalsky.com
D: fabio de gregorio, romina mallina C: fabio de gregorio P: advgroup
A: advgroup M: fabio.degregorio@advgroup.it

lafabbricainterattiva.com
D: la fabbrica interattiva
A: la fabbrica interattiva M: info@lafabbricainterattiva.com

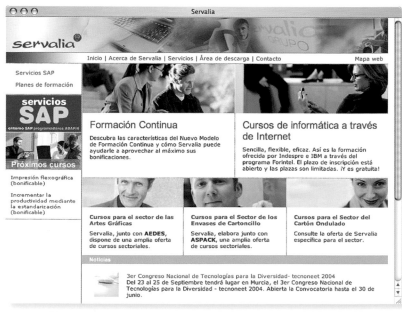

www.servalia.com
D: daniel sánchez casado C: daniel sánchez casado P: tomi osuna
M: elproceso@eresmas.com

136

www.crossmind.net
D: kirill brusilovsky C: johann spari P: kirill brusilovsky
A: crossmind communications M: kirill@crossmind.net

www.createl.ru
C: zakirov lenar
A: createl-media M: info@createl.ru

www.shop33.com
D: takayuki sugihara C: hiroshi yokoi P: yuki ohta
A: raf M: hy@raf-dl.com

137

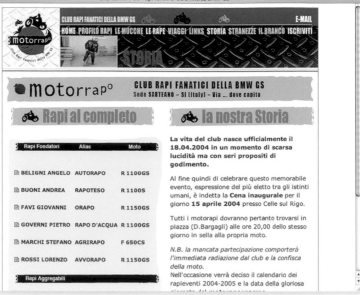

www.bmwmotorrapo.it
D: gian pietro dringoli C: alterego P: motorrapo
A: motorrapo M: postmaster@bmwmotorrapo.it

www.zubvector.com
D: zubvector studio
A: zubvector studio M: pan@zubvector.com

www.eidoscinema.it
D: alessandro strinati
A: telematica italia srl M: a.strinati@tiscali.it

www.oppositeofcorporate.com
D: kristopher brown
A: doubleoc uncorporated (in-house) M: contact@doubleoc.com

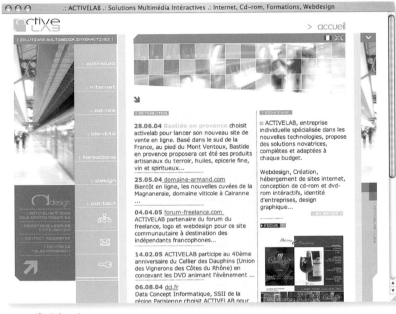

www.activelab.net
D: segura stephane
A: activelab M: stephane@activelab.net

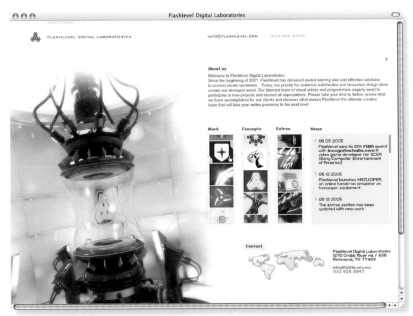

www.flashlevel.com
D: dashiell ponce de leon C: luis orozco P: dashiell ponce de leon
A: flashlevel digital labs. M: info@flashlevel.com

www.4dhome.de
D: stefan binning C: tobias ruhland P: stefan binning, tobias ruhland
A: 4d - architektur & mediendesign M: info@4dhome.de

www.machado.web.pt
D: pedro machado C: rui gonzalves, pedro xixa P: pedro machado
M: pedro.machado@gotadagua.com

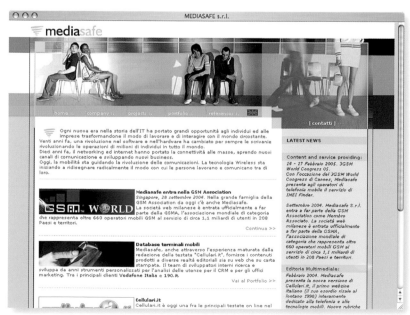

www.mediasafe.it
D: dr. ghita pasquali C: paolo bassini P: dr. nicola bellotti
A: blacklemon M: g.pasquali@blacklemon.com

www.agroplan.co.cr
D: ricardo arce
A: agroplan s.a. de costa rica M: info@ricardoarce.com

www.shiseido.com.tw
D: tim C: amo P: ting
A: envy new media M: ting@envynewmedia.com

www.oreally.tk
D: jelmer de boer C: thomas kos P: thomas kos
A: oreally581 M: jelmerdeboer@home.nl

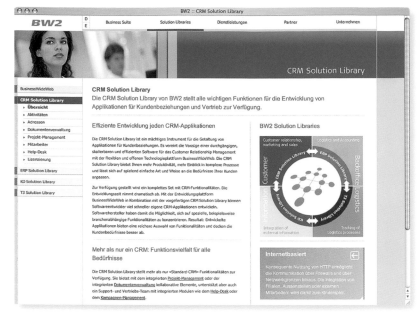

www.businesswideweb.com
D: nicolas jene
M: nicolas.jene@businesswideweb.com

www.reina.com.my/webdesign/msc/
D: lin lay geng C: shawn lin P: lin lay geng
A: reina design M: laygeng@reina.com.my

benoitlamouche.free.fr
D: benoit lamouche
A: krepusculdesign M: kabkinfr@yahoo.fr

142

www.digitaleasy.de
D: uwe bareuter
A: digitaleasy.de M: mail@digitaleasy.de

www.icti.es
D: icti consulting C: jose antonio guerra P: jose antonio guerra
A: icti consulting M: jaguerra@icti.es

www.q-too.com
D: stephen england C: marc rinderknecht P: marc rinderknecht
M: www.kobebeef.ch

www.digital-worlds.com
D: johan arensman
A: digital-worlds.com **M:** johanmail@gmail.com

www.blindzero.net
D: juliana pinto da costa
A: julianapintodacosta.com **M:** juliana@julianapintodacosta.com

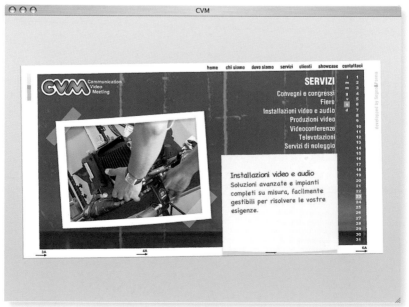

www.cvm-mi.it
D: daniele lodi rizzini **C:** daniele giusti **P:** daniele lodi rizzini
A: segno&forma **M:** daniele@segnoeforma.it

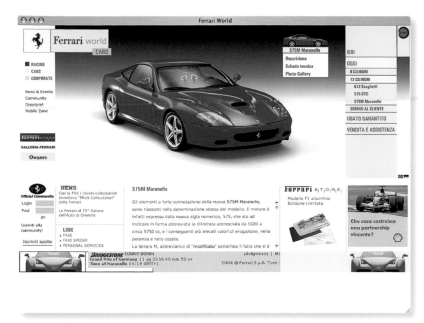

www.ferrariworld.com
D: raffaella di gesù, luca perli, riccardo sofia C: paolo nicoletti
A: testawebedv M: pietro.bonada@testawebedv.it

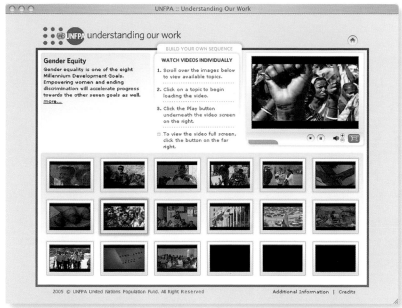

www.unfpa.org/mt
D: allysson lucca C: giuseppe sorce P: alvaro serrano
A: luccaco. M: info@luccaco.com

www.ndesign-studio.com
D: nick
A: n. design studio M: nickcreative@gmail.com

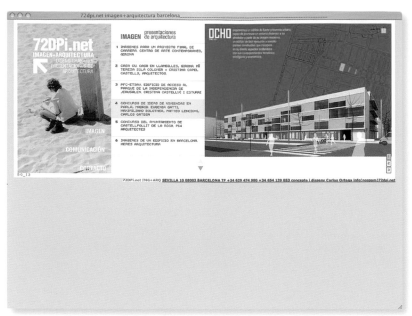

72dpi.net
D: carlos ortega
A: 72dpi.net M: webmaster@72dpi.net

www.sahnizoc.pt
D: multiweb ti lda
A: multiweb ti lda M: lmartins@multiweb.pt

www.nasenhaar.de
D: dirk heinemann C: inhouse P: inhouse
A: nordisch.com M: heinemann@nordisch.com

www.aguycalledbilly.com
C: a guy called billy / c2k
A: a guy called billy M: info@aguycalledbilly.com

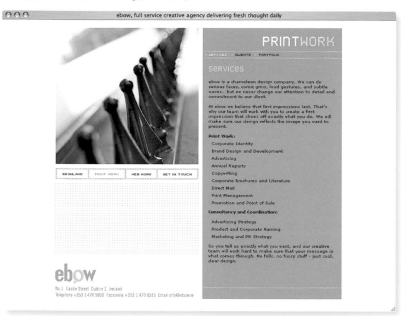

www.ebow.ie
D: karen hanratty C: david douglas
A: ebow M: karen@ebow.ie

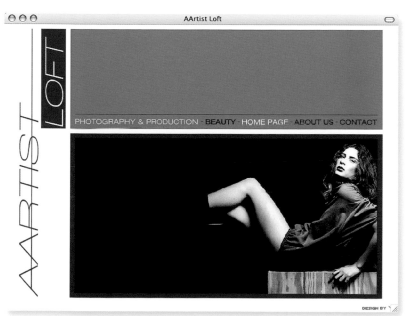

www.aartistloft.com
D: ali tan ucer
A: visualxchange M: www.visualxchange.com

www.mistyisland.tv
D: dawid marcinkowski
M: dawid.marcinkowski@wp.pl

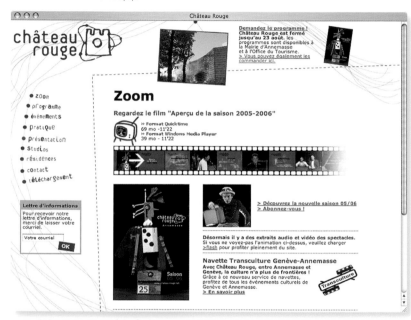

www.chateau-rouge.net/site/index.php
D: chris gaillard
A: chris gaillard M: chris@chrisgaillard.com

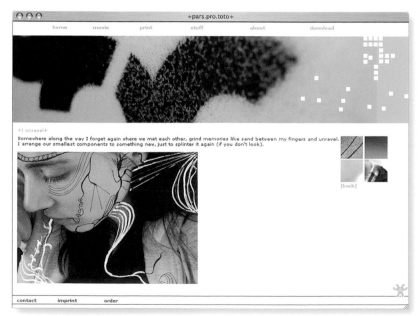

www.pars-prototo.de
D: sarah kramme
M: sarah@pars-prototo.de

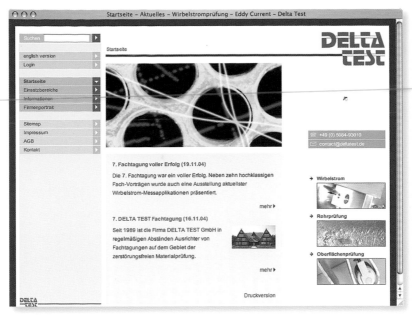

www.deltatest.de
C: ralf germershausen, wolfgang becker, jens reichelt
A: macina M: pd@macina.com

www.fettundrosig.com
D: alexander braun
A: fettundrosig M: design@alexbraun.de

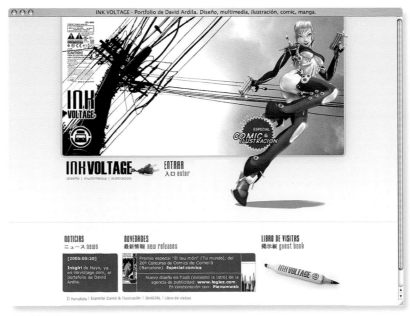

www.inkvoltage.com
D: david ardila
M: ink@inkvoltage.com

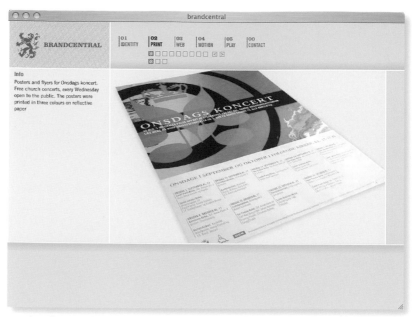

www.brandcentral.dk
D: gerard whelan C: martin beuschau P: gerard whelan
A: brandcentral M: whelan@brandcentral.dk

www.mondoalfa.ch
D: meik szelies C: jörn peter rieber
A: smoox gmbh (www.smoox.com) M: szelies@smoox.com

www.leupartner.ch
D: michel seeliger
A: chameleon graphics gmbh M: info@chameleongraphics.ch

www.stadiohotel.it
D: daniele lodi rizzini C: daniele giusti P: daniele lodi rizzini
A: segno&forma M: daniele@segnoeforma.it

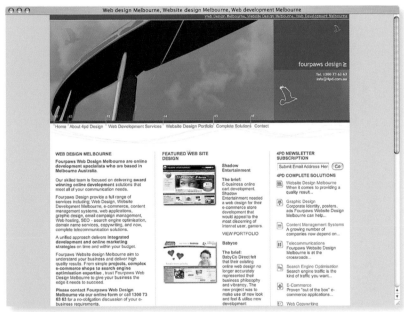

www.4pd.com.au
D: sam pascua C: michael tuni P: michael dockery
A: 4pd M: samp@4pd.com.au

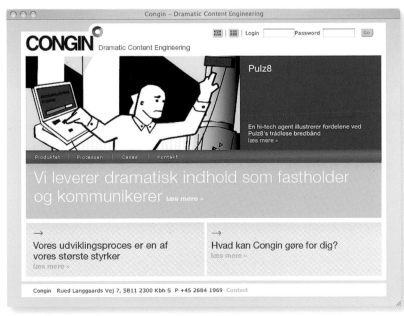

www.congin.com
D: gerard whelan
A: brandcentral M: whelan@brandcentral.dk

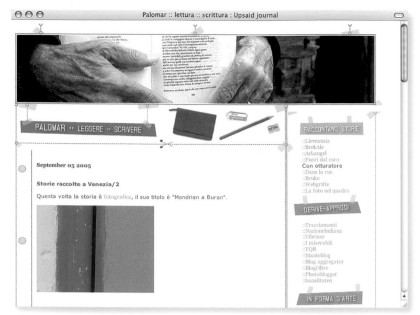

www.upsaid.com/palomar
D: alberto bogo
A: clic M: alberto.bogo@libero.it

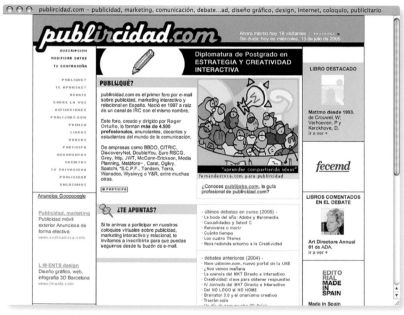

www.publircidad.com
D: roger ortuño flamerich
A: citric M: info@citricagency.com

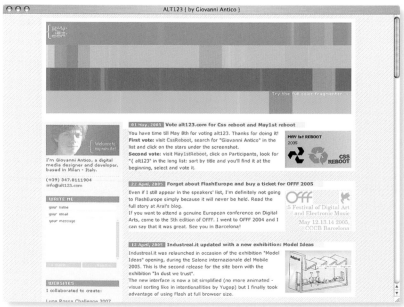

www.alt123.com
D: giovanni antico
M: info@alt123.com

www.ada-project.com
D: gianluca vatore P: giorgio lippolis
A: m-dd multimedia digitaldesign s.r.l. M: info@m-dd.net

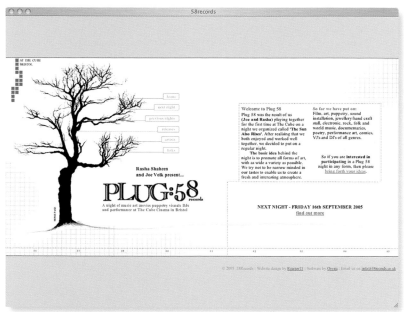

www.58records.co.uk
D: michael saunders
A: reactor15 M: mike@reactor15.com

www.jakefitter.co.nz
D: jake fitter
A: jake fitter M: jake@jakefitter.co.nz

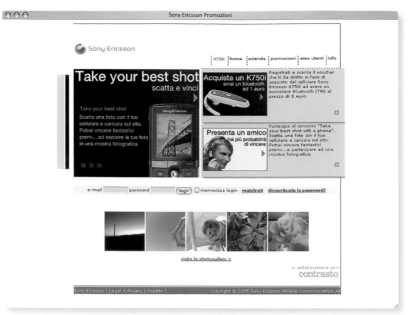

www.sonyericsson.com/k750promo
D: jiolahy C: francesco pastore P: jiolahy
A: jiolahy M: www.jiolahy.it

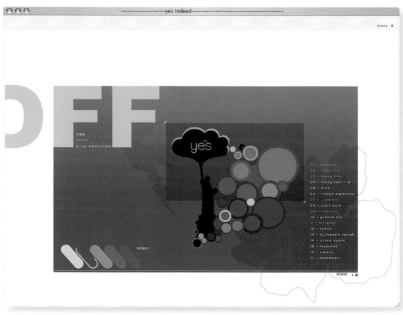

www.yes-indeed.net
D: moi même
A: yes indeed M: donna@yes-indeed.net

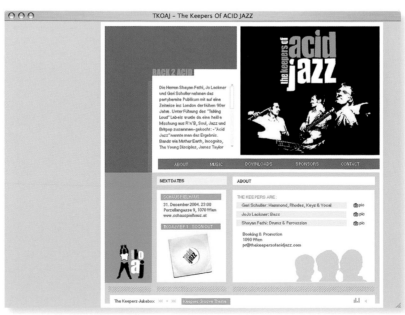

www.thekeepersofacidjazz.com
D: dietmar halbauer
A: moore stephens austria - embers consulting gmbh M: dietmar.

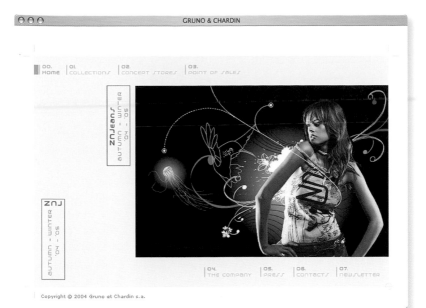

www.znj.com
D: sophie hollebecq
A: contient des eléments interactifs M: info@elementsinteractifs.com

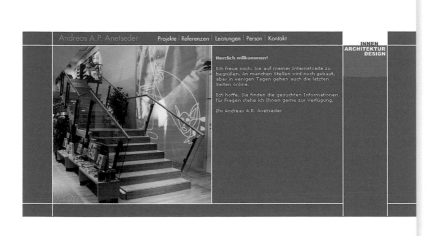

www.anetseder.com
D: reihel
A: reihel M: www.anetseder.com

www.declient.com
D: pieter lesage C: raoul jacobs
P: raoul jacobs

155

www.housemeister.info
D: daniel wetzel C: florian bemm
M: gutentag@gestaltreich.com

www.dr3.de
D: mediamonks
A: mediamonks M: manuel@unshift.de

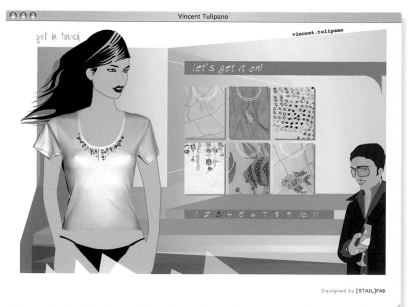

www.vincent-tulipano.it
D: francesca aielli C: pablo gallo
A: stailfab srl M: francesca@stailfab.it

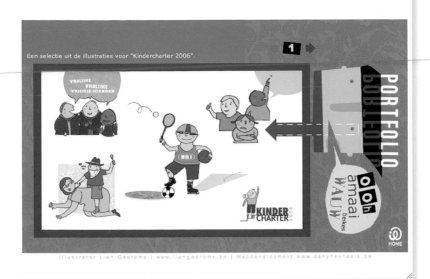

www.liengeeroms.be
D: lien geeroms C: dany heyndels
M: info@danyheyndels.be

www.loopscollective.com
D: andre lai
A: ikhlas inovasi M: andrelai@ikhlas-inovasi.com

www.Zaplayin.Com
D: y. yilmaz C: s. orhan P: r. tiyano, m. kalaora
A: magiclick digital solutions M: info@magiclick.com

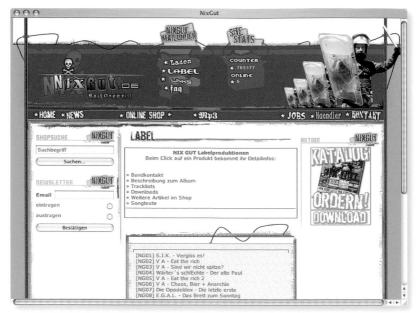

www.nix-gut.com/website/
D: patrick weber C: michael frey P: nixgut Mailorder
A: riotweb M: pxl@wowe.ch

www.blankprojectdesign.com
D: blank project design
A: blank project design M: sophia@blankprojectdesign.com

www.rogermacdsgn.com
D: rogerio macieira
A: rogermac design M: roger@tenshy.com

www.mojostudios.com
D: todd eaton
A: mojo studios M: info@mojostudios.com

www.alonsobalaguer.com
D: ferran pruneda, edgar seoane C: edgar seoane, ferran pruneda
A: grapa disseny M: ferran@grapa.ws

www.scribbly.nl
D: sjoerd eikenaar C: joost gielen P: freshheads
A: freshheads M: joost@freshheads.com

www.multiform-holte.dk
D: martin leblanc bakmar
A: biocandy M: mlb@opensystems.dk

www.kopfgold.de
D: thorsten singhofen
A: kopfgold M: thorsten@kopfgold.de

www.lancia.be
D: cedric danaux C: gilles deketelaere P: jean philippe mommaert
A: digital age design M: audry@dad.be

www.andreabianchi.net
D: andrea bianchi
A: and art&design M: info@andreabianchi.net

www.selfstock.com/book/
D: yannick scordia
A: yannick scordia M: yan@selfstock.com

yourthink™ team work
www.yourthink.com
Designed by zmz 2001-2005
Yourthink team 2001-2005 All Right Reserved©
073873

沪ICP备05025754号

www.yourthink.com
D: minzheng, zhu
A: e2 design M: zmzart@msn.com

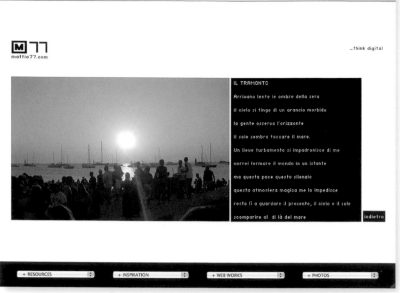

www.mattia77.com
D: mattia dell'era
M: mattia8@email.it

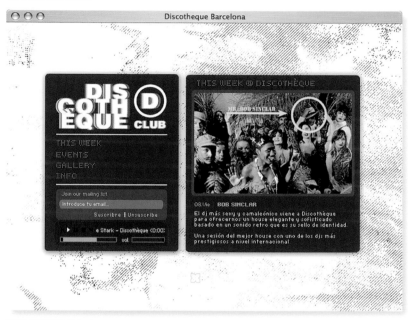

www.discotheque.ws
D: xavi royo C: xavi royo P: helice management
A: xafdesign M: xavi@xafdesign.com

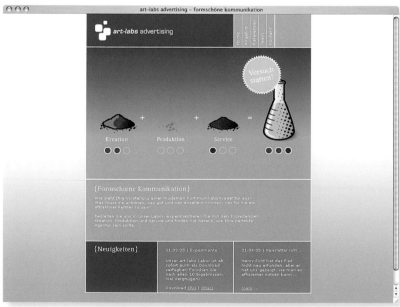

www.art-labs.at
D: patrick bauer C: jürgen vanicek P: jürgen vanicek
A: art-labs advertising gmbh M: jv@art-labs.at

162

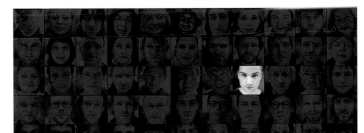

THE THOUGHT PROJECT
LIFE-SNAPS BY SIMON HØGSBERG

adopt design

ABOUT THE PROJECT
CONTACT

PRIVATE & PUBLIC

www.simonhoegsberg.com
D: rune hoegsberg, simon hoegsberg C: rune hoegsberg
A: adopt design M: rune@adoptdesign.com

Le Rouge et le Noir : Livre de joueurs

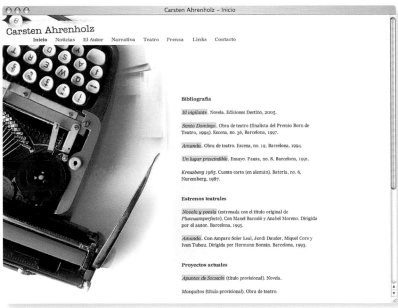

LE ROUGE ET LE NOIR livre de joueurs

www.lerougeetlenoir.fr
D: philippe guillot C: bruno frémy P: laetitia ballet
A: 31mille M: guillot@31mille.net

Carsten Ahrenholz – Inicio

Carsten Ahrenholz

Inicio Noticias El Autor Narrativa Teatro Prensa Links Contacto

Bibliografia

El vigilante. Novela. Ediciones Destino, 2005.

Santo Domingo. Obra de teatro (finalista del Premio Born de
Teatro, 1994). Escena, no. 36, Barcelona, 1997.

Amanda. Obra de teatro. Escena, no. 12, Barcelona, 1994.

Un lugar prescindible. Ensayo. Pausa, no. 8, Barcelona, 1991.

Kreuzberg 1985. Cuento corto (en alemán). Batería, no. 6,
Nuremberg, 1987.

Estrenos teatrales

Novela y poesía (estrenada con el título original de
Pluscuamperfecto). Con Manel Barceló y Anabel Moreno. Dirigida
por el autor. Barcelona, 1995.

Amanda. Con Amparo Soler Leal, Jordi Dauder, Miquel Cors y
Ivan Tubau. Dirigida por Hermann Bonnín. Barcelona, 1993.

Proyectos actuales

Apuntes de Szczecin (título provisional). Novela.

Mosquitos (título provisional). Obra de teatro.

www.carsten-ahrenholz.com
D: josep ortega C: david dawnay
A: kings of mambo M: www.kingsofmambo.com

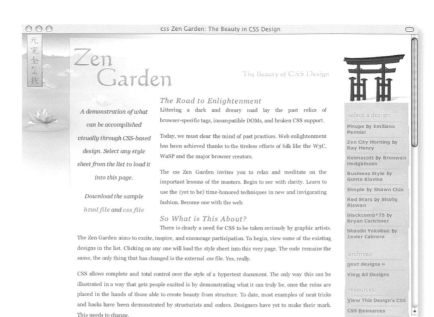

www.csszengarden.com
D: dave shea
M: www.mezzoblue.com/

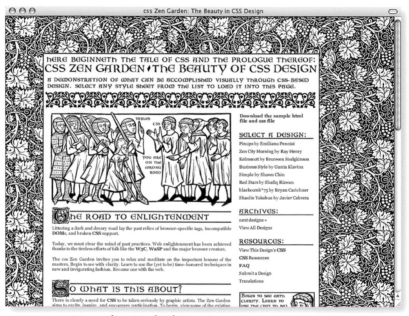

www.csszengarden.com/?cssfile=/176/176.css&page=0

D: bronwen hodgkinson

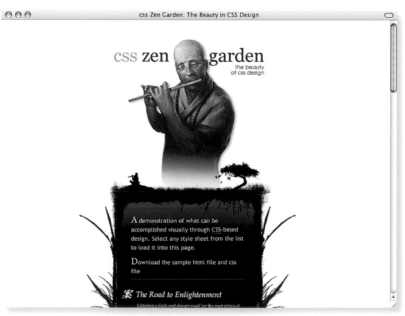

www.csszengarden.com/?cssfile=/171/171.css&page=0
D: javier cabrera
A: emaginación M: javier@emaginacion.com.ar

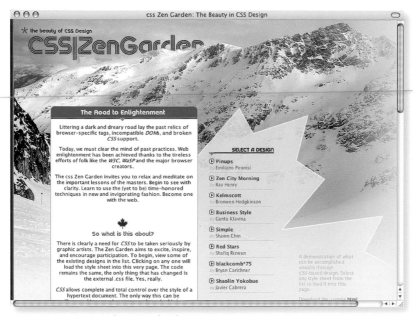

www.csszengarden.com/?cssfile=/172/172.css&page=0
D: bryan carichner
A: bryan carichner M: www.carichner.com

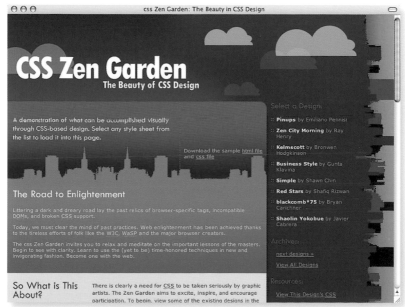

www.peamarte.it/02/03.html
D: emiliano pennisi
A: metrostation design M: metrostation@gmail.com

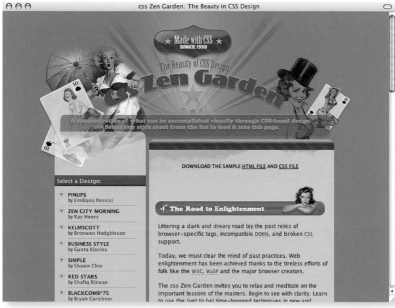

www.csszengarden.com/?cssfile=/177/177.css&page=0
D: ray henry

tees.cuoli.pt
D: pedro godinho, pedro cerqueira
A: cuoli M: pedro.godinho@cuoli.pt

www.marceleichner.de
D: marcel eichner
A: ephigenia m. eichner M: love@ephigenia.de

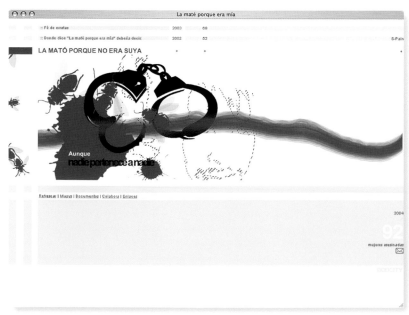

www.lamateporqueeramia.com
D: rubén cárdenas C: rubén cárdenas P: casa de la mujer de zaragoza
A: oddcity M: djlashit@oddcity.com

166

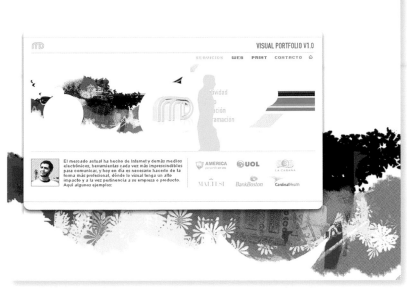

dere.com.ar
D: matias dere
A: dere M: dere.com.ar

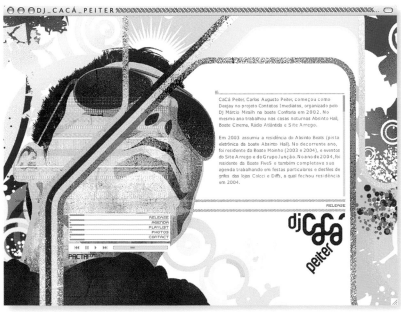

www.djcacapeiter.com.br
D: daniel dos santos
A: pactacom M: daniel@pactacom.com.br

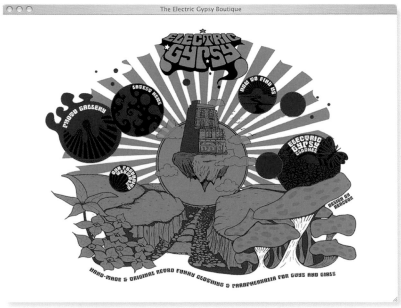

www.theelectricgypsy.com
D: michael saunders
A: reactor15 M: mike@reactor15.com

167

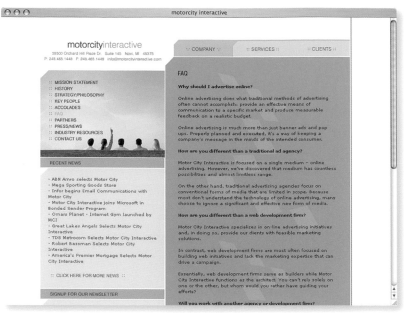

www.fynite.com
D: goran bajazetov C: jozef selesi P: goran bajazetov
A: rebuilt world M: goran.bajazetov@gmail.com

www.cybergraphix-anim.com
D: sebastian gronemeyer
A: independent.blue M: sebastian@independentblue.com

www.amcgestion.com
D: marta aguiló C: gustavo ullán P: amc
A: amc gestión personalizada M: marta@amcgestion.com

www.dreamastic.com/academy.html
D: brian choy
A: dreamastic limited M: brian@dreamastic.com

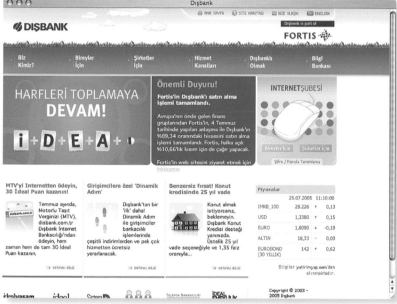

www.Disbank.Com.Tr
D: n. sagynbaev, t. kilinc, y. yilmaz
A: magiclick digital solutions M: info@magiclick.com

www.dbinario.pt
D: nuno conceição C: jason babo P: nuno conceição
A: design binário - soluções publicitárias M: info@dbinario.pt

www.jugi nbg.de
D: cindy schaab C: michael schaab
A: solution room gbr M: cindy.schaab@solutionroom.de

www.w-dizajn.hr
D: tomislav katinic
A: w-design M: info@w-dizajn.hr

www.crumplereurope.com
D: michael lelliott C: ian chia
A: michael lelliott (80 cubes) M: mike@crumpler.de

www.levedetuinstad.nl
D: donald roos
A: otherways souterrain studio M: donald.roos@otherways.nl

www.cheyenne-pt.com
D: josé cardoso C: miguel carvalho P: comunick
A: comunick M: support@comunick.com

www.7graus.com
D: 7graus
A: 7graus - sistemas de informação M: ruimarques@7graus.com

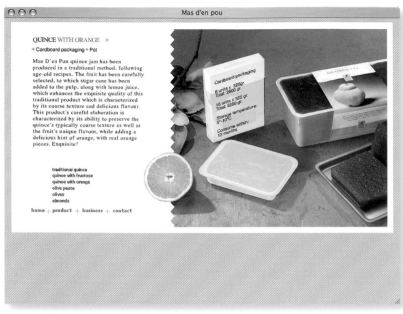

www.masdenpou.com
D: mariana eidler C: isaac bordons P: isaac bordons
A: symbyosys M: isaac@symbyosys.cc

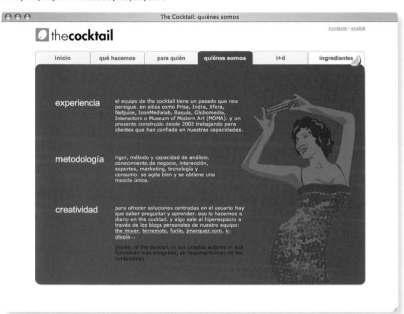

www.the-cocktail.com
D: javier cañada C: alvaro ortiz P: the cocktail
A: indra M: denovoa@madrid.com

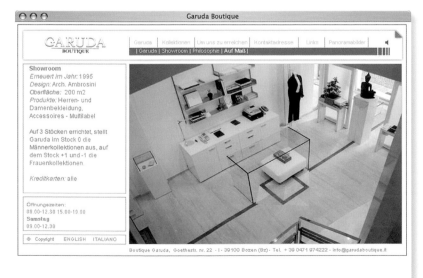

www.garudaboutique.it
D: altea software
A: altea M: kob@altea.it

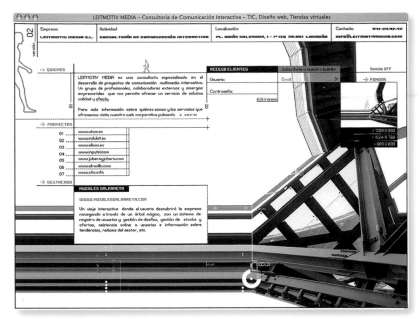

www.leitmotivmedia.com
D: guillermo rivillas soria
A: leitmotiv media M: info@leitmotivmedia.com

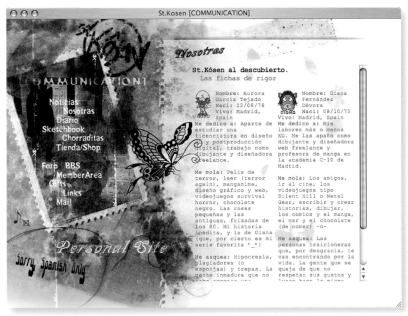

stkosen.com/comm
D: studio kōsen
A: studio kōsen M: kosen@arrakis.es

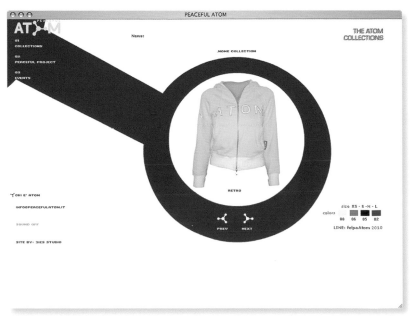

www.peacefulatom.it
D: andrea cucchi
A: 3ies studio M: tre@3ies.it

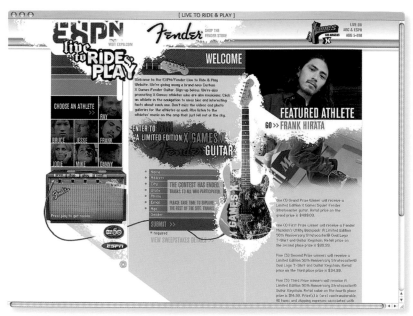

www.fender.com/expn
D: david bean, jake stutzman C: jake stutzman P: david bean
A: the visual reserve M: david@visualreserve.com

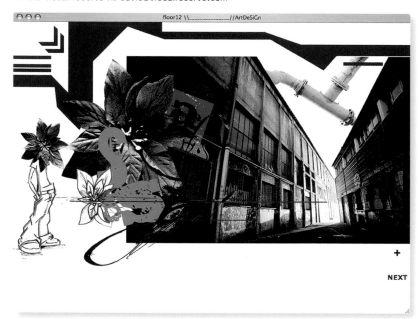

artdesigntd.free.fr
D: luciole
A: net conception M: dlaurent@net-conception.com

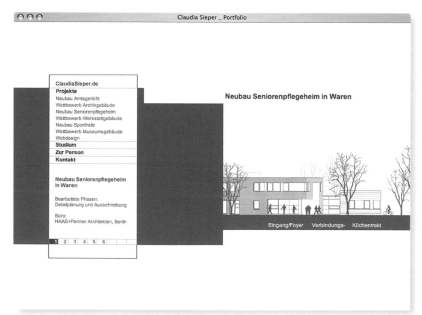

www.claudiasieper.de
D: claudia sieper C: christoph packhieser
M: wir@kalt8.de

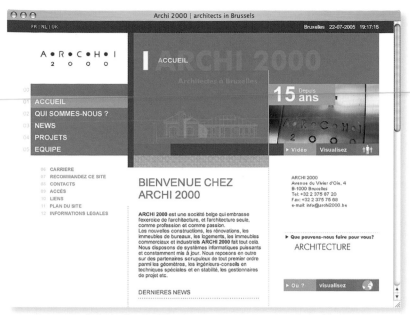

www.archi2000.be/fr/home/home.php
D: christophe carbonnery
M: studio@arcolan.com

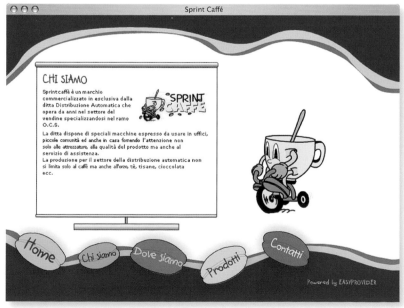

www.sevenindustries.com
D: massimo sirelli
A: dimomedia lab M: info@dimomedia.com

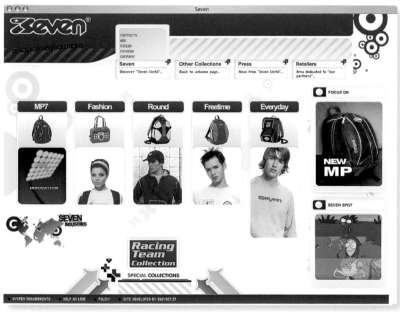

www.caffesprint.com
C: nat amigoni P: easyprovider.com
A: easyprovider.com M: info@easyprovider.com

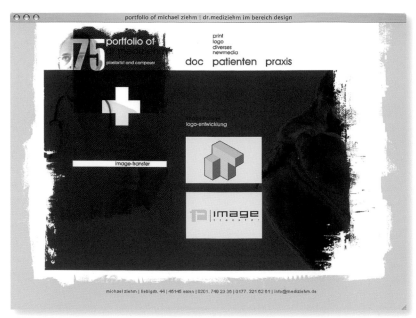

www.mediziehm.de
D: michael ziehm
M: info@mediziehm.de

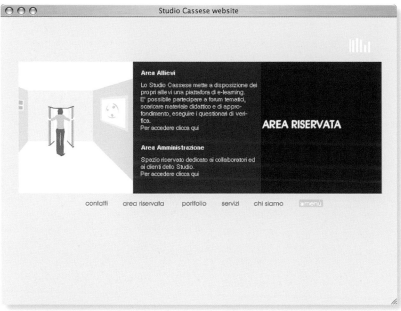

www.studiocassese.it
D: luciano cassese
A: studiocassese M: info@studiocassese.it

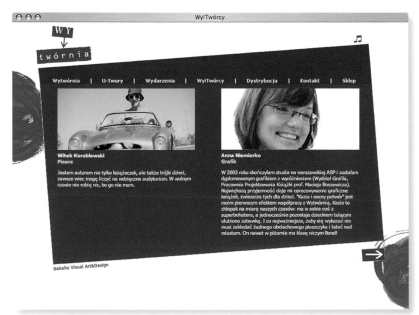

www.wytwornia.com
D: studio bakalie
A: studio bakalie M: www.studiobakalie.pl

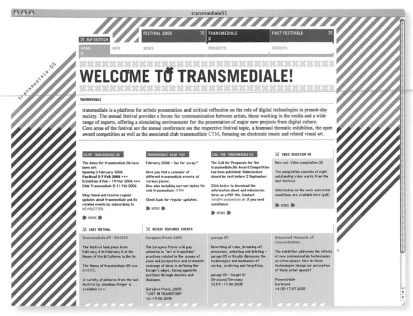

www.transmediale.de
D: david linderman C: markus hamami P: stefan riekeles
A: frog unstable media M: www.frog.de

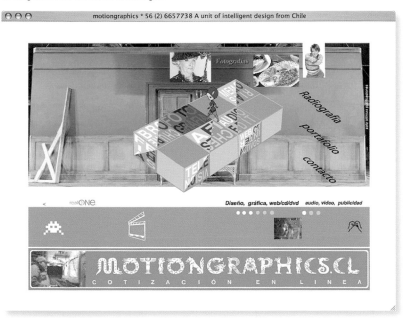

www.motiongraphics.cl
C: daniel valdés
A: motiongraphics chile M: dvaldes@motiongraphics.cl

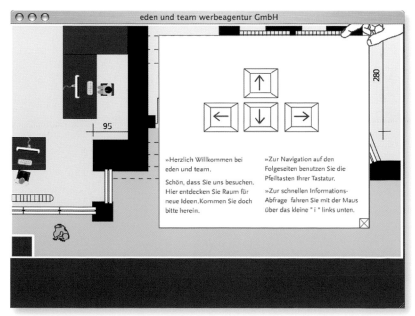

www.eden-team.de
D: vanessa mikoleit
A: vamiko M: javan@gmx.de

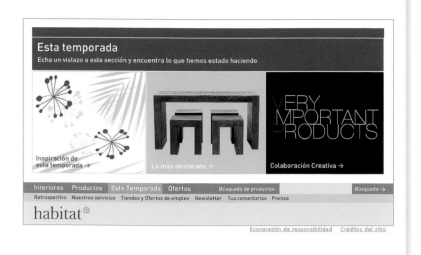

www.habitat.fr/spain/main_spain.htm
D: kiwilab
A: kiwilab M: pablojimenez@kiwilab.com

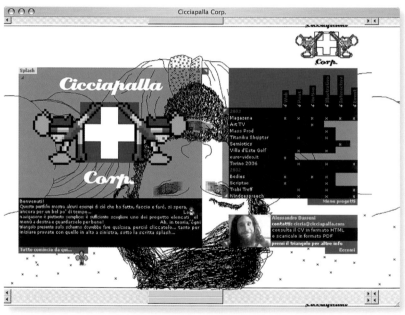

www.cicciapalla.com
D: cicciapalla corp.
A: cicciapalla corp. M: lemiecose@cicciapalla.com

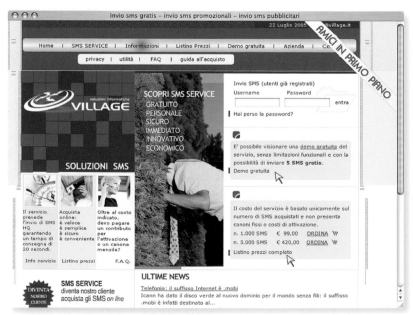

www.village.it/invio_sms.htm
D: ilaria boz C: andrea araghiyan
A: village srl M: iboz@village.it

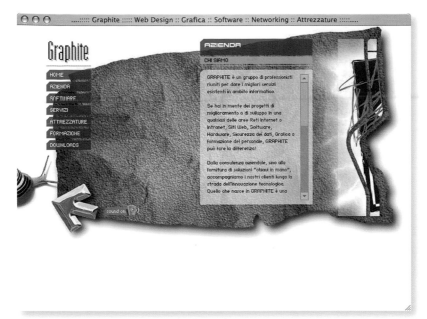

www.graphite.it
D: samuele granzotto **C:** emanuele ferrabo
A: graphite s.r.l.

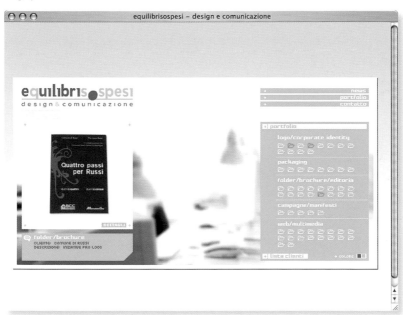

www.equilibrisospesi.com
D: equilibrisospesi
A: equilibrisospesi **M:** luca@equilibrisospesi.com

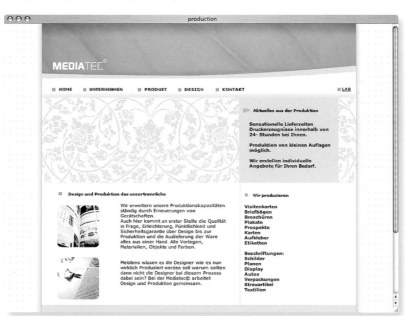

www.mediatec-info.com
D: burak yildirim
A: mediatec design and production **M:** mtec@mediatec-info.com

179

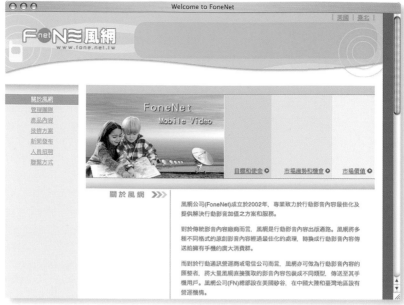

www.fone.net.tw
D: liao mu wei P: fone
M: wingerliao@pchome.com.tw

equilibrisospesi.com
D: luca bartolini
A: equilibrisospesi M: luca@equilibrisospesi.com

www.iama.de
D: holger maassen
A: iama M: holger.maassen@iama.de

www.disenosebq.com
D: esteban bonet quiles
A: diseños|ebq M: info@disenosebq.com

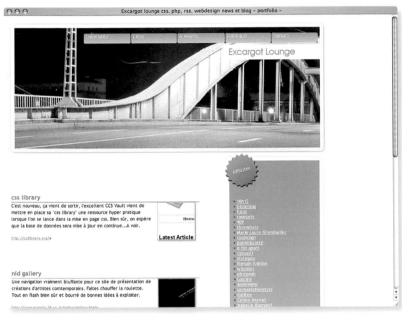

www.excargot.net
D: marie neff
M: marie.neff@gmail.com

www.caffarorossi.com
D: cecilia alegro
M: ceciliaalegro@hotmail.com

www.b-unique.info
D: sonja radke C: justus siebert P: smart interactive
A: smart interactive M: s.radke@smart-interactive.de

www.cidae.net
D: cidae
A: cidae M: cidae@cidae.net

www.culinor.com
D: kjell robberecht C: kim van mossevelde P: benoit dubrulle
A: agx M: info@agx.be

The principal criteria on which adtio Web Design is based, are design quality, innovation and the effectiveness. Different kinds of web design are featured in adtio DESIGN. It can range from single-page sites with simple, text-only layouts, to snazzy and complicated structures featuring the latest capabilities. With our professional, both designs can be attractive and effective

design.adtio.com
D: joseph chau
A: adtio group limited M: joseph.chau@adtio.com

www.cabezolo.com
P: desoños
A: desoños M: multimedia@desonhos.net

www.nach-art-des-hauses.com
D: katrin mai
M: katrinmai@gmx.de

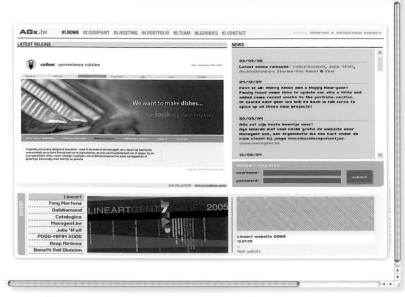

www.agx.be
D: kjell robberecht C: kim van mussevelde P: benoit dubrullo
A: agx M: info@agx.be

www.luisbordalo.com
D: luis bordalo
M: luismbordalo@netcabo.pt

www.camport.pt
D: nuno martins C: nuno martins P: house of brands
A: nuno martins, house of brands M: nuno@nunomartins.com

www.procolor.com.sg
C: ronnie liew
A: everyday design M: ivan@everyday.com.sg

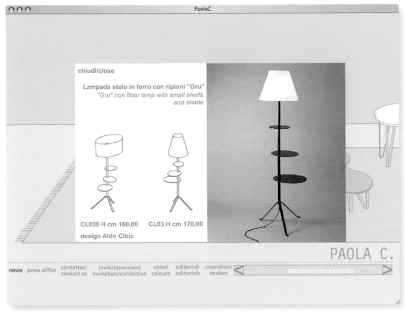

www.paolac.com
D: michelangelo petralito, sara benettolo
A: im'zdesign M: michelangelopetralito@imzdesign.com

www.happydogband.com
D: myung-hun lee
M: greghuns@lycos.co.kr

www.aliantedizioni.it
D: alessandro loschiavo C: giuseppe de santis P: sade-sign
A: alessandro loschiavo design M: info@alessandroloschiavo.com

www.visit-anagram.de
D: sebastian müller, christian caspersen, sandra stiller
A: anagram design group M: sebastian.mueller@visit-anagram.de

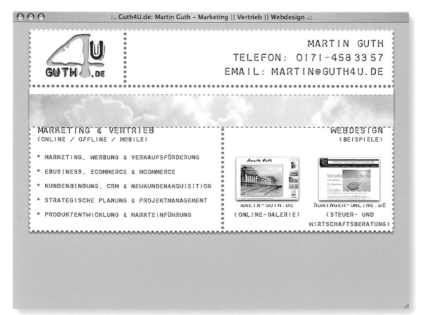

www.Guth4U.com
D: martin guth
A: guth4u.com M: www.guth4u.com

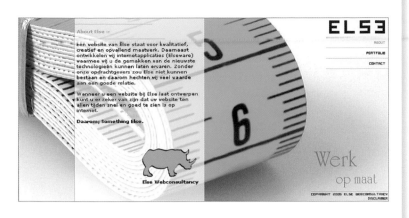

www.elseonline.nl
D: arjan van de steeg
A: else webconsultancy M: arjan@elseonline.nl

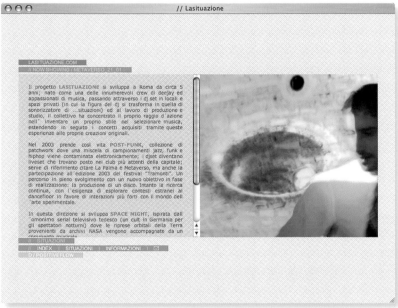

www.lasituazione.com
D: tina+ C: tina+ P: lasituazione
M: tinabar@libero.it

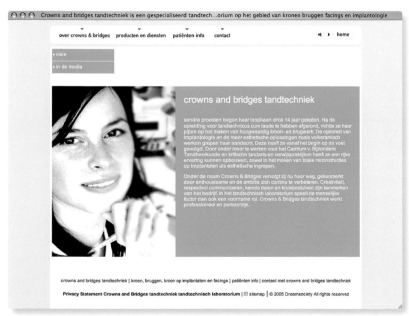

www.crownsandbridges.nl
D: coen van den broek
A: dreamsociety M: info@dreamsociety.nl

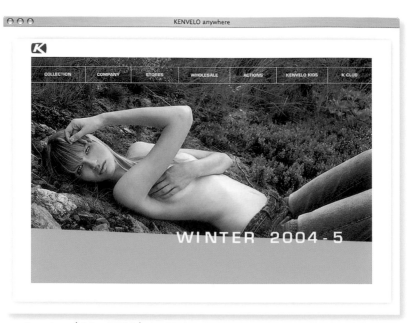

www.kenvelo.cz/winter_2004-5/index.html
D: milan nedved C: jiri petvaldsky P: milan nedved
M: elwiz@elwiz.cz

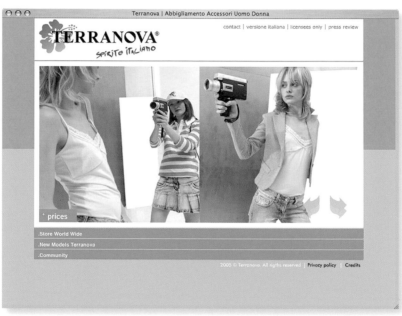

www.terranova-on-line.com
D: extera
A: extera M: simon@extera.com

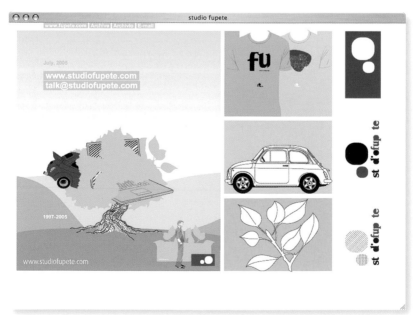

www.fupete.com
D: fupete
A: studio fupete M: head@fupete.com

SuperGlobules : Super communication visuelle, Super energie creative pour l'edition & pour le web

www.superglobules.com
D: faivre-migliore
A: superglobules **M:** supercontact@superglobules.com

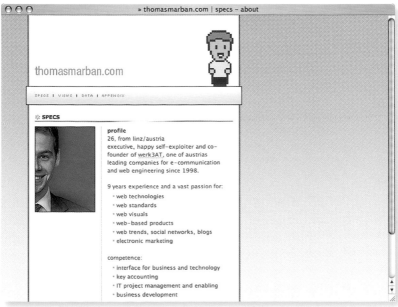

zündung - die brand-stifter - Frankfurt/Main - Kommunikati... Anzeigen, Mailings, Zeitschriften, Messen, Events, CD-ROM

www.zuendung.net
D: alexander dimolaidis
A: zuendung **M:** a.dimolaidis@zuendung.net

» thomasmarban.com | specs - about

profile
26, from linz/austria
executive, happy self-exploiter and co-founder of werk3AT, one of austrias leading companies for e-communication and web engineering since 1998.

9 years experience and a vast passion for:
- web technologies
- web standards
- web visuals
- web-based products
- web trends, social networks, blogs
- electronic marketing

competence:
- interface for business and technology
- key accounting
- IT project management and enabling
- business development

thomasmarban.com
D: thomas marban
A: werk3at **M:** thomas@marban.at

www.terzobinario.it
D: carlo zapponi
A: digitalfog M: webdesign@digitalfog.it

www.m-dd.net
D: gianluca vatore P: luca piombino
A: m-dd multimedia digitaldesign s.r.l. M: info@m-dd.net

www.tastedesign.be
D: sofie vandesompele C: valentijn vyvey P: valentijn vyvey
A: snortsoft vof M: valentijn@snortsoft.be

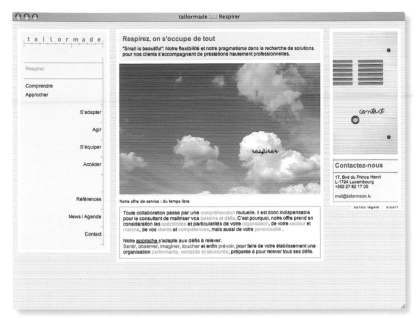

www.tailormade.lu
D: laurent daubach C: viktor dick P: tailormade
A: bizart M: laurentdaubach@bizart.lu

www.twiztedimagebuilding.be
D: stef verbeeck C: tom lefever P: kirsten ujvari
A: twizted imagebuilding M: stef@twizted.be

www.espanyoltrespuntzero.com
D: carles
M: carles@cr4c.com

www.patriziaminuta.it
D: chiara mussini P: patrizia minuta
M: chiaramuss@tele2.it

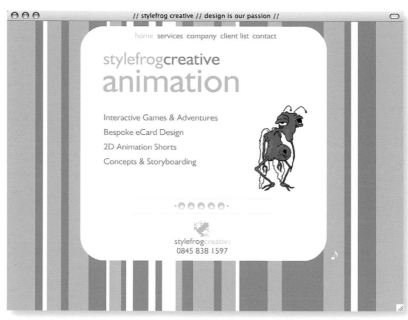

www.stylefrogcreative.com
D: matt faulkner
A: stylefrog creative M: matt@stylefrogcreative.com

www.dissenzoo.com
D: tiscia antonello
A: navsolution srl M: info@t-shart.com

www.biomega.dk
D: jens martin skibsted, bo møller jensen C: magnetix P: magnetix
A: magnetix M: mbj@biomega.dk

www.weloveart.net
P: weweje
M: bruno@energumene.com

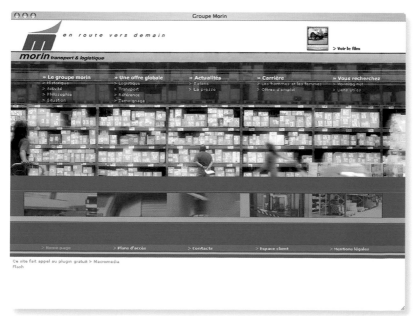

www.morin-logistic.com
D: luc serrano C: chris gaillard P: luc serrano
A: beautifulscreen.tv M: chris@chrisgaillard.com

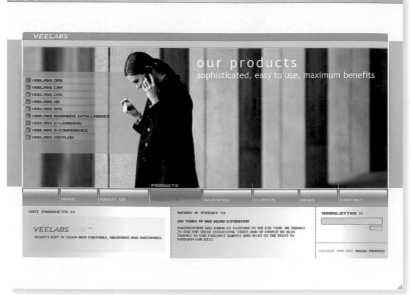

www.veelabs.com
D: victor wiguna, ratna haris P: victor wiguna, elvran harris
A: veelabs indonesia, pt. M: victor@veelabs.com

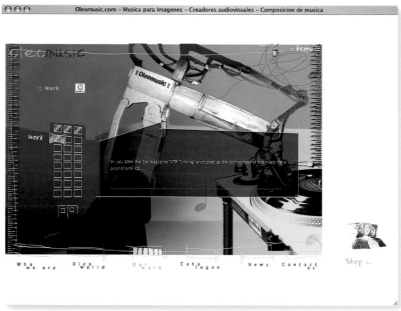

www.oleomusic.com
D: alfonso corrales C: enrique valentin P: ana belén álvarez
A: grapha intuitive M: ana@grapha.net

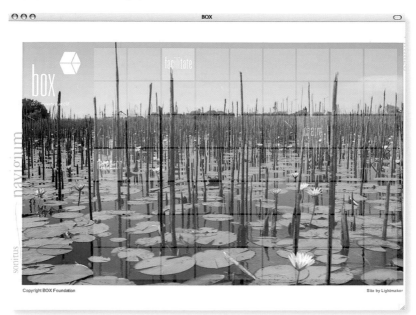

www.boxfoundation.org
D: lightmaker.com
C: lightmaker.com

www.bridgemedia.co.uk
D: matt etherington
A: bridge media ltd. M: info@bridgemedia.co.uk

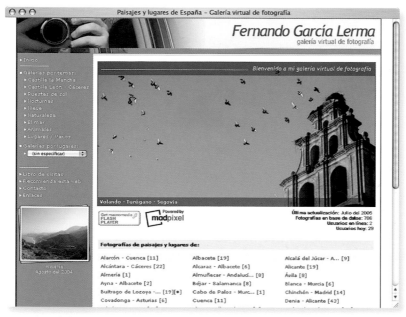

www.artecastellano.com
D: fernando garcía lerma
A: madpixel M: info@artecastellano.com

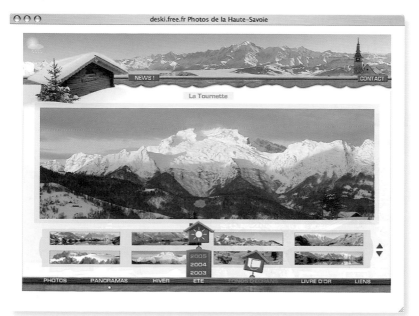

deski.free.fr
D: desquirez
M: deski@libertysurf.fr

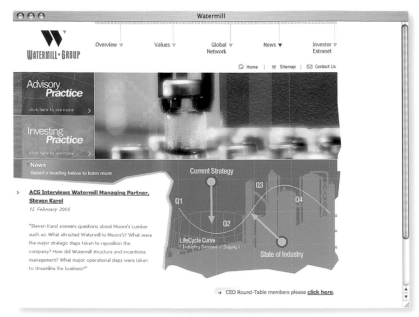

www.Watermill.Com
D: t. kilinc C: s. orhan P: m. kalaora
A: magiclick digital solutions M: info@magiclick.com

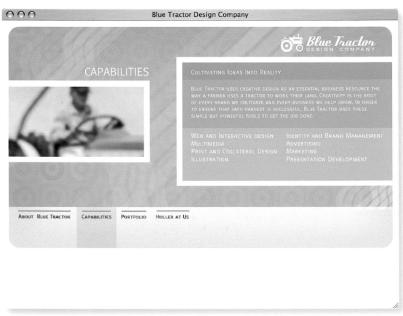

www.bluetractor.com
D: john thomas
A: blue tractor design company M: john@bluetractor.com

www.rhumantic.net
D: céréssia olivier
M: webmaster@rhumantic.net

www.cchasselt.be

D: monique rutten C: arthur odekerken P: laurent pitsi
A: cc hasselt M: admin@cchasselt.be

www.maristasalicante.com

D: stefano beltrán
M: stefanobb@bigfoot.com

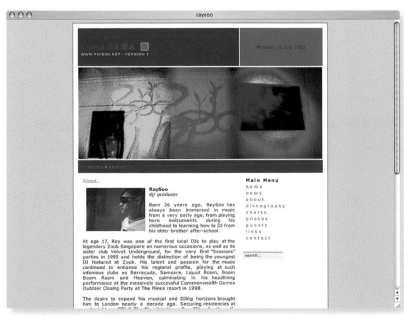

www.raysoo.net

D: orbitant
A: lostcommunications M: clarence@lostcom.com

197

www.mcperry.it
D: tiziana benedetti, locati fabrizio C: locati fabrizio
A: digimedia s.a.s. M: service@digimediasas.it

www.aixagaliana.com
D: ziddea sl
A: ziddea sl M: julio@ziddea.com

www.design-insights.com
D: frankie tong ling keat
A: design insights M: frankie@design-insights.com

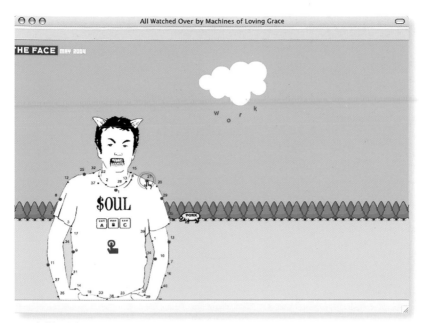

www.keithwalsh.com
D: keith walsh C: anders jessen P: keith walsh
A: keithwalsh.com M: keith@keithwalsh.com

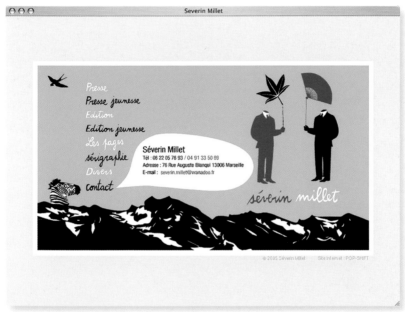

www.severinmillet.com
D: jean-christophe lantier C: nicolas brignol P: severin millet
A: pop-shift M: jlantier@pop-shift.com

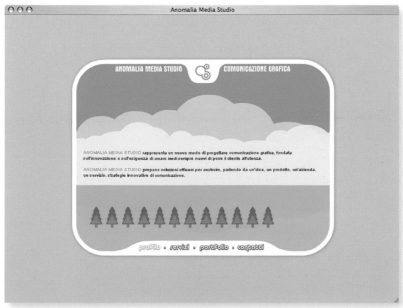

www.anomalia.cc
D: marco rocca C: giovanni ghirardi P: marco rocca
A: anomalia media studio M: info@anomalia.cc

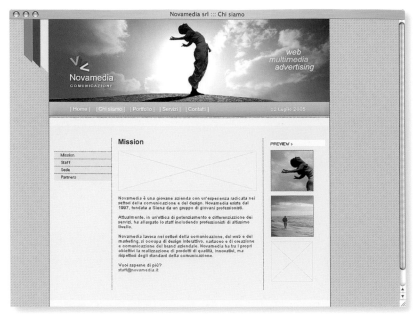

www.novamedia.it
D: mimmo manes P: canefantasma studio
A: canefantasma studio M: m@canefantasma.com

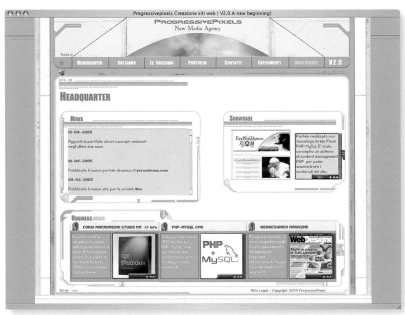

www.progressivepixels.com
D: marco C: daniele
A: progressivepixels M: info@progressivepixels.com

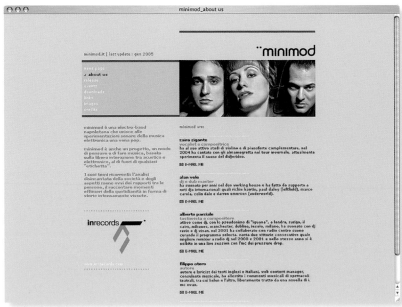

www.minimod.it
D: vitaliano de vita
A: vitaliano de vita | visual communication M: info@vitalianodevita.com

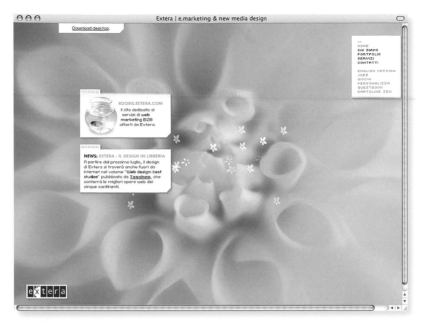

www.extera.com
D: extera
A: extera srl M: contact@extera.com

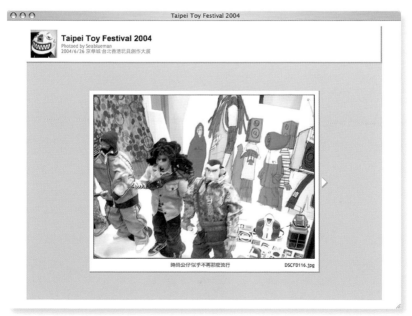

www.parapluesch.de
D: martin kittsteiner
M: kittsteiner@parapluesch.de

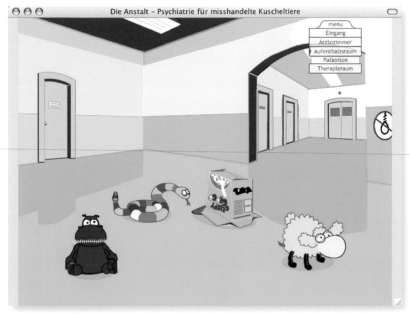

seablueman.myweb.hinet.net
D: seablueman
M: chunkai@skysoft.com.tw

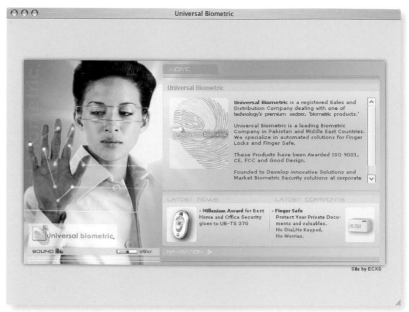

www.universalbio.com
D: rahil hassan
A: system innovation (pvt) ltd. M: rahil97@hotmail.com

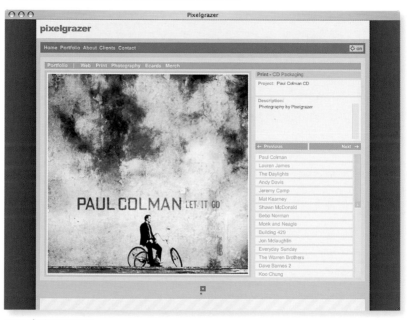

www.pixelgrazer.com
D: jeremy cowart, daniel ariza C: jeremy pinnix P: pixelgrazer
A: pixelgrazer M: jeremy@pixelgrazer.com

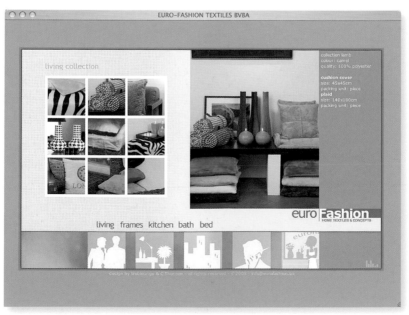

www.eurofashion.be
D: weblounge
A: weblounge M: info@weblounge.be

202

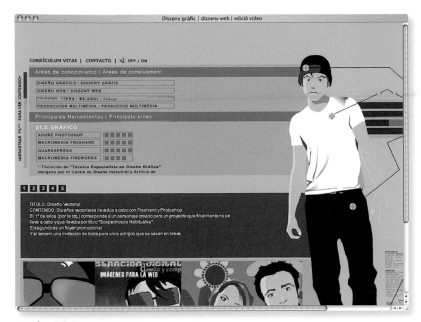

www.joanlafulla.com
D: joan lafulla
A: gumfaus M: disseny@joanlafulla.com

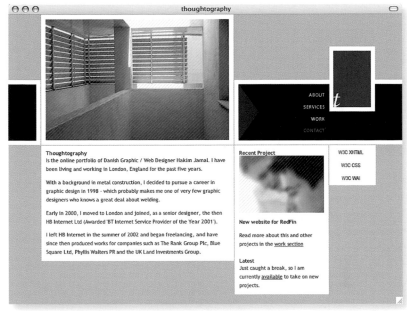

www.thoughtography.net/contact.html
D: hakim jamal
A: thoughtography M: hakim@thoughtography.net

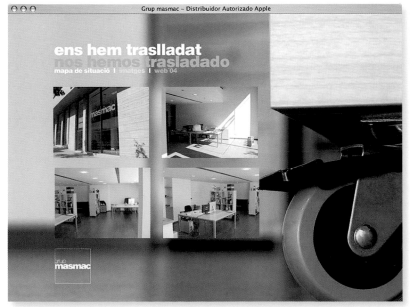

www.masmac.com
D: jacinto lana
M: www.masmac.com

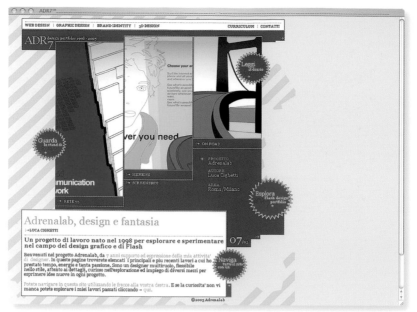

www.adrenalab.com
D: luca cighetti
A: adrenalab M: luca@adrenalab.com

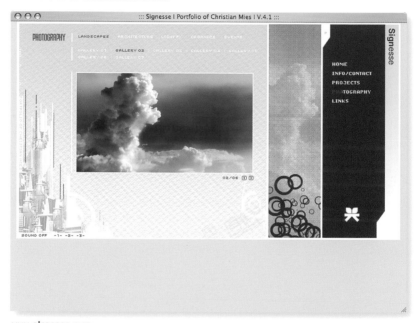

www.signesse.com
D: christian mies
M: christian.mies@signesse.com

www.eureka-digital.com
D: kelly sze
A: eureka digital ltd M: kelly@eureka-digital.com

www.lizwolfe.com
D: ken wong
M: kenwong@yours.com

www.indigoart.net
D: patrick walsh C: patrick walsh P: lee walker shepherd, indigo, llc
A: promesis.com M: patrickwalsh@promesis.com

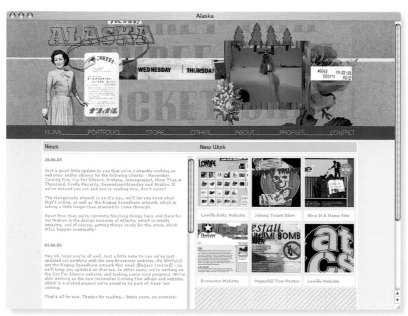

www.alaska-design.com
D: jack dixon
A: alaska design M: jack@alaska-design.com

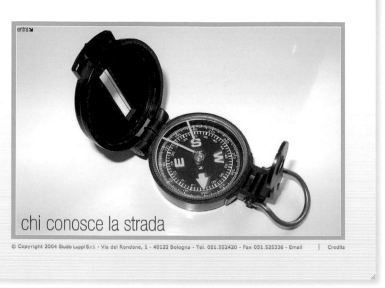

www.studioluppi.it
D: daniele pascerini
A: fishandchips M: daniele@fishandchips.it

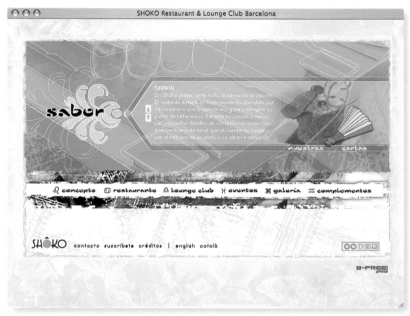

www.shoko.biz
D: raul bein, dani martí C: dani martí, guillem lorman
A: pat-a-cake M: dani@mardelcoral.com

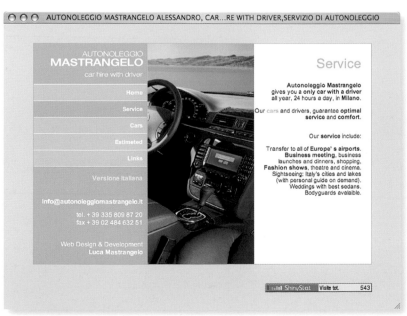

www.autonoleggiomastrangelo.it
D: luca mastrangelo
A: activeye M: info@lucamastrangelo.it

206

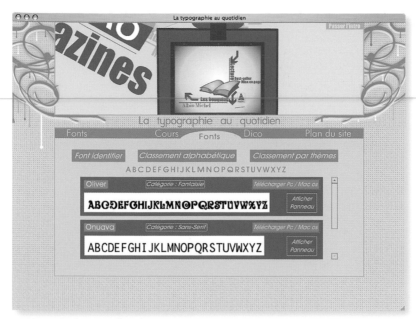

cedric.cauderlier.free.fr/site/
D: cauderlier cédric
M: code_ced@hotmail.com

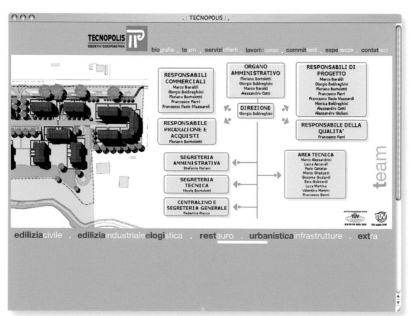

www.clickwerk.ch
D: daniel kyburz C: thomas herzog, thomas brandenburger P: urs welti
A: clickwerk gmbh M: welti@clickwerk.ch

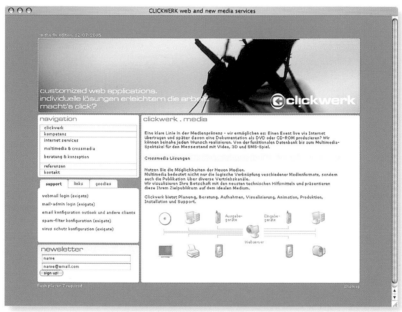

www.tecnopolis.it
C: bongiovanni gabriele P: giuseppe ottani
A: bjmaster M: sara@bjmaser.com

www.enricomottola.com
D: benedetta rech
M: benny.r@infinito.it

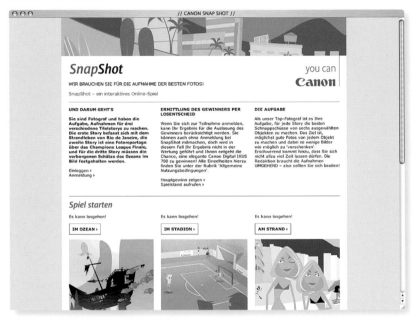

deu-game.snapshot.canon-europe.com
D: maria tomeczek, judith hoffmann, joachim ensslin P: twmd gmbh
A: twmd gmbh M: mt@twmd.de

www.kimram.com
D: håvard gjelseth C: trond sørli
A: this way design M: havardg@klapp.no

www.isiweb.nl
D: indra simons
A: isi webdesign and fotography M: info@isiweb.nl

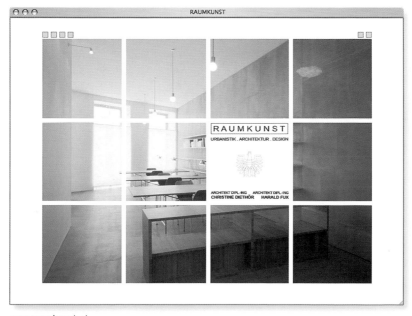

www.actevizuel.fr.st
D: hashka
A: hashka M: actevizuel@graphisme.com

www.raumkunst.at
D: sebastian schmid
A: raumkunst M: cd@raumkunst.at

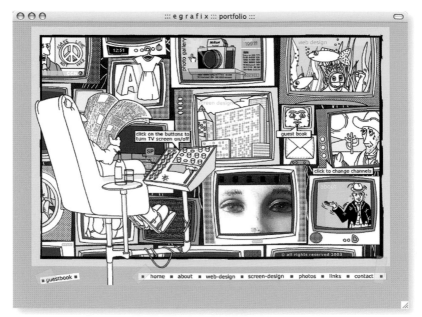

www.egrafix.co.il
D: doron yefet
A: egrafix M: avivy@netvision.net.il

www.dieutopianer.de
D: andreas bertler C: stefan heckler P: andreas bertler
A: dieutopianer M: bertler@dieutopianer.de

cedric.cauderlier.free.fr
D: cedric cauderlier
A: code_ced M: code_ced@hotmail.com

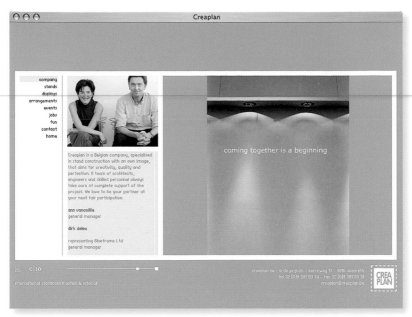

www.creaplan.be
D: alec lux P: pieter holvoet
A: corpstien M: alec@corpstien.be

deido.it
D: nadia ragazzo C: omicron technologies P: deidò
A: deidò M: info@deido.it

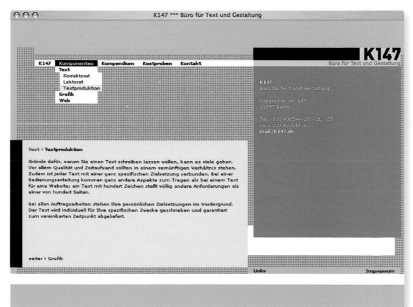

www.k147.de
D: guido wortmann
A: k147 M: schreib@k147.de

www.sofake.com
U: jordan stone
A: sofake M: nofake@sofake.com

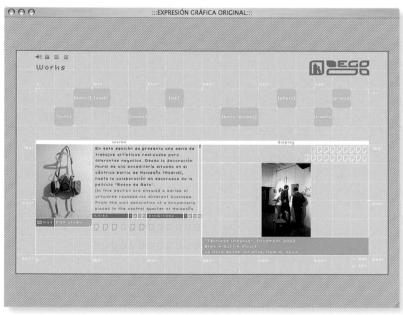

www.egocrew.com
D: jorge negrotti
M: bielo@egocrew.com

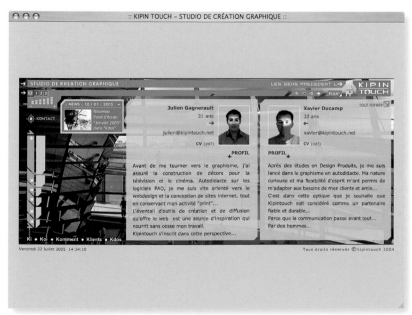

www.kipintouch.net
D: xavier, julien C: julien gagnerault P: kipin touch
A: kipin touch M: contact@kipintouch.net

www.thevisualreserve.com
D: david bean, jake stutzman C: jake stutzman P: david bean
A: the visual reserve M: david@visualreserve.com

www.officinaquack.it
D: officina quack, piergiorgio carozza, gabriele cossu
A: officina quack! M: g.cossu@officinaquack.it

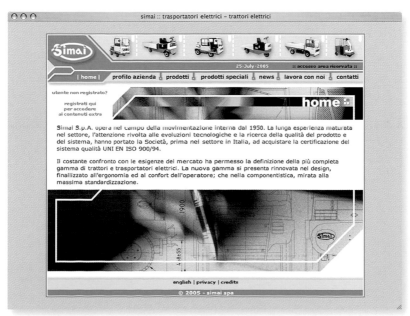

www.simaispa.com
D: francesco antonibon
A: wildstylers media M: info@wsmedia.it

www.kylehaapala.com
D: kyle haapala
M: contact@kylehaapala.com

www.echo.co.il
D: maria ilin-sorek C: adi sorek
A: echo

www.lieve-31mei2004.nl
D: debby van dongen
A: conk M: webmaster@conk.nl

214

www.electropost.de
D: ulrich schaefer
A: electropost M: mailto.postbox@gmx.de

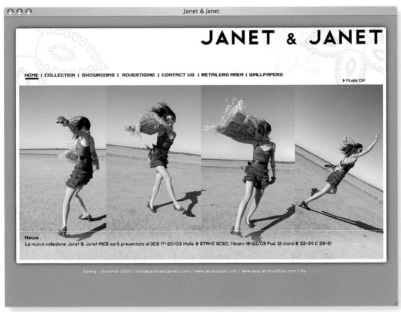

www.janetandjanet.com
D: alessio michelini
A: creso srl M: alessio@cresosrl.it

www.alexdinamo.com
D: rogelio lopez alvarez C: luis zuno mandeur P: luis zuno mandeur
A: alex dinamo diseño M: control@alexdinamo.com

www.alternativeloc.com
N: christelle barraud
A: créa open web M: contact@creaopenweb.com

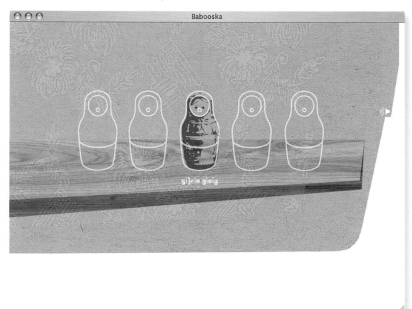

www.babooska.it
D: franz degano C: giovanni ripoldi P: massimo manera
A: zona cesarini M: www.zona-cesarini.it

www.ugokigym.com
D: lee hsu
A: misos.com M: nano_topia@hotmail.com

www.bakyard.biz
D: francesca gaggio, nicola jc valletti C: marco biagiotti P: nicola jc val-
letti

www.atelierchae.com
D: eva chupikova
A: atelier chae M: info@atelierchae.com

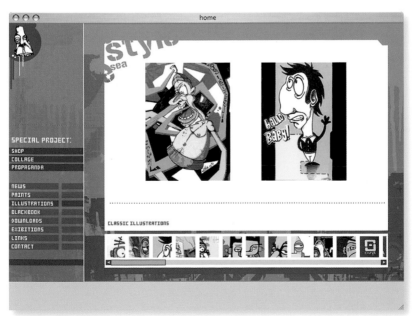

www.seacreative.net
D: sea
A: seacreative M: seacreative@tin.it

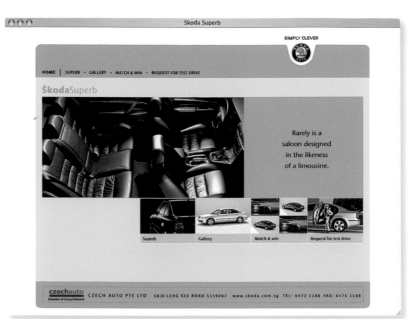

www.caffeine.com.sg/skodasuperb/
D: juliana goh C: francis chay P: francis chay
A: caffeine interactive M: joe@caffeine.com.sg

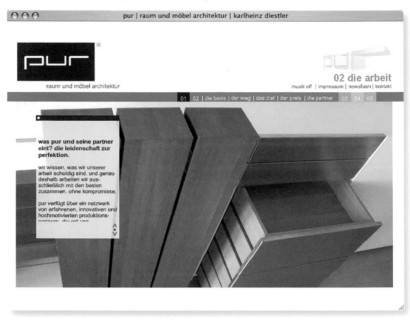

www.pur.cc
D: christian moerth, michael pasterk C: johannes schreiner
A: kreativagentur c.m.m. | graz. M: juergen.mellak@cmm.at

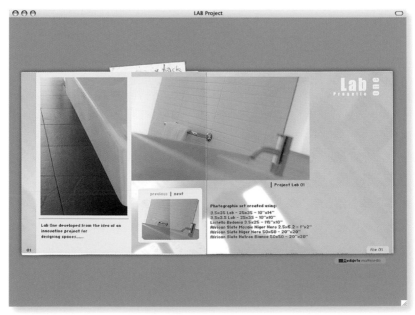

www.labone.it
D: mediarte srl
A: mediarte srl M: francesco@mediarte.it

www.ielrc.org
D: tchiwas C: gervaz P: tchiwas
A: tchiwas.net M: info@tchiwas.net

www.grismobles.com
D: marta aguiló, raquel cortinas C: gustavo ullán P: amc
A: amc M: info@amcgestion.com

www.eleven18.net
D: gerard, agnes
A: junkflea M: www.junkflea.com

www.theselfimages.com
D: lars højberg C: filip anselm P: lars højberg
A: the self images M: www.theselfimages.com

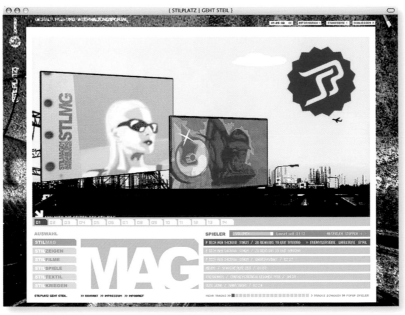

www.stilplatz.com
D: jan riecke, kristian joshi C: jan riecke, kristian joshi P: formliga
A: formliga M: www.formliga.de

www.jasmin-schneider.de
D: jasmin schneider
A: blender70 M: she@blender70.com

www.factorianorte.com
D: ruben sanchez
A: factoria norte M: ruben@factorianorte.com

www.zonadvd.com
D: miguel a. martin C: alejandro fernandez larrosa
A: zonadvd networks s.l. M: correo@zonadvd.com

www.pragmapublicitat.com/asierpragmakers
D: asier lópez
A: pragma àgencia de publicitat general M: asier@pragmapublicitat.com

www.estacio16.com
D: dani martí, manel martí C: dani martí
A: estació16 M: dani@estacio16.com

www.designworkscs.nl
D: donald roos
A: otherways souterrain studio M: donald.roos@otherways.nl

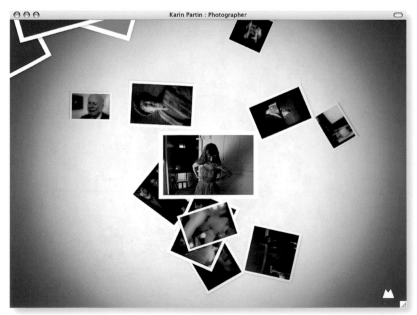

www.karinpartin.com
D: mark miller
A: mark made M: www.stretchdaily.com

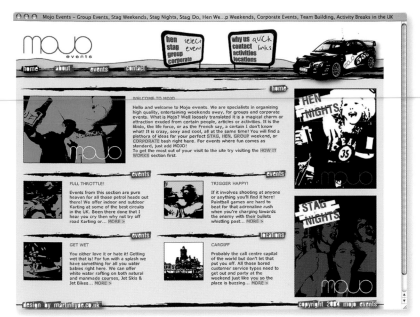

www.mojoevents.co.uk
D: martin hyde
A: martin hyde design M: www.martinhyde.co.uk

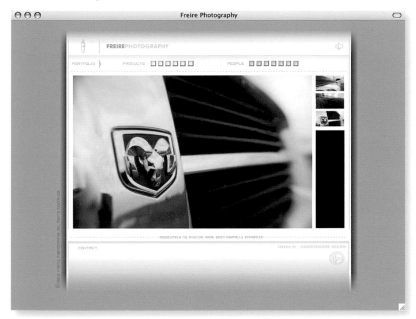

www.freirephoto.com
D: johnny molina
A: liquidchrome design, inc. M: www.liquidchrome.net

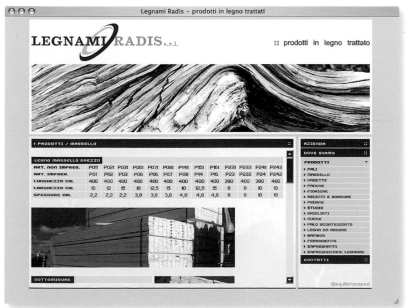

www.legnamiradis.it
D: luca bartolini
A: equilibrisospesi M: luca@equilibrisospesi.com

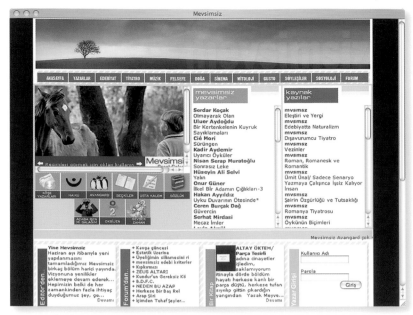

www.mevsimsiz.com
D: vural kinayman C: ahmet ulas firat P: eskiz design
A: eskiz design and internet solutions M: vural@eskiz.net

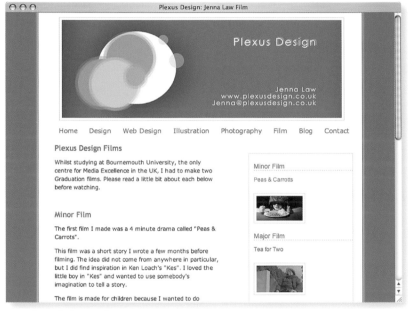

www.plexusdesign.co.uk
D: jenna law
A: plexus design M: jenna@plexusdesign.co.uk

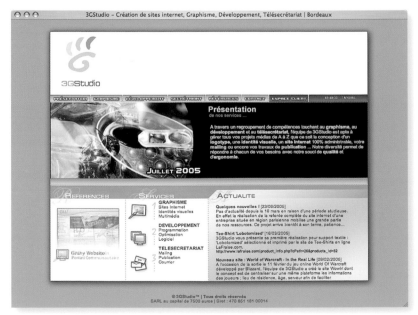

www.3gstudio.net
D: christophe grunenwald
A: 3gstudio M: christophe@3gstudio.net

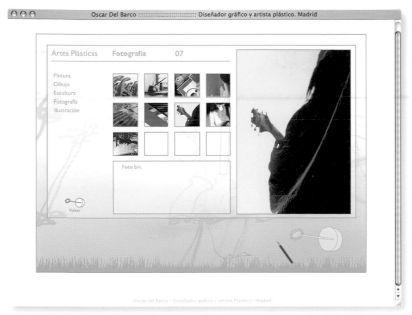

www.delbarco.srmorfus.com
D: oscar del barco barrantes **C:** oscar del barco barrantes **P:** sr. morfus
A: del barco design **M:** delbarcooscar@yahoo.com

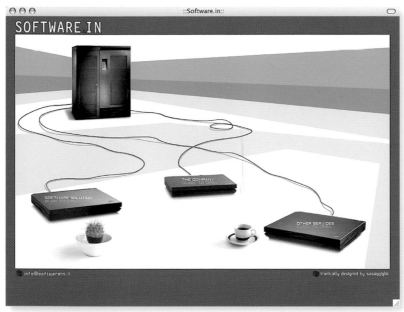

www.softwarein.it
D: alessandro giglio **C:** alessandro giglio **P:** software.in
A: adduma communication **M:** alessandro.giglio@adduma.it

www.krepusculdesign.com
D: benoit lamouche
A: krepusculdesign **M:** kabkinfr@yahoo.fr

www.haosmultimedia.com
D: bonev goce P: alexandar bozinov
A: haos.multimedia M: info@haosmultimedia.com

www.photostyle.at
D: linda dziacek
M: litoart@gmx.at

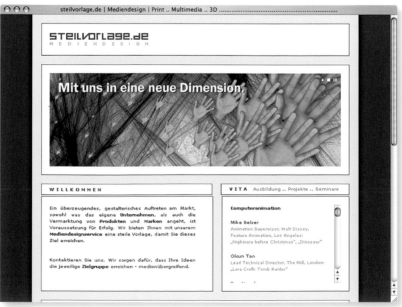

www.steilvorlage.de
D: tobias immel
A: steilvorlage.de M: info@steilvorlage.de

226

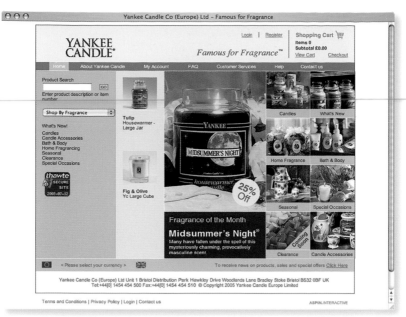

www.yankeecandleshop.co.uk
D: nathan kingstone C: adam gorse P: dave morley
A: aspin interactive M: marcusp@aspin.co.uk

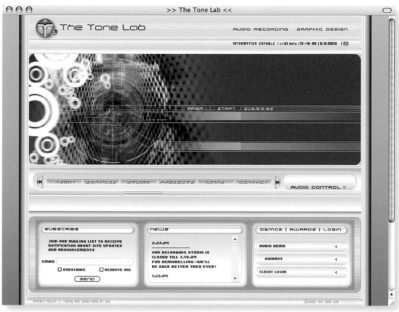

www.thetonelab.com
D: stacey oku, joe sigretto C: stacey oku
A: the tone lab M: info.requests@thetonelab.com

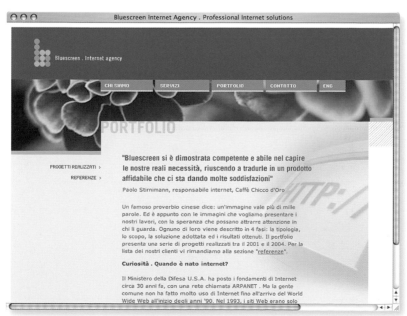

www.bluescreenia.ch
D: cristiano sifari
A: bluescreen M: info@bluescreenia.ch

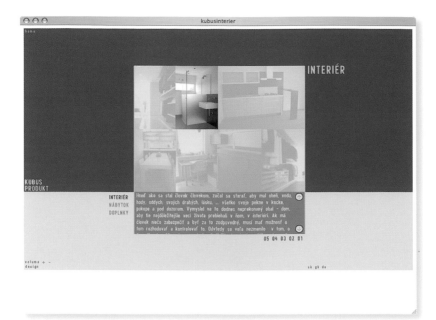

www.kubusinterier.sk
D: michal bartko
A: webdesignfactory M: factory@webdesignfactory.sk

peterwaterschoot.be
D: ghunter fobe C: edwin koster P: edwin koster
A: popcorncolors M: info@popcorncolors.com

www.sergiuardelean.com
D: sergiu ardelean
M: me@sergiuardelean.com

www.icity360.com/magazine/eMag/AllMag/flip.htm
D: zhang xiao ning
A: icity360 group M: x_since1984@hotmail.com

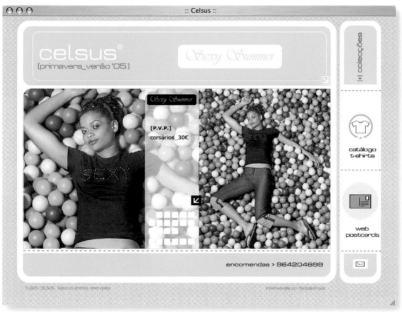

www.celsustyle.com
D: celso assunção C: joão paulo monteiro
A: celsus M: celso10ign@hotmail.com

www.maxweber.com
D: grzegorz mogilewski, ania trojanowska
A: max weber M: max@maxweber.com

www.tex.de
D: anna pyrlik, julia schulte
M: juliaschulte@hotmail.com

www.caffedelprincipe.it
D: ilaria boz
A: village s.r.l. M: iboz@village.it

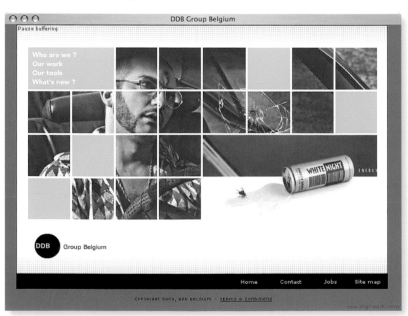

www.ddb.be
D: sven nijs C: thomas huret
A: inspire M: sven@inspire.be

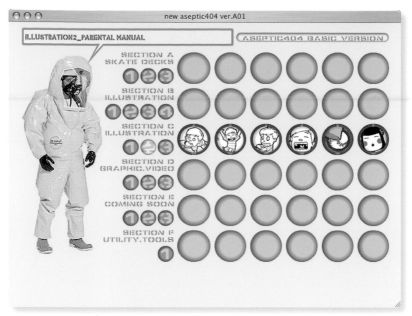

www.aseptic404.net/new
D: alessandro randi
A: aseptic404 M: info@aseptic404.net

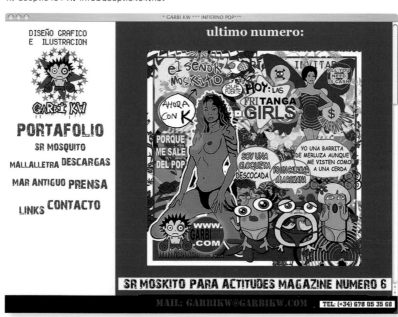

www.garbikw.com
D: qarbi kw
A: garbi kw M: garbikw@garbikw.com

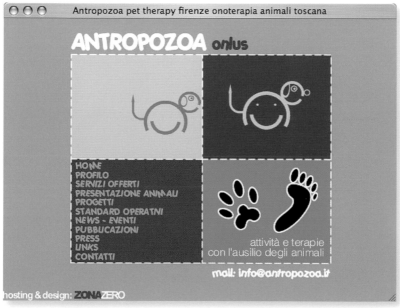

www.antropozoa.it
D: stefano lucherini C: matteo gramigni P: francesco barocchi
A: antropozoa M: steve@zonazero.it

www.immaginema.com
D: piccarda di montereale mantica
A: immaginema M: info@immaginema.co

www.capitalcultural.cl
D: jorge barahona C: maximiliano martin P: adlofo morales
A: ayerviernes s.a. M: jbarahona@ayerviernes.com

www.maedchenprojekt-jena.de
D: núria badia comas C: robert häber
A: 3kon gmbh - informationstechnologien M: nbadia@buschjena.de

phurbano.com
D: esteban cosin C: cintia di consoli P: esteban cosin
A: cosin branding M: ecosin@datafull.com

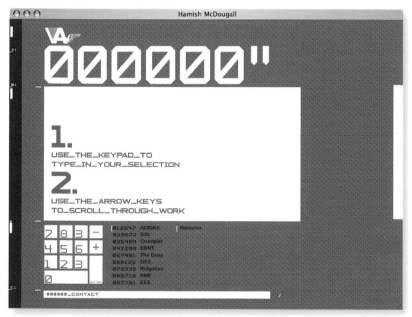

www.folio.visualastronaut.com
D: hamish mcdougall
A: visual astronaut M: hgm@visualastronaut.com

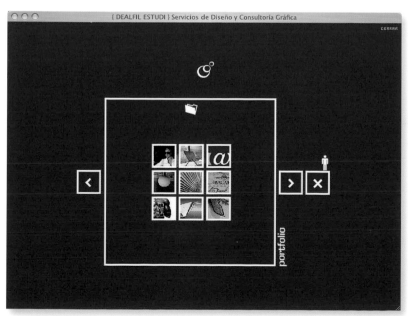

www.dealfil.com
D: alberto álvarez C: daniel sánchez
A: dealfil estudi M: alberto@dealfil.com

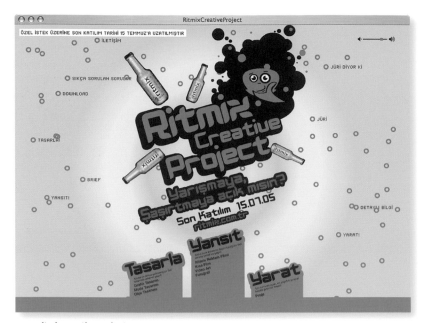

www.ritmixcreativeproject.com
D: ozhan binici
A: aritab M: ozhan@aritab.com

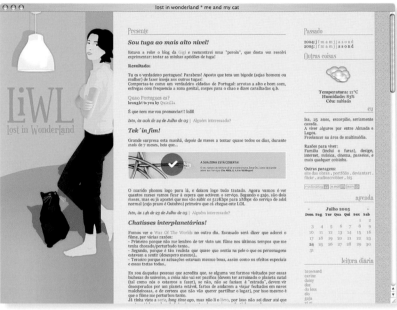

liwl.net
D: isa costa C: nuno pereira
M: isa@liwl.net

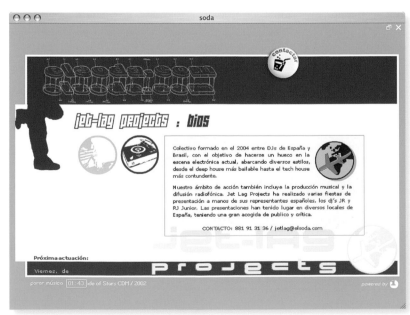

www.elsoda.com
D: david cobo C: pablo díaz P: onetune.com
A: onetune.com M: info@onetune.com

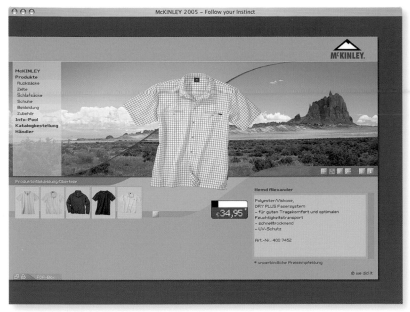

www.mckinley.de
D: heino deppe P: heino deppe, pia hildebrand
A: work.id M: www.workid.de

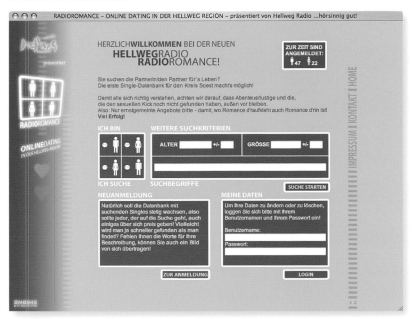

www.radioromance.de
D: christian spatz
A: engine-productions medienproduktion M: gahrmann@engine-produc-

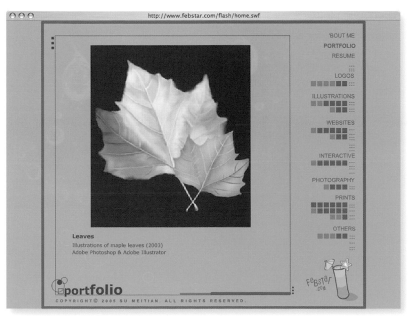

www.febstar.com
D: shirlynn su
M: febstar2000@yahoo.co.uk

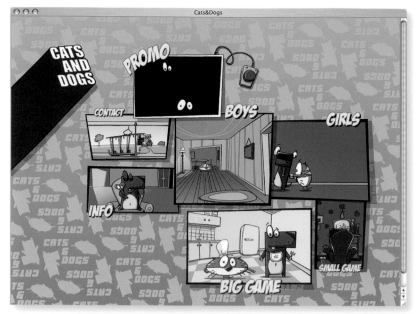

www.cats-and-dogs.be
D: jeroen van laethem C: kristoffer dams P: miech rolly
A: cats and dogs M: evan@theparkinglot.com

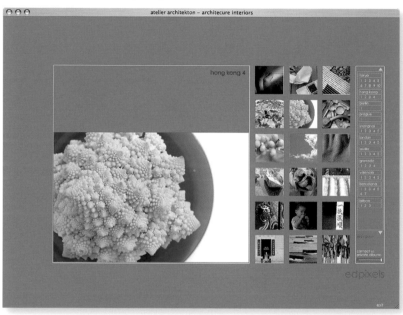

www.atelier-architekton.com
D: edmund chan
A: atelier-architekton M: edmundchan1@yahoo.com

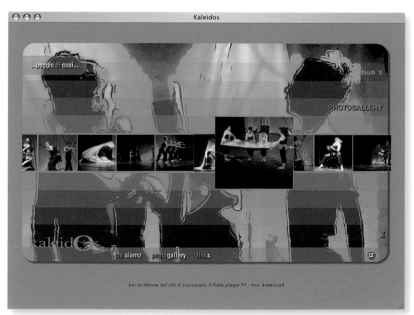

www.kaleidosdanza.com
D: nicola destefano
M: info@empusa.it

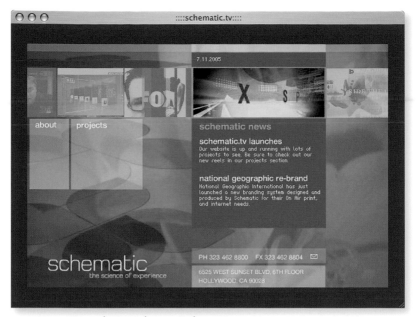

www.vidromedia.com/portfolio/schematic/index.html
D: rocio villalobos
A: schematic M: rocio@vidromedia.com

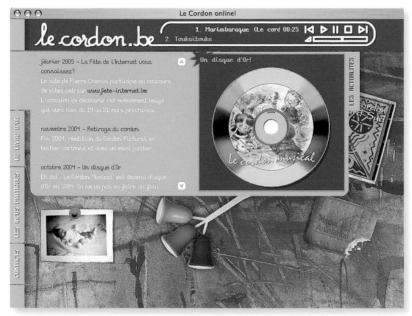

www.lecordon.be
D: benoît vrins C: martin dewolf P: pierre chemin
A: média animation M: b.vrins@media-animation.be

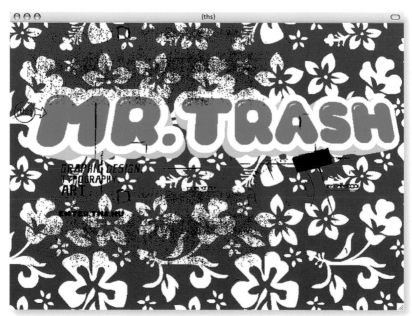

www.ths.nu
D: thomas schostok
A: {ths} thomas schostok design M: www.ths.nu

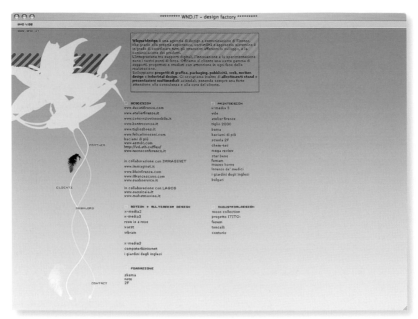

www.wnd.it
D: whynotdesign
A: whynotdesign snc M: info@wnd.it

limoon.gafmediastudio.com
D: gabriel faucon
A: gafmedia studio M: limoon@neuf.fr

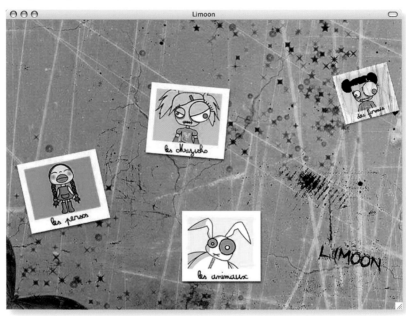

www.jarokoco.sk
D: julius bencko C: martin kapinos
A: absolution creative studio M: juiceabsolution.sk

www.mondotrendy.com
D: rosario vargas, pablo moreno C: rosario vargas P: rosario vargas
A: mondotrendy M: charuca@charuca.net

www.drachenboote.com
D: clemens conrad C: holger fitzner
A: n-load | next level of art design M: info@n-load.de

www.momedia.nl
D: coen van den broek
A: dreamsociety M: info@dreamsociety.nl

www.developdesign.ch
D: jan voellmy C: jan voellmy P: nicole boillat
A: edit M: jv@edit.li

www.abimaxx.de
D: dietz
A: nextarts internet marketing M: info@nextarts.de

www.nopage.nl
D: rob hamerlinck
A: nopage arnhem M: info@nopage.nl

www.arancedicalabria.com
D: francesco vicari C: francesco vicari P: magazzino virtuale
A: magazzino virtuale M: info@magazzinovirtuale.com

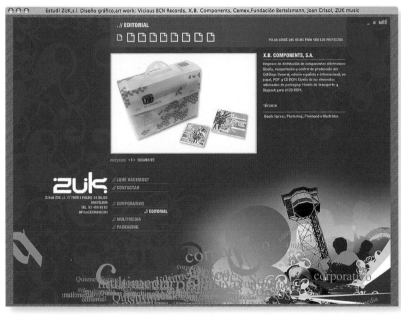

www.zetauka.com
D: xavi martin - guillermo lucini C: guillermo lucini P: guillermo lucini
A: estudi zuk M: guillermo@zetauka.com

www.alpixel.com
D: josep gonzalez C: oscar rey P: pedro ortiz
A: alpixel M: josep@alpixel.com

www.x-ten-electric.de
D: sebastian rühl
A: paranoiavisuals M: info@paranoia-visuals.de

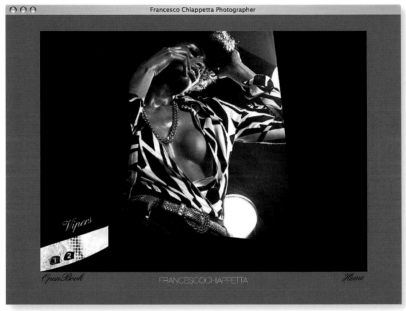

www.francescochiappetta.com
D: andrea cucchi
A: 3ies studio M: tre@3ies.it

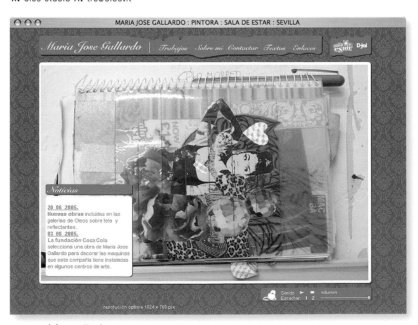

www.mariajosegallardo.com
D: jose alberto medina zurita C: rafael rivero
M: alberto@d-jal.com

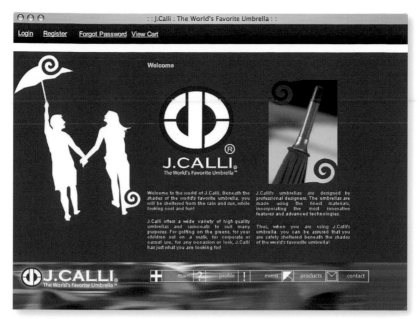

www.jcalli.com
D: kevin foong
A: gxm medialab M: lek@gxmstudio.com

www.raffaelecorcione.net
D: raffaele corcione
M: info@raffaelecorcione.net

www.ruachembalagens.com.br
D: bruno neves
A: ruach embalagens M: contato@brunofree.com.br

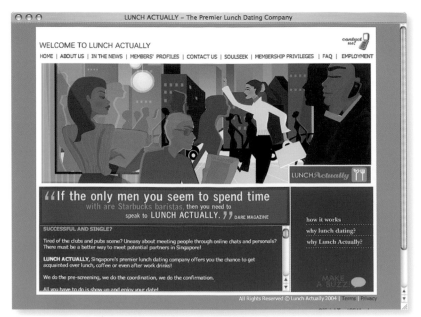

www.lunchactually.com
D: dawn teo C: james tan P: james tan
A: 2minds design M: teamsg@2mindsdesign.com

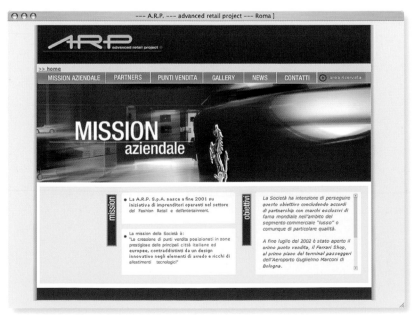

cv.uoc.edu/~rsanchezf/PEC2/PEC2.htm
D: ruben sanchez fernandez
M: ruben@factorianorte.com

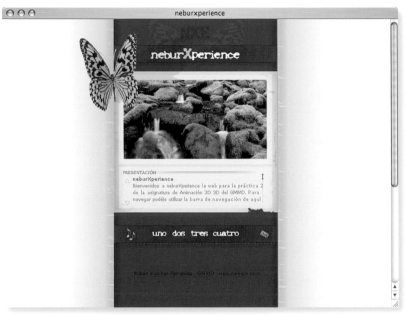

www.arpspa.com
D: gaia zuccaro P: arp s.p.a.
M: gaia.zuccaro@email.it

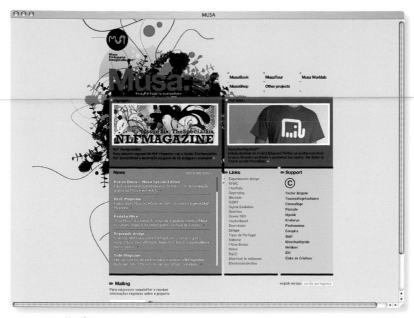

www.musacollective.com
D: raquel viana, ricardo alexandre, paulo lima C: raquel viana
A: musaworklab M: raquel.viana@musacollective.com

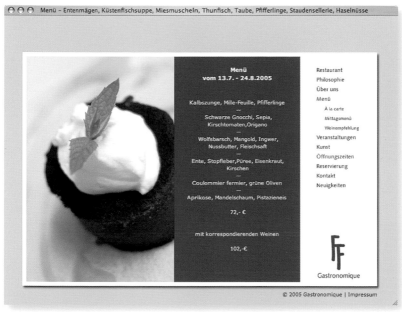

www.gastronomique.de
D: holisticdesign
A: holisticdesign M: info@holisticdesign.de

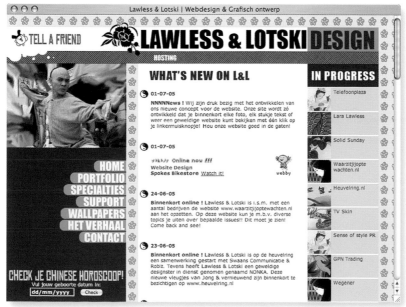

www.lawlesslotski.nl
D: lesley-ann hania, lotte staats C: lesley-ann hania P: lawless & lotski
A: lawless & lotski M: lesje@lawlesslotski.nl

www.grafikas.com
D: gra-fi-kas
A: gra-fi-kas M: talk@grafikas.com

www.metalomarao.pt
D: rafael machado C: pedro cunha P: rafael machado
A: metalomarão M: rafaelmachado@redirect.pt

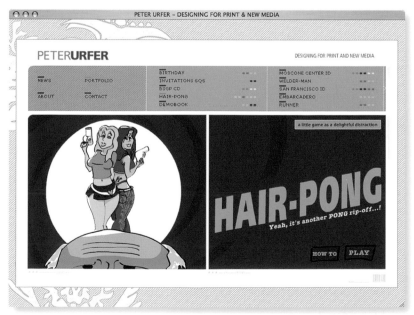

www.peterurfer.com
D: peter urfer
M: wdi@peterurfer.com

www.redberry-media.co.uk
D: piers berry
A: redberry media M: piersberry@mac.com

www.zerodesigners.com
D: sara mº sirvent C: enrique d. calatayud P: zerodesigners
A: zerodesigners M: info@zerodesigners.com

www.manualmente.it
D: demicheli alessandro, destefano nicola
M: info@dimostra.it

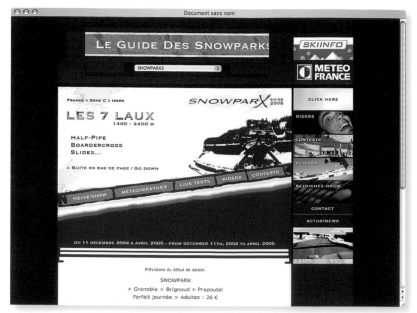

www.snowparx.net
D: jérémie mougeolle
A: fruta voodoo M: jm@frutavoodoo.com

www.sereiadagelfa.com
D: ricardo ferreira C: ricardo ferreira P: sereia da gelfa
A: mutitudo M: design@multitudo.net

www.bemsentar.pt
D: ana granja
A: pcw M: paulagranja@pcw.pt

www.remorse3.com
D: lance C: lance P: lance and remorse
A: syncprodz M: www.syncprodz.com

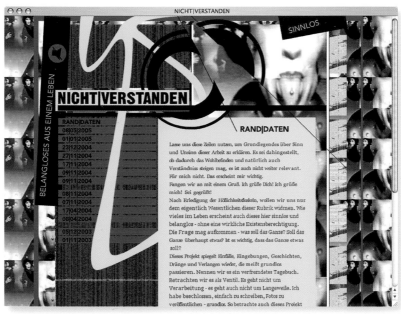

www.nichtverstanden.de
D: sutil daniel
M: daniel@sutil.de

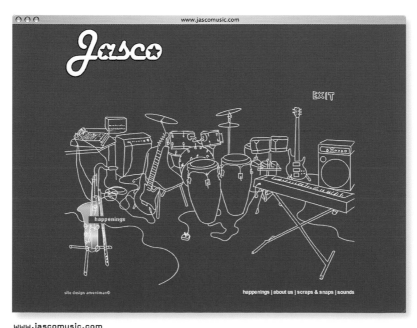

www.jascomusic.com
D: alison merriman
M: alison@amerriman.co.uk

www.projectemergencia.net
D: alfredo jaar C: joonyoung suk P: alfredo jaar
M: realpictures@aol.com

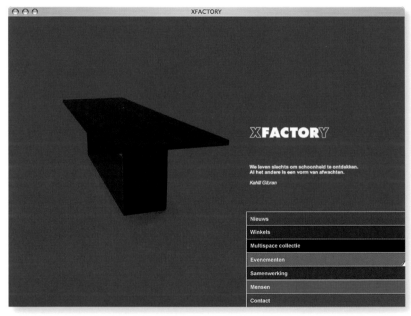

www.xfactory.nl
D: sjoerd eikenaar C: joost gielen P: freshheads
A: freshheads M: joost@freshheads.com

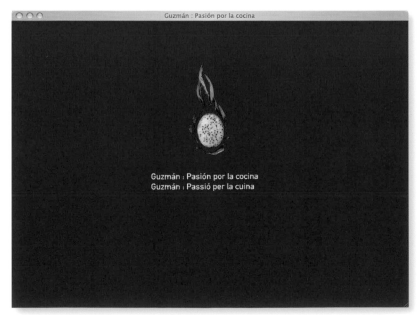

www.fruitsguzman.com
D: paco laluca C: sigurd buchberger P: annette abstoss
A: bamboo productions M: www.bamboo-productions.com

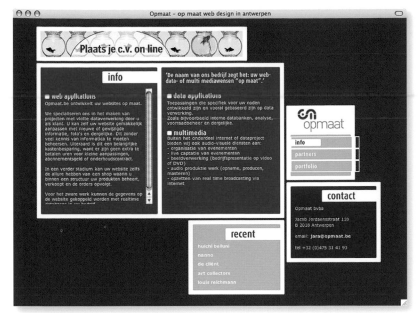

www.opmaat.be
D: pieter lesage C: raoul jacobs P: raoul jacobs
A: opmaat bvba M: jara@opmaat.be

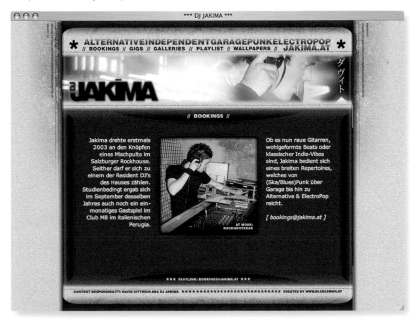

www.jakima.at
D: bernhard aichinger
A: dj jakima M: office@bluelemon.at

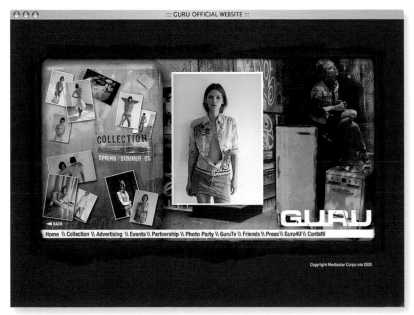

www.guru.it
D: marchiori emanuele C: marchiori emanuele P: mediastar corporate
A: mediastar corporate M: grafica@mediastarcorporate.com

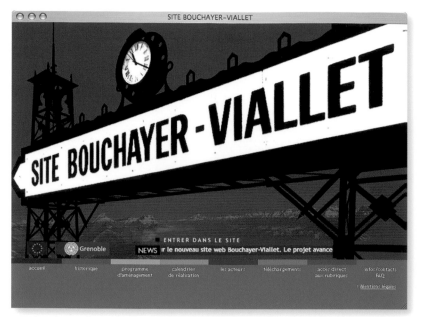

www.bouchayer-viallet.info
D: luc serrano C: chris gaillard P: luc serrano
A: beautifulscreen.tv M: chris@chrisgaillard.com

www.athleticbihotzez.com
D: nemonica
A: nemonica M: sgarcia@nemonica.com

www.mirandalockhorst.nl
D: jeroen vesseur
A: klowntjepiet.com M: jeroen@klowntjepiet.com

www.effecter.net
D: rei ogata
A: effecter M: lay@effecter.net

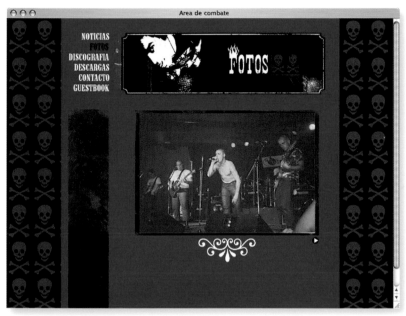

www.areadecombate.com
D: david sanchez fernandez
A: factoria norte M: ruben@factorianorte.com

www.en-movimiento.org
D: xavi royo
A: xafdesign M: info@xafdesign.com

www.septime-creation.com
D: septime team
A: septime team M: contact@septime-creation.com

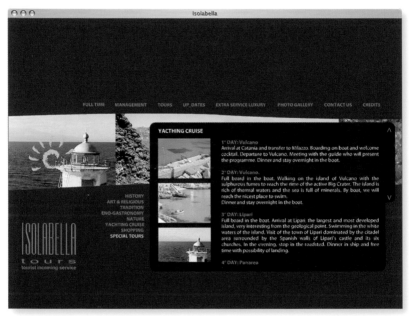

Isolabella

FULL TIME MANAGEMENT TOURS UP_DATES EXTRA SERVICE LUXURY PHOTO GALLERY CONTACT US CREDITS

HISTORY
ART & RELIGIOUS
TRADITION
ENO-GASTRONOMY
NATURE
YACHTING CRUISE
SHOPPING
SPECIAL TOURS

ISOLABELLA
t o u r s
tourist incoming service

YACHTING CRUISE

1° DAY: Vulcano.
Arrival at Catania and transfer to Milazzo. Boarding on boat and welcome cocktail. Departure to Vulcano. Meeting with the guide who will present the programme. Dinner and stay overnight in the boat.

2° DAY: Vulcano.
Full board in the boat. Walking on the island of Vulcano with the sulphurous fumes to reach the rime of the active Big Crater. The island is rich of thermal waters and the sea is full of minerals. By boat, we will reach the nicest place to swim.
Dinner and stay overnight in the boat.

3° DAY: Lipari
Full board in the boat. Arrival at Lipari, the largest and most developed island, very interesting from the geological point. Swimming in the white waters of the island. Visit of the town of Lipari dominated by the citadel area surrounded by the Spanish walls of Lipari's castle and its six churches. In the evening, stop in the roadsted. Dinner in ship and free time with possibility of landing.

4° DAY: Panarea

www.isolabellatours.com
D: michelangelo petralito, lolanda rotiroti
A: im'zdesign M: michelangelopetralito@imzdesign.com

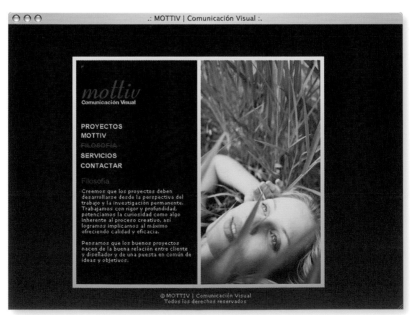

.: MOTTIV | Comunicación Visual :.

mottiv
Comunicación Visual

PROYECTOS
MOTTIV
FILOSOFÍA
SERVICIOS
CONTACTAR

Filosofía

Creemos que los proyectos deben desarrollarse desde la perspectiva del trabajo y la investigación permanente. Trabajamos con rigor y profundidad, potenciamos la curiosidad como algo inherente al proceso creativo, así logramos implicarnos al máximo ofreciendo calidad y eficacia.

Pensamos que los buenos proyectos nacen de la buena relación entre cliente y diseñador y de una puesta en común de ideas y objetivos.

© MOTTIV | Comunicación Visual
Todos los derechos reservados

www.mottiv.com
D: martín fernández álvarez C: twa s.l. P: martín fernández álvarez
A: mottiv | comunicación visual M: martin@mottiv.com

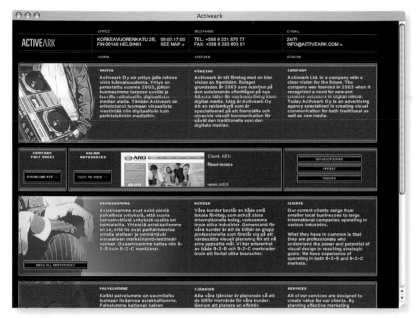

www.activeark.com
D: j. hautamaki, j. mikander C: samuel thesleff P: robin bade
A: activeark ltd M: robin.bade@activeark.com

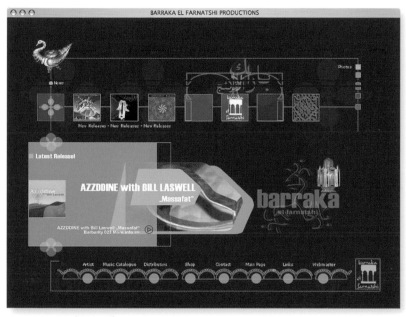

www.maroc.net/barraka/
D: nasreddine fidouh C: nasreddine fidouh P: barraka elfarnashi
A: neue medien und wege

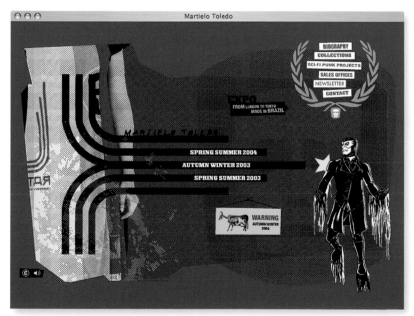

www.martielotoledo.com
D: herbert rafael
A: 3bits.net M: hrafael@3bits.net

www.harpox.com
D: ghirardi giovanni
M: lab@harpox.com

www.bornformusic.nl
D: leonard hamers
A: yaikz! M: leo@yaikz.nl

www.ideegrafiche.net
D: marco cabboi
A: ideegrafiche M: info@ideegrafiche.net

www.stockphotos.es
D: josep gonzalez
A: alpixel M: josep@alpixel.com

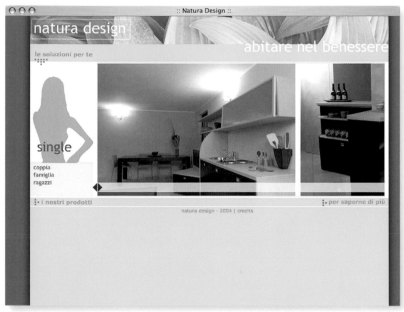

www.naturadesign.it
D: meta-idea
A: meta-idea M: andrea.greco@meta-idea.com

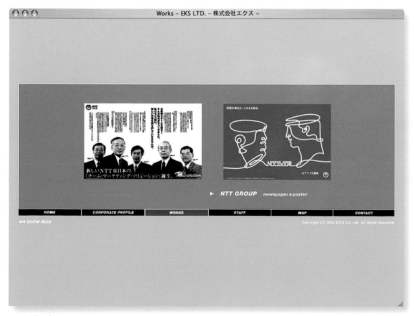

www.eks-jp.com
D: kenji abe
M: sltgr_akj@yahoo.co.jp

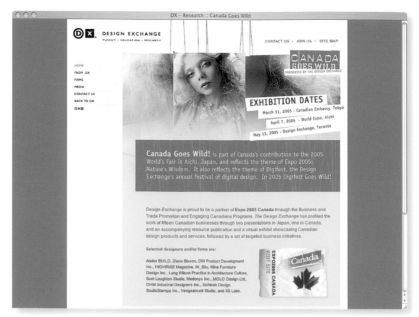

www.dx.org/canadagoeswild
D: edvin lee C: edvin lee P: paola poletto
A: design exchange toronto M: hello@piperboy.com

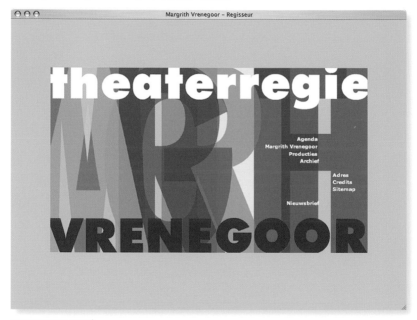

www.mvrenegoor.nl
D: els de jong C: thijs van der laan P: suzanne rodrigues pereira
A: browserbeest M: srp@browserbeest.nl

www.magaclick.com
D: magali piterman
A: magaclick M: www.magaclick.com

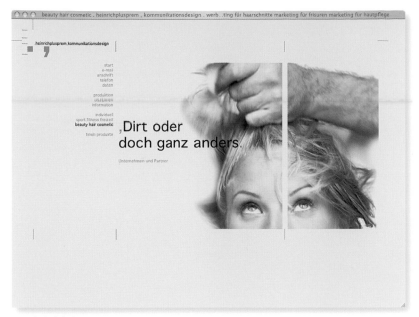

www.heinrichplusprem.com
D: claus, roland, heinrich C: patricia prem
A: heinrichplusprem M: hallo@heinrichplusprem.com

www.000-3.com
D: cedric van eenoo
M: mail@000-3.com

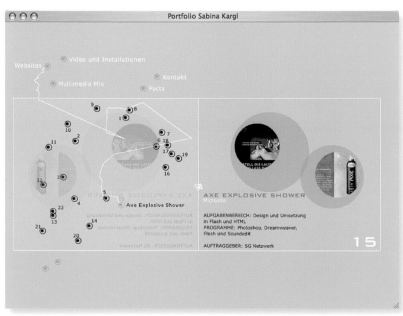

www.sabinakargl.at
D: sabina kargl
A: sabina kargl M: office@sabinakargl.at

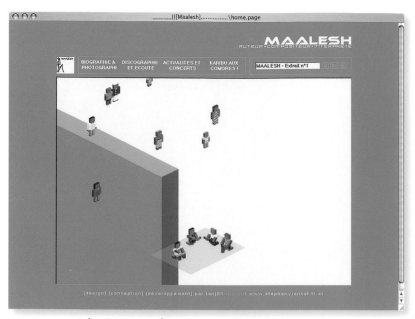

perso.wanadoo.fr/stephan.viennet/maalesh
D: stéphan viennet
A: stéphan viennet M: stephan.viennet@wanadoo.fr

www.mundoverde.tk
D: karin reyes
A: mundoverde.tk M: pinion@outgun.com

www.webberz.it
D: marco marini
A: webber M: marco.m@webberz.it

www.creaopenweb.com
D: christelle barraud
A: créa open web M: contact@creaopenweb.com

www.carlosmarcelo.com
D: eric deesey
A: eric deesey interactive M: matrixmovie@poczta.onet.pl

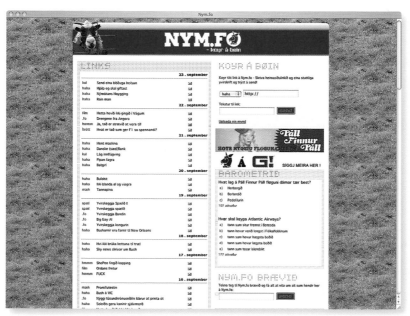

www.nym.fo
D: runar reistrup, svein rasmussen C: svein rasmussen P: runar reistrup
A: reistrup.com M: runar@reistrup.com

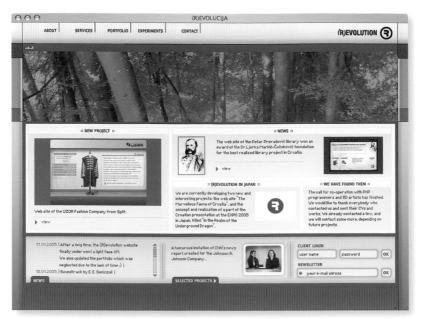

www.revolucija.hr
D: vladimir koncar C: gorjan agacevic
A: revolution ltd. M: vladimir@revolucija.hr

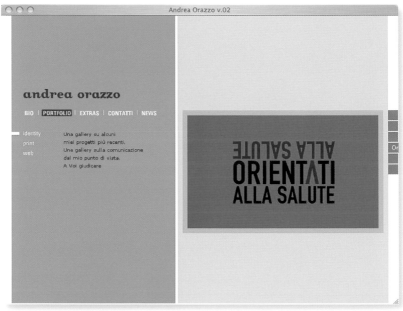

www.andreaorazzo.com
D: andrea orazzo
M: andrea@andreaorazzo.com

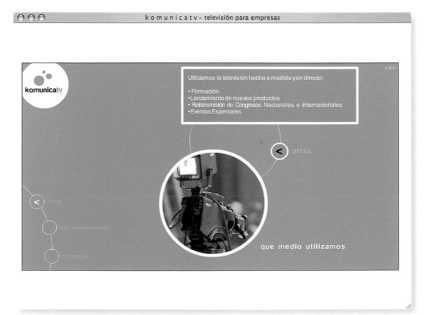

www.komunicatv.com
C: jordi pujadas P: hector anoro
A: producions planetàries M: info@propla.net

262

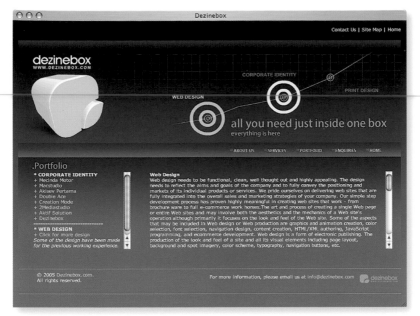

www.dezinebox.com
D: amril abdul rahman
A: dezinebox M: info@dezinebox.com

www.pixeloso.com
D: marcelo lozada
A: pixeloso M: info@pixeloso.com

www.laietanajazzproject.com
D: josep ortega C: pablo sánchez
A: kings of mambo M: www.kingsofmambo.com

www.engineers-cgn.de
D: claus huber **C:** daniel scholz
A: engineers **M:** mail@engineers-cgn.de

www.llemon.com
D: ting
A: llemon **M:** t-in@163.com

www.min-style.de
D: jann de vries
M: contact@min-style.de

www.beautiful-junk.com
D: chun woei C: terry neoh P: tau-ew.com
A: tau-ew.com M: terry@tau-ew.com

www.toptalent.europrix.org/tta05/index.htm
D: martin hyde C: dejan linkic P: rainer steindler
A: martin hyde design M: www.martinhyde.co.uk

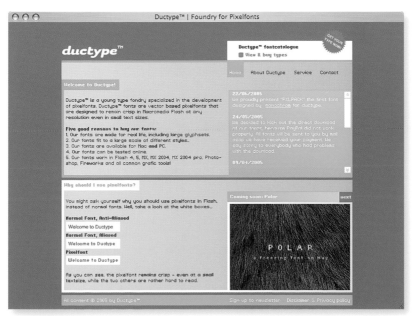

www.ductype.com
D: ted fröhlich, kai heuser
A: ductype M: nico@ductype.com

www.fluidowear.com
D: fabio geloso
M: lup@email.it

www.arthousetraffic.com
D: alex chepiga C: alex chepiga P: dennis ivanov
A: arthousetraffic M: creative@arthousetraffic.com

www.paulremmelts.nl
D: paul remmelts
A: studio rmmlts M: info@paulremmelts.nl

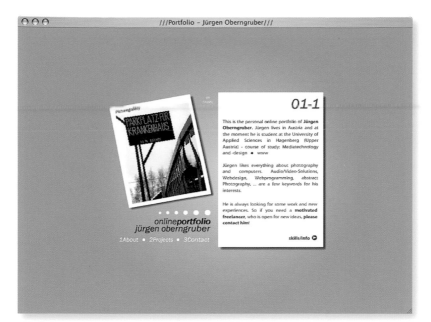

www.baby-4-face.com
D: oberngruber jürgen
M: juergen.oberngruber@fh-hagenberg.at

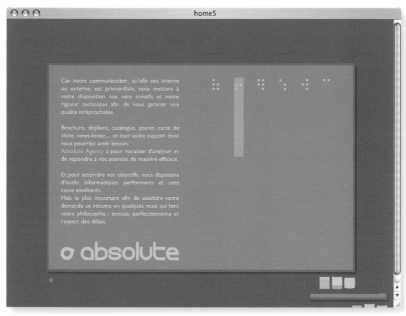

www.absolute-agency.be
D: hélène renaud
A: absolute agency M: helene@absolute-agency.be

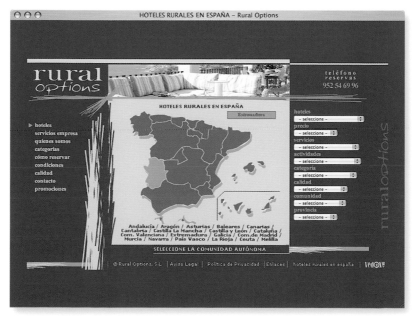

www.ruraloptions.com
D: rosa heredia C: alejandro mozo
A: vedox.com M: www.vedox.com

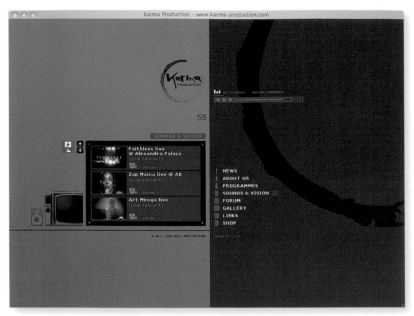

www.karma-production.com
D: fx. marciat C: fx. marciat P: j. veronesi
A: xy area M: xy@xyarea.com

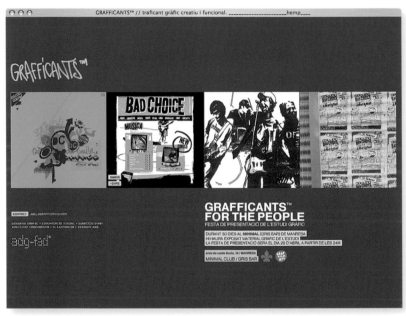

www.grafficants.com
D: joel abad
A: grafficants.com M: joel@grafficants.com

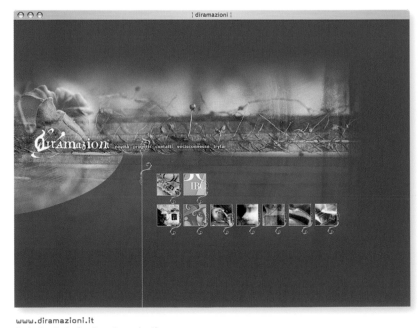

www.diramazioni.it
D: tryfar C: tryfar P: autoproduction
M: tryfar@diramazioni.it

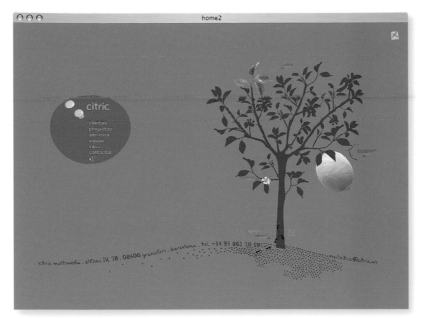

www.citric.ws
D: citric sala multimedia
A: citric M: feno@citric.ws

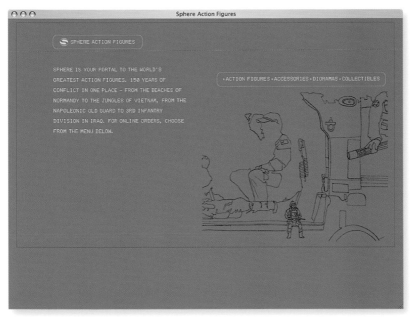

www.spheremarketing.net
D: ivan tan, reuben kee P: jean tan
A: everyday design M: ivan@everyday.com.sg

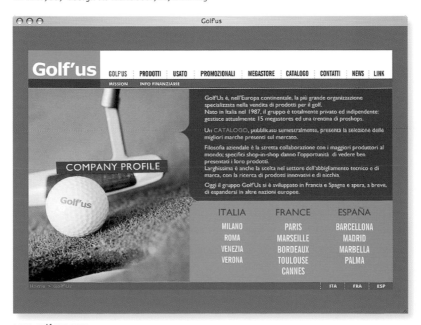

www.golf-us.com
D: grusovin paolo

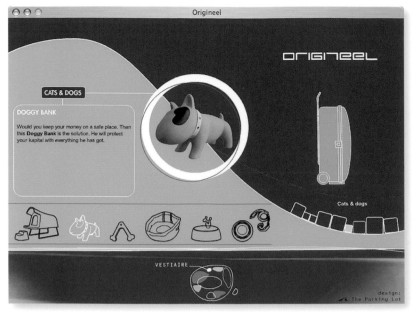

www.origineel.be
D: jeroen van laethem C: kristoffer dams P: miech rolly
A: origineel M: evan@theparkinglot.com

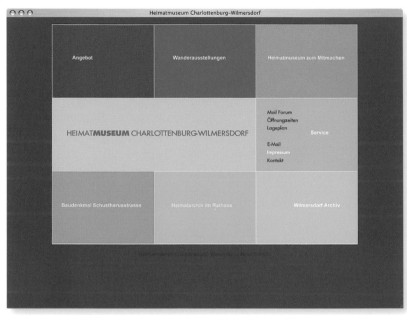

www.heimatmuseum-charlottenburg.de
D: torsten schöbel
M: schoebel@miomodo.de

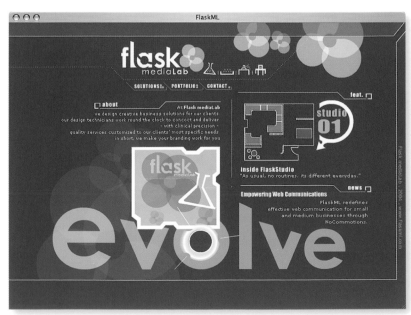

www.flaskml.com
D: kaitat
A: flask medialab M: kaitat@flaskml.com

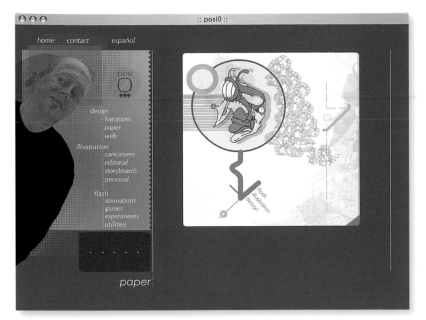

www.posi0.com
D: alfonso fernández
A: de facto M: alfonso.fernandez@defactops.com

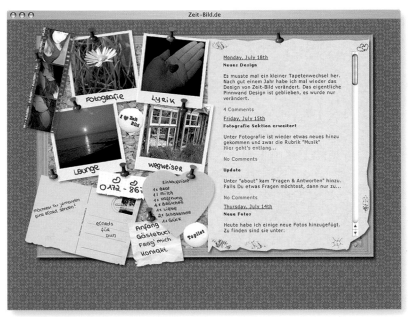

www.zeit-bild.de
D: sabine rosch
M: sabine@zeit-bild.de

www.tau-ew.com/bjunk
D: terry neoh
A: tau-ew.com M: terry@tau-ew.com

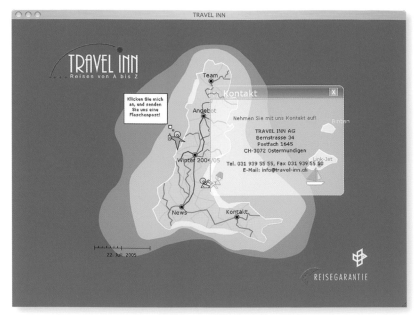

www.travel-inn.ch
D: christoph salzmann
A: lobuma M: cs@lobuma.ch

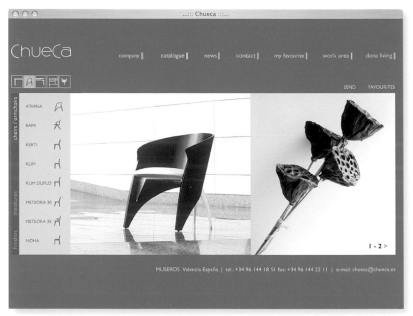

www.chueca.es
D: chary esteve C: benjamín núñez P: cdroig
A: cdroig M: maria@cdroig.com

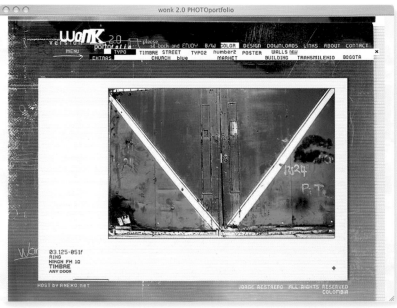

www.wonksite.com
D: jorge restrepo
A: + wonksite + M: wonksite@gmail.com

www.kleresite.nl
D: l.f. hamers
A: yaikz! M: info@yaikz.nl

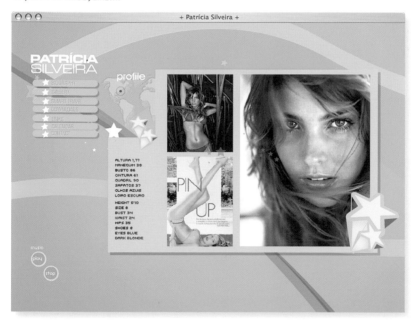

www.patriciasilveira.com.br
D: digitalmakers
A: digitalmakers M: kenj@digitalmakers.com.br

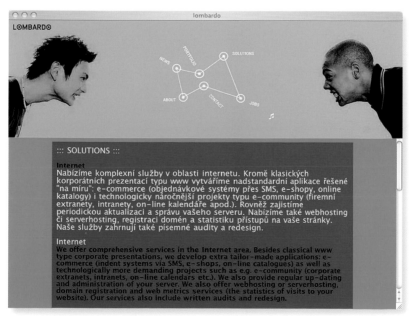

::: SOLUTIONS :::

Internet
Nabízíme komplexní služby v oblasti internetu. Kromě klasických korporátních prezentací typu www vytváříme nadstandardní aplikace řešené "na míru": e-commerce (objednávkové systémy přes SMS, e-shopy, online katalogy) i technologicky náročnější projekty typu e-community (firemní extranety, intranety, on-line kalendáře apod.). Rovněž zajistíme periodickou aktualizaci a správu vašeho serveru. Nabízíme také webhosting či serverhosting, registraci domén a statistiku přístupů na vaše stránky. Naše služby zahrnují také písemné audity a redesign.

Internet
We offer comprehensive services in the Internet area. Besides classical www type corporate presentations, we develop extra tailor-made applications: e-commerce (indent systems via SMS, e-shops, on-line catalogues) as well as technologically more demanding projects such as e.g. e-community (corporate extranets, intranets, on-line calendars etc.). We also provide regular up-dating and administration of your server. We also offer webhosting or serverhosting, domain registration and web metrics services (the statistics of visits to your website). Our services also include written audits and redesign.

www.lombardo.cz
D: jan trnka C: petr mára P: petr mára
A: lombardo M: petr.mara@lombardo.cz

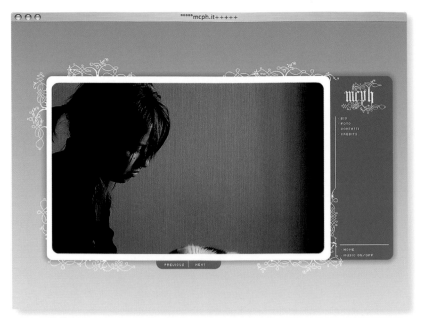

www.mcph.it
D: marco cabboi
A: ideegrafiche M: marco@mcph.it

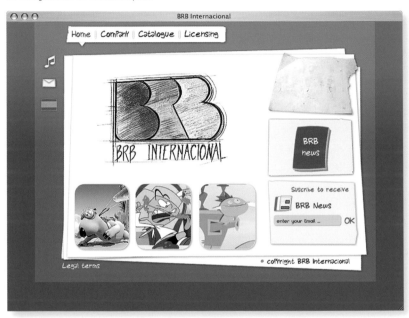

www.brb.es
C: luis dorado
A: espacio digital M: cqs@edigital.es

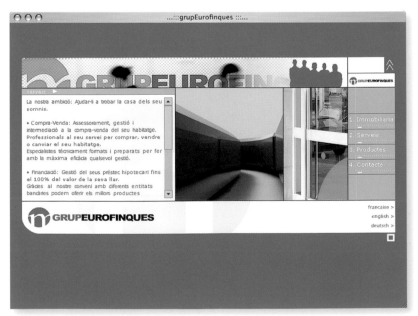

www.grupeurofinques.com
D: roberto sancho martinez C: isidro sanchez
A: cub animacio M: roberto@cubanimacio.com

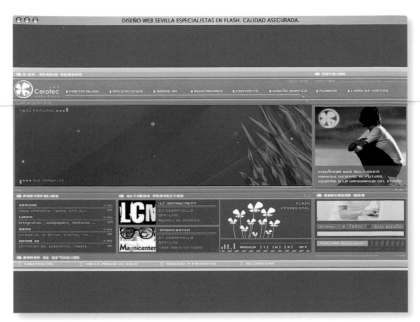

www.cerotec.net
D: sergio romero cortijo
A: cerotec estudios M: sergio@cerotec.net

www.ericeiracamping.com
D: multiweb ti lda P: luís martins
A: multiweb ti lda M: lmartins@multiweb.pt

www.aims.it
D: jiolahy C: francesco pastore
A: jiolahy M: info@jiolahy.it

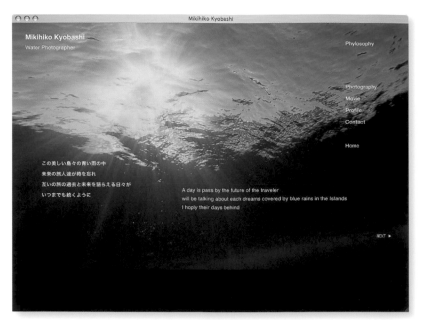

www.mikihiko.com
D: yagi takaaki
A: form::process M: yagi@form-process.com

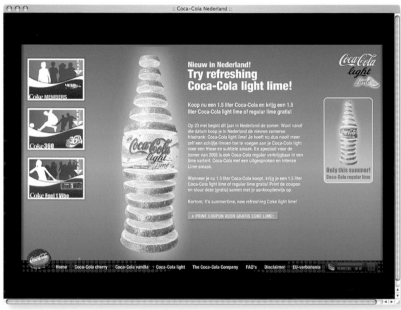

www.enjoylight.nl
D: jurriaan van bokhoven, roel ter voort C: neil young P: clockwork
A: clockwork M: jurriaan@clockwork.nl

www.2ndsky.com
D: daniel boran C: mike rosenbusch P: daniel boran
A: riegg & partner intercorp. gmbh M: info@2ndsky.com

www.pasol.org
D: knowledge stream
A: knowledge stream M: lucas.ober@knowledge-stream.net

www.markia.it
D: marta dallasta
A: studio grafico markia M: info@markia.it

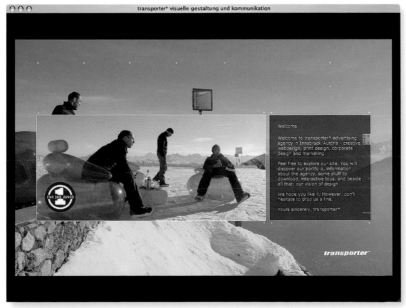

www.transporter.at
D: fabrizi, hoeller, reiter
A: transporter* M: lounge@transporter.at

www.ingraphicswetrust.com
D: sebastian onufozak
A: in graphics we trust M: onufszak@ingraphicswetrust.com

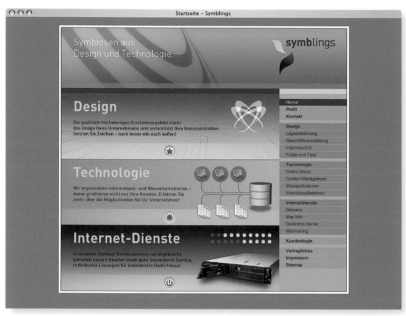

www.symblings.net
D: frank beier C: florian bauer
A: symblings communication components M: kontakt@symblings.net

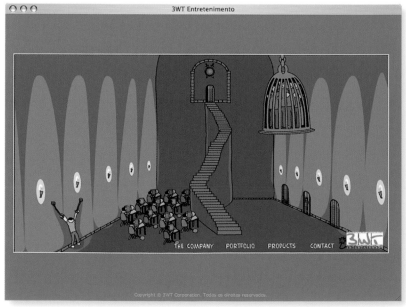

www.3wt.com.br/entretenimento
D: luciano guedes C: luciano guedes P: adriano kancelkis
A: ápice tecnologia de informação M: lu75br@yahoo.co.uk

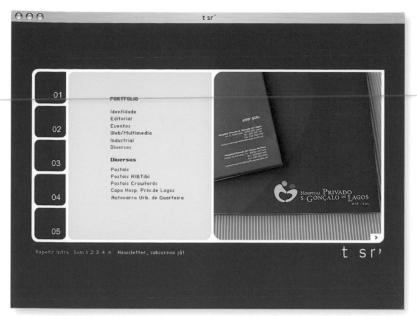

www.teaser.pt/turdestanos/
D: bruno conceição
M: bruno@teaser.pt

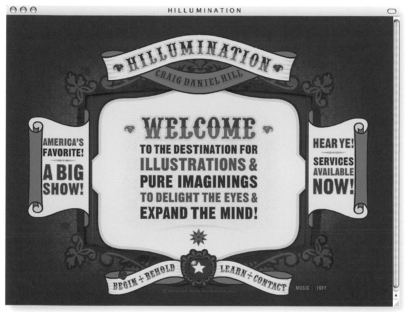

www.hillumination.com
D: craig hill
M: info@hillumination.com

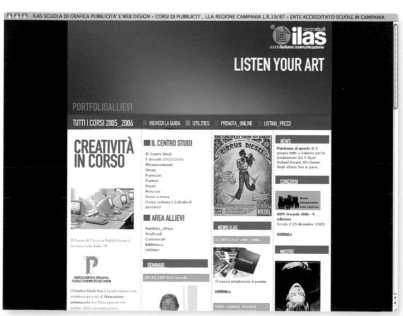

www.ilas.com
D: veronica cangemi C: stafano simioli P: argentovivo, ilas
A: centro studi ilas M: direttore@ilas.com

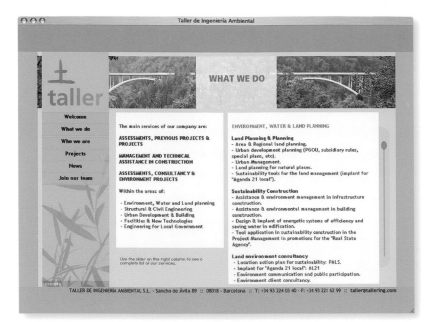

www.tallering.com
D: pedro valdeolmillos
A: meltemi M: pv@meltemi.info

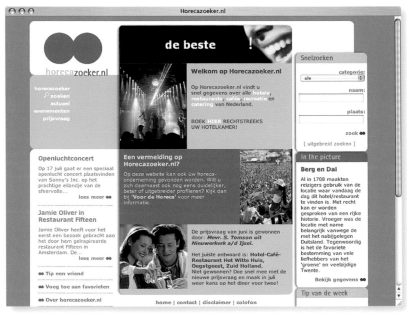

www.horecazoeker.nl
D: johan van tongeren C: jos leenen
A: insiders online M: johan@insiders.nl

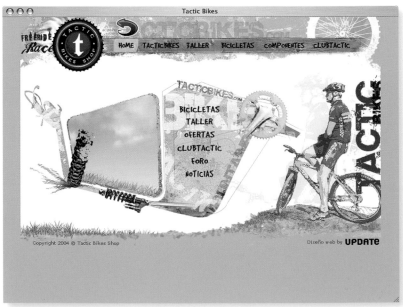

www.tacticbikes.com
D: kike rodriguez
A: update M: www.update.es

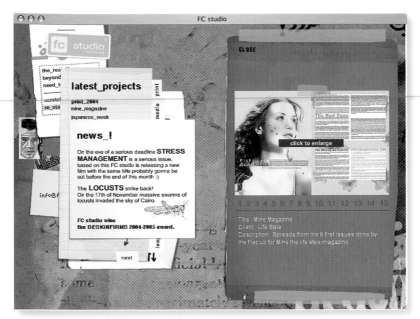

www.fileclub.org
D: fc studio C: sherif samy P: fc studio
A: fc studio M: sherifsamy@fileclub.org

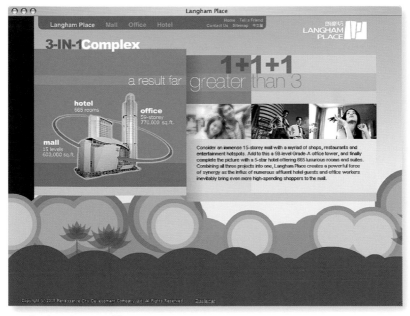

www.langhamplace.com.hk
D: denis lee P: davy ma
A: media explorer ltd. M: sam@me.com.hk

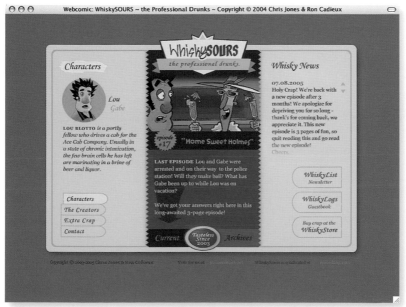

www.whiskysours.com
D: chris jones
A: jonesid.com M: www.jonesid.com

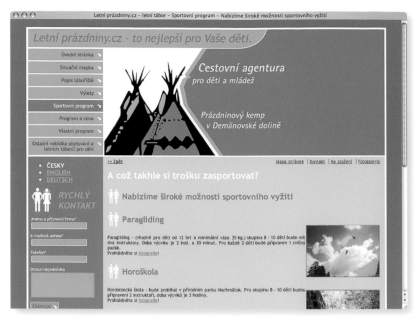

www.letniprazdniny.cz
D: lukas sudacki C: lukas sudacki P: jaroslav zberovsky
A: mediafabrica M: sudacki@mediafabrica.cz

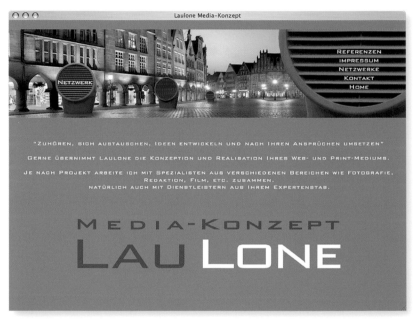

www.LauLone.de
D: j.schütters
A: laulone M: info@laulone.de

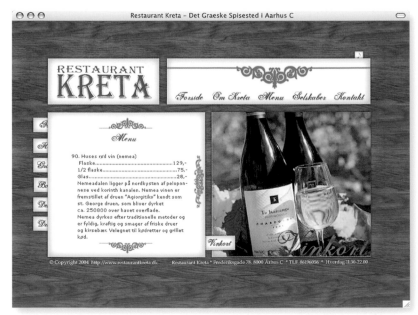

www.restaurantkreta.dk
D: maruf yusupov C: shakhboz sidikov P: katsiaryna staurapoltsava
A: k&m – creative media M: info@kandm.dk

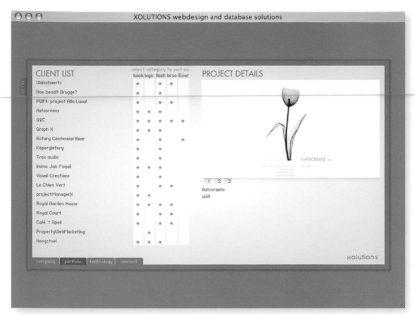

www.xolutions.be
D: xolutions
A: xolutions M: gijs@xolutions.be

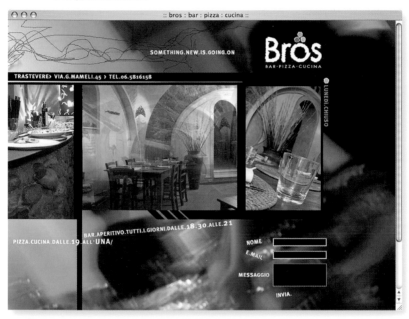

www.brosroma.com
D: francesco kurhajec C: alessandro balasco P: kmstudio
A: kmstudio M: info@kmstudio.it

www.monokai.nl
D: wimer hazenberg
A: booreiland M: wimer@booreiland.nl

www.kimbretton.com
D: nik jordan
A: dayseven M: www.dayseven.co.uk

www.woodker.it
D: mediarte srl
A: mediarte srl M: francesco@mediarte.it

www.sueperseks.de
D: stefan schröter C: joscha rüdel P: salon91 media network
A: salon91 media network M: kontakt@salon91.com

www.amirlev.tk
D: doron yefet
A: black is good M: contact@blackisgood.ch

www.brantt.be
D: hipatrip
A: hipatrip M: www.hipatrip.com

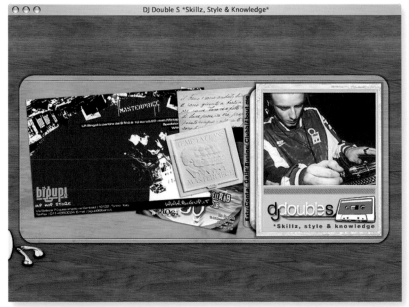

www.djdoubles.com
D: massimo sirelli
A: dimomedia lab M: info@dimomedia.com

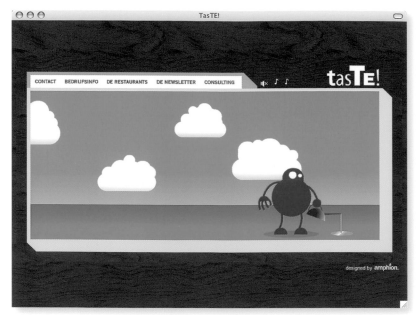

www.taste.nu
D: toon van de putte
A: amphion M: info@amphion.be

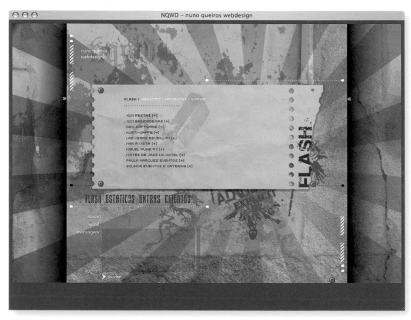

www.nunoqueiros.co.pt
D: nuno queiros
A: nuno queiros design M: nunoqueiros@yahoo.com

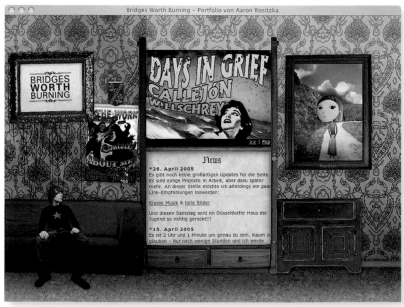

www.bridgesworthburning.com
D: aaron rositzka
A: bridges worth burning M: aaron@bridgesworthburning.com

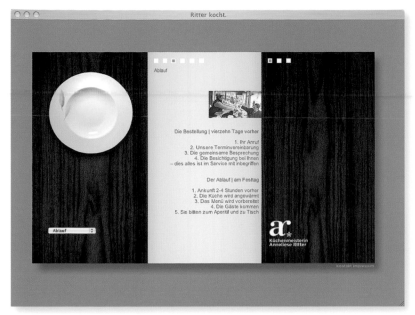

www.ritter-kocht.de
D: ilja sallacz C: sebastian onufszak P: sebastian onufszak
A: liquid | agentur für gestaltung M: onufszak@ingraphicswetrust.com

www.hippocampestudio.com
D: anthony thibault, delphine lechat C: anthony thibault
A: hippocampe studio M: anthony@graphismedia.com

www.letsgotowar.com
D: joão mascarenhas
M: joao.mascarenhas@gmail.com

www.ippocity.com
D: veronica cangemi, angelo scognamiglio
A: centro studi ilas M: direttore@ilas.com

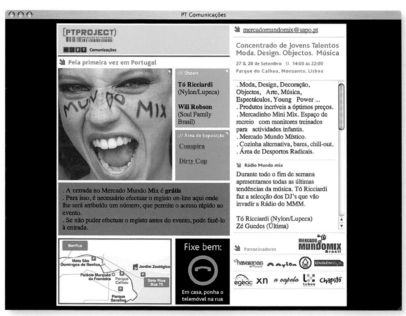

www.ptcom.pt/mercadomundomix
D: alexandra rocha C: joão fernandez P: vitor magalhães
A: webware | grupo infopulse M: alexandra.rocha@infopulse.pt

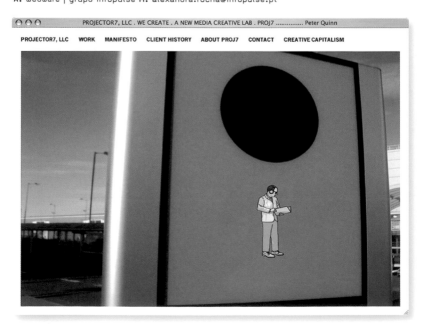

www.proj7.com
D: peter quinn
A: projector7, llc M: quinn@proj7.com

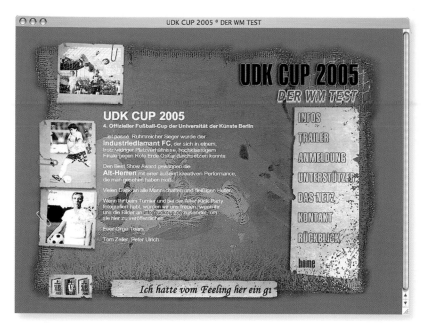

www.udkcup.de
D: peter ulrich
A: abmonk.de M: peter.ulrich@gmx.de

home.tele2.fr/zanzabar
D: eric
A: zanzabar M: zanzabar@tele2.fr

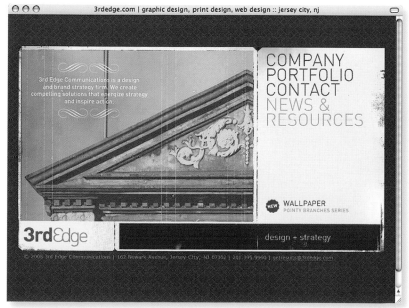

www.3rdedge.com
D: manny dilone, frankie gonzalez, melissa medina mackin
A: 3rd edge communications M: rob@3rdedge.com

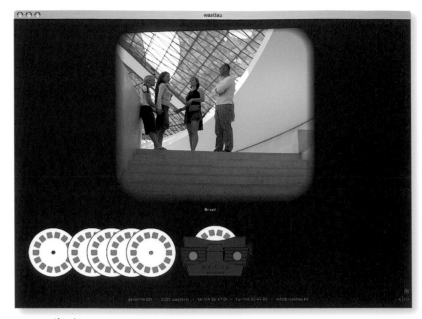

www.wastiau.be
D: alec lux **P:** pieter holvoet
A: corpstien **M:** alec@corpstien.be

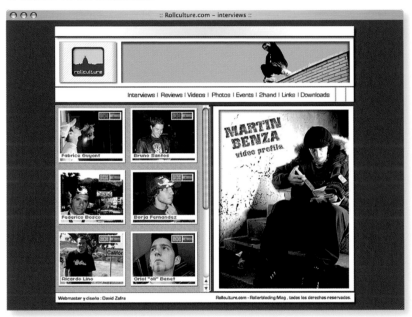

www.rollculture.com
D: david zafra
A: 1mind studios **M:** davidzafra@gmail.com

www.diet-riot.net
D: philipp zurmöhle
A: philipp zurmöhle **M:** mail@phillennium.com

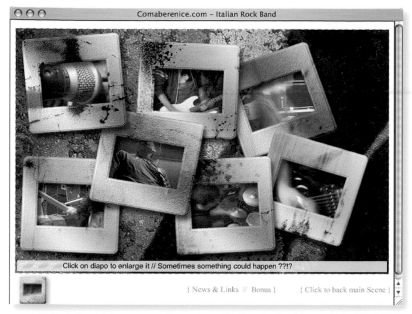

www.comaberenice.com
D: beat fly lab
A: comaberenice M: pakolongo@libero.it

www.kbm-informatica.com
D: fernanada katz C: gustavo manuzza P: kbm informática, s.l.
A: katz barrero & manuzza informática, s.l. M: info@kbm-informatica.com

www.elektrikbuttshaperz.com
D: plastikfantastik
A: plastikfantastik M: sale@terapija.net

www.hencken.com/design
D: christian klein, claus hencken C: christian klein
A: ceka media design M: ceka@ceka-media.net

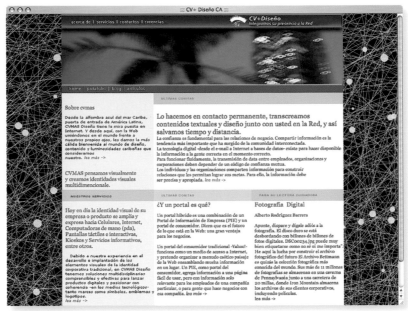

www.cvmas.net
D: cerro mijares C: pablo de dios P: cerro mijares
A: cv diseno ca M: cerro_mijares@cantv.net

www.postgal.com
D: john chan yu fung
A: postgal workshop M: info@postgal.com

www.flethenkieker.de
D: silvan jockel
M: info@silvanjockel.de

www.bilimmerkezi.org.tr
D: murat canbaz, selcuk safci
A: d4d digital brand solutions co M: murat@d4d.com.tr

www.montainifilms.com
D: dânia afonso
A: netamorphose M: design@netamorphose.pt

www.keik-bcn.com
D: roger ortuño flamerich
A: citric M: info@citricagency.com

www.x-filme.de
D: hermann köpf, klaus thomas
A: kader eins M: empfang@kadereins.net

www.bugwahn-dragracing.de
D: pixeleye interactive
A: pixeleye interactive M: dirk@pixeleye-racing.com

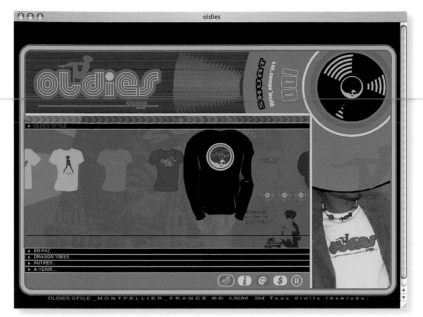

www.oldiesstyle.com
D: samh
A: samh M: samlform@free.fr

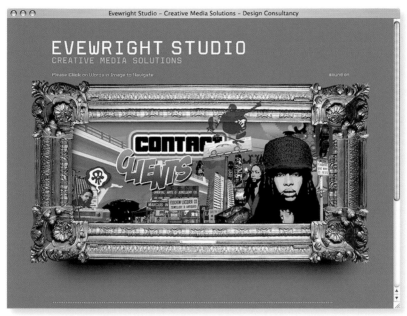

www.evewrightstudio.com
D: mike staines C: mike staines P: everton wright
A: mpsworks.co.uk/ltd M: mike@mpsworks.co.uk

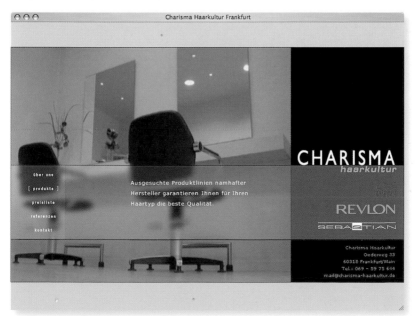

www.charisma-haarkultur.de/index1.htm
D: sylvia trautmann
A: das tagewerk M: info@das-tagewerk.de

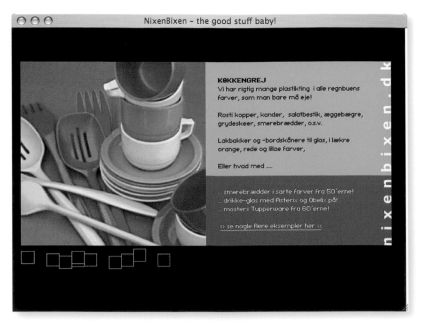

KØKKENGREJ
Vi har rigtig mange plastikting i alle regnbuens farver, som man bare må eje!

Rosti kopper, kander, salatbestik, æggebægre, grydeskeer, smørebrædder, o.s.v.

Lakbakker og -bordskånere til glas, i lækre orange, røde og lillae farver,

Eller hvad med

... smørebrædder i sarte farver fra 50'erne!
... drikke-glas med Asterix og Obelix på!
... mosters Tupperware fra 60'erne!

>> se nogle flere eksempler her <<

www.nixenbixen.dk
D: lars bregendahl bro P: kunstkonsulatet.dk
A: westend.dk M: lbb@westend.dk

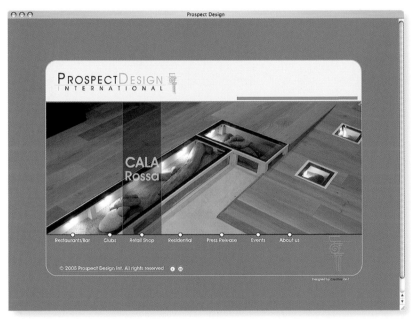

PROSPECTDESIGN
INTERNATIONAL

CALA
Rossa

Restaurants/Bar Clubs Retail Shop Residential Press Release Events About us

© 2005 Prospect Design Int. All rights reserved

Designed by Creative 24-7

www.prospect-design.com
D: alistair jameson
A: creative 24-7 M: alistair@247dxb.com

in records | news

inrecords

news

minimod
metalage e.p.

il primo progetto della in records è l' e.p. "metalage" della band "minimod", in un case di puro metallo dal design incredibilmente elegante...

noon
under the same sky (previsto ad aprile)

"under the same sky" è il titolo del primo album del progetto "noon", le poche notizie che ci è concesso dare...

minimod
album (previsto a maggio)

oltre alle tre tracce di metalage e.p. troverete altri 8 brani inediti...

www.in-records.com
D: vitaliano de vita
A: vitaliano de vita | visual communication M: info@vitalianodevita.com

www.mondsilber.de
D: bettina schmiedel
M: schmiedel@mondsilber.de

www.superstar-hk.com
D: e-quota.net
M: www.superstar-hk.com

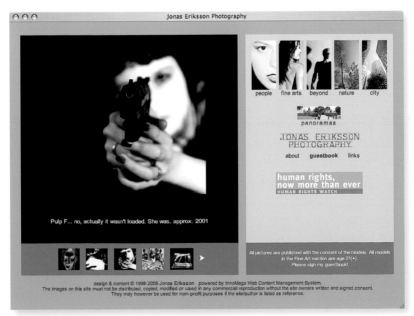

www.eriksson.de
D: jonas eriksson
A: innomega ag M: jonas.eriksson@innomega.de

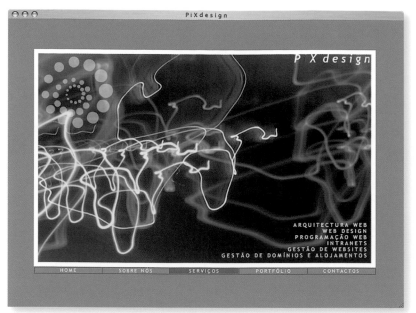

www.pix-design.net
D: pedro piedade
A: pix M: pedro@nitrogenio.net

www.instamersion.com
D: alexander cheng
A: instamersion studios M: alex@instamersion.com

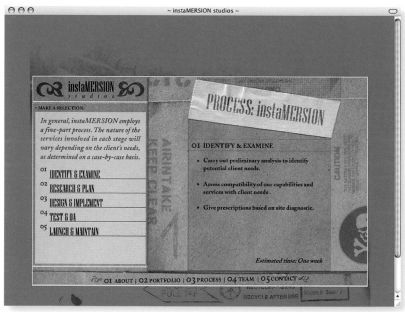

www.raizglobal.com/oscardelacuesta
D: oscar de la cuesta
A: oscar de la cuesta M: oscar.delacuesta@gmail.com

www.sterroir.com
D: stephanie terroir C: rana haber P: stephanie terroir
M: stephanie@sterroir.com

pixma.canon.mikrosites.com
D: maria tomeczek, judith hoffmann, dorota feicht, anja coyne
A: twmd gmbh M: mt@twmd.de

www.redley.com
D: sérgio barbará filho C: sérgio barbará filho
A: pura comunicação - design iltd M: sergio@puracomunicacao.com.br

www.chris-interactive.co.uk
D: christian williams
A: pretson city link M: icqhixxy@hotmail.com

www.mueblesgalarreta.com
D: guillermo rivillas soria P: guillermo rivillas
A: leitmotiv media s.l. M: www.leitmotivmedia.com

www.zementmosaikplatten.de
D: antje weber, hanno denker
A: querdenker M: hanno@quer-denker.com

noborder.hku.nl
D: dafna linden, rania baltagi C: eric miller P: dafna linden, rania baltagi
A: hku/ no border M: dafnalinden@yahoo.com

www.deli.naive.it
D: marco quintavalle
A: phorma studio s.r.l. M: m.quintavalle@phormastudio.com

www.pixemotion.net
D: david tisserand
M: pixemotion@wanadoo.fr

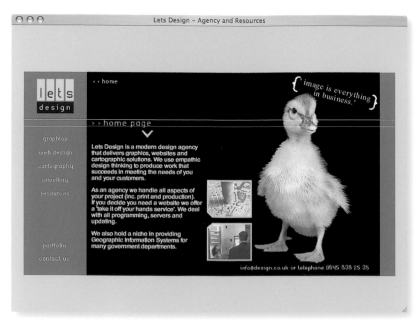

www.letsdesign.co.uk
D: david rudge
A: lets design M: drudge@letsdesign.co.uk

www.linkodromo.com.ar
D: marcelo pellizo, victor mochkofsky C: hemisferio 2 P: marcelo pellizo
A: pellizo design M: dear gunter beer

www.batunit.dk
D: lars bregendahl bro
A: westend.dk M: lbb@westend.dk

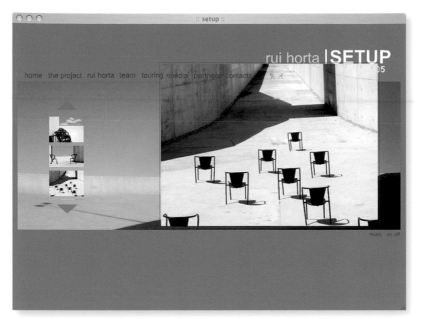

www.oespacodotempo.pt/setup
D: helder cardoso
A: o espaço do tempo M: hk_design@servk.com

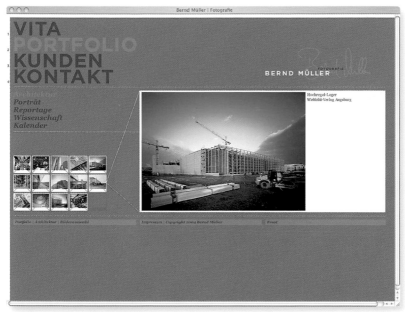

www.berndmueller-fotografie.de
D: sebastian onufszak C: sebastian onufszak P: bernd müller
A: liquid M: onufszak@liquid.ag

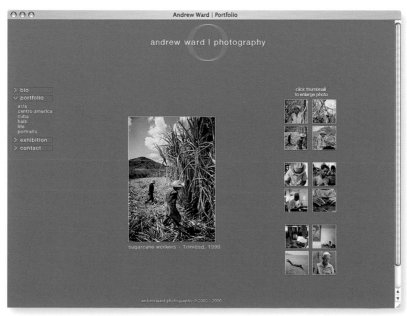

www.andrewwardphotos.com
D: alexandra ward
A: alexandra creative M: design@alexandracreative.com

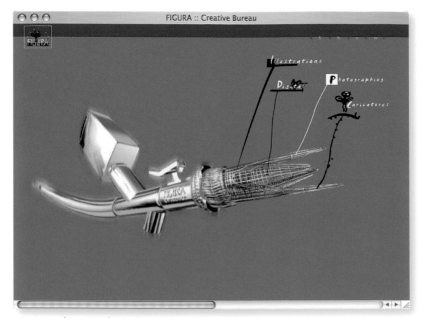

www.fgr.ru/figura_v2/index.html
D: serg liaschenko C: serg liaschenko P: figura creative bureau
A: figura creative bureau M: figura@fgr.ru

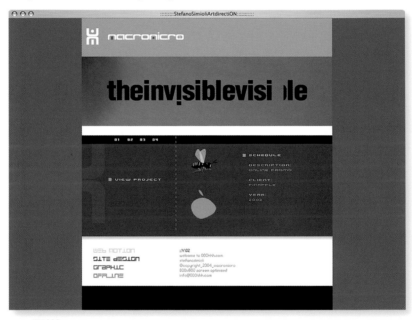

www.000hhh.com
D: stefano simioli
A: stefanosimioliartdirection M: info@000hhh.com

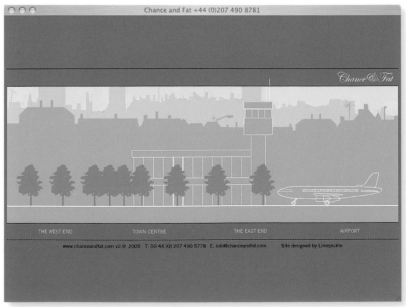

www.chanceandfat.com
D: mark jenkinson
A: limepickle limited M: mark@limepickle.net

www.modeklasse.at
D: oliver hunger
A: think a bit x-media communications M: office@thinkabit.net

www.rmoutinho.com.pt
D: ricardo moutinho
M: rmoutinho@mail.telepac.pt

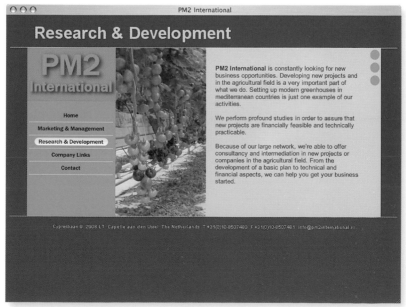

www.pm2international.nl
C: nelleke de boer
A: webwords M: info@webwords.nl

www.anderschristiansen.dk
C: jakob brandt-pedersen P: (stillleben)
A: spacecontroller M: jbrandtp@get2net.dk

www.webkantoor.info
D: peter westerhof C: peter otte, peter westerhof
A: webkantoor M: westerhof@webkantoor.net

www.paulavazquez.com
D: patricia pastor arratia C: mariano casla P: paula vázquez
A: bolaextra M: patricia@bolaextra.com

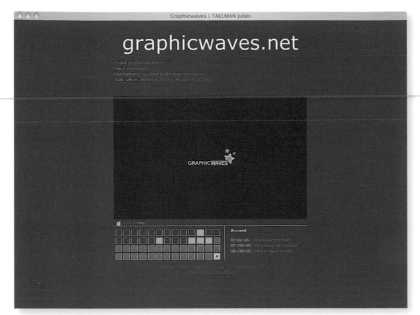

www.graphicwaves.net
D: julien taelman
A: graphicwaves M: julien.taelman@gmail.com

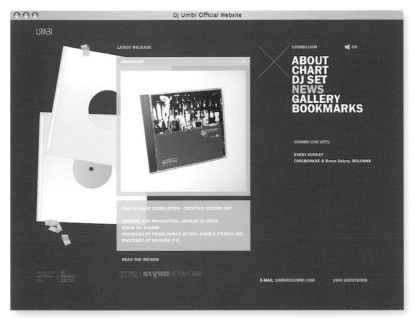

www.djumbi.com
D: giovanni paletta
A: djumbi M: umbi@djumbi.com

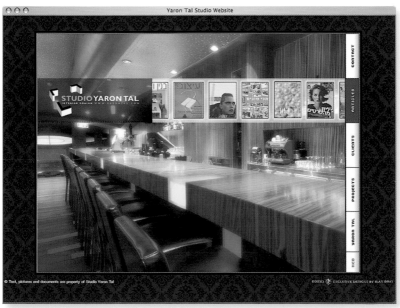

www.yarontal.com
D: ilan dray
A: inkod M: ilan@inkod.com

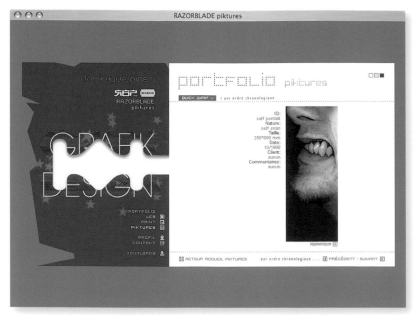

razorbladepiktures.free.fr
D: dominique gibert
M: d.gibert@numericable.fr

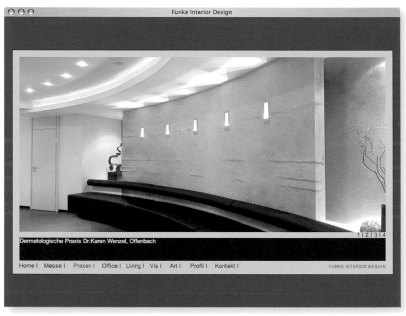

www.funkeinteriordesign.com
D: www.ch-art.de
M: info@ch-art.de

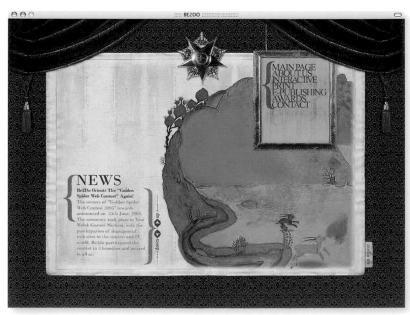

www.be2do.com
D: devrim altayli C: ihsan sedat ozkan P: banu ipeker
A: be2do.com M: info@be2do.com

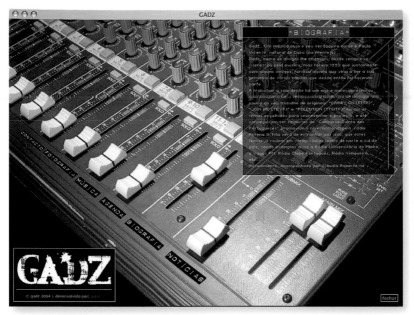

www.gadzproject.com
D: pedro espírito santo
M: aovelhanegra@hotmail.com

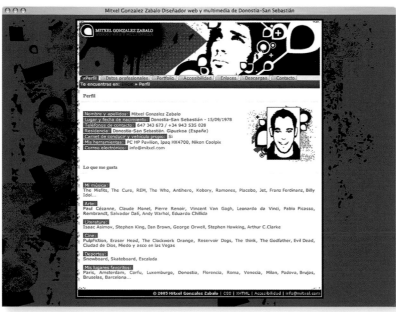

www.mitxel.com
D: mitxel gonzález
A: mitxel gonzález M: info@mitxel.com

www.pedroespiritosanto.net
D: pedro espírito santo
M: aovelhanegra@hotmail.com

www.guerillamedia.de
D: k. gulla
A: streamcom M: k.gulla@streamcom.de

www.thecrowd.be
D: sven godijn P: godijn sven
A: encounters media M: sven_godijn@hotmail.com

www.raulbelinchon.com
D: diego hurtado de mendoza
M: info@mantequillaymermelada.com

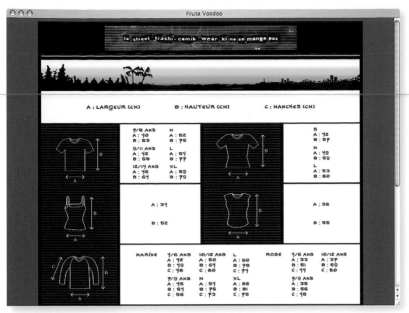

www.frutavoodoo.com
D: jérémie mougeolle
A: fruta voodoo M: jm@frutavoodoo.com

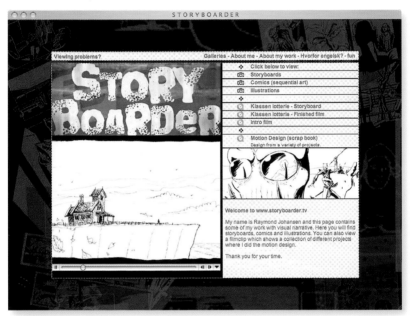

www.storyboarder.tv
D: raymond johansen C: raymond johansen, espen knudsen
A: accurro M: raymond@storyboarder.tv

www.cdgrafico.com
D: carlos durand
M: tootooarloc@yahoo.com

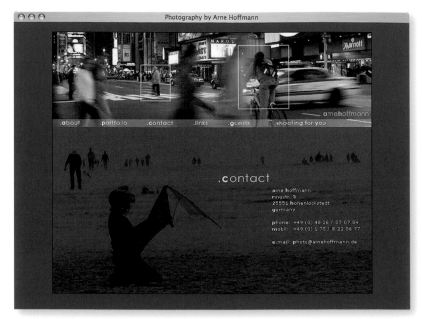

www.arnehoffmann.de
D: arne hoffmann
M: letters@arnehoffmann.de

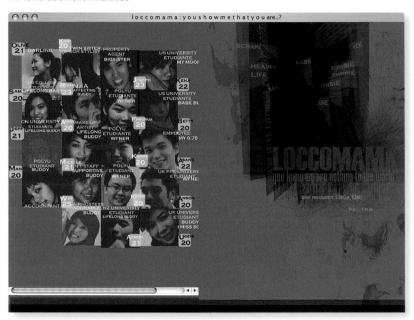

www.loccomama.com
D: ren
A: nu M: private_kodi@yahoo.com

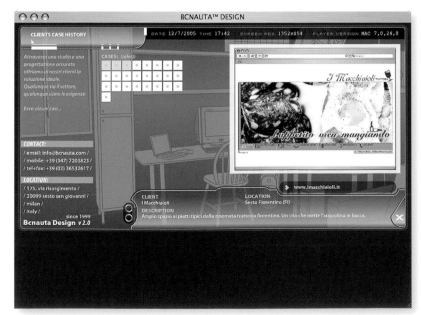

www.bcnauta.com
D: simone simola
A: bcnautadotcom M: simone@bcnauta.com

www.mojime.de
D: moritz mehrlein
A: mojime:media M: mail@mojime.de

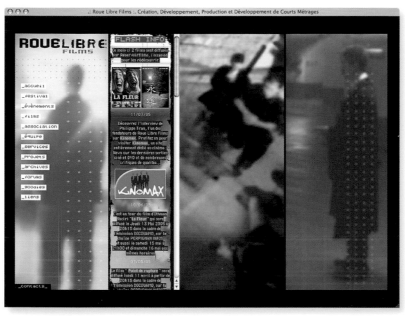

www.rouelibre-films.com
D: ballot anastasia
A: roue libre films M: graphiste@anab13.com

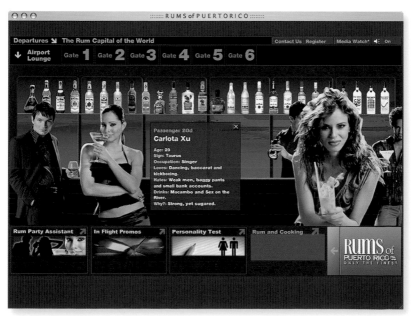

www.rumcapital.com
D: pedro ortiz C: sixto luis santos, steven martell P: eduardo rosado
A: populicom, inc. M: steven@populicom.com

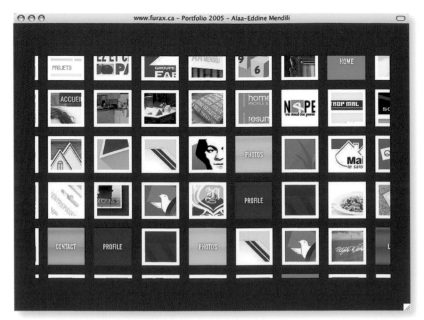

www.furax.ca
D: alaa, eddine mendili
A: alaa, eddine mendili M: info@furax.ca

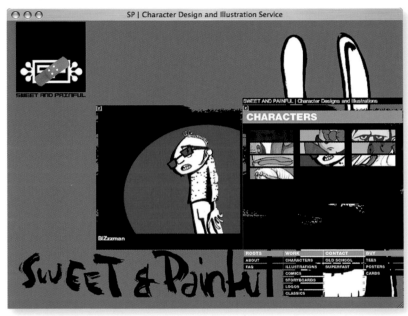

www.sweetandpainful.com
D: philipp pontzen
M: mail@sweetandpainful.com

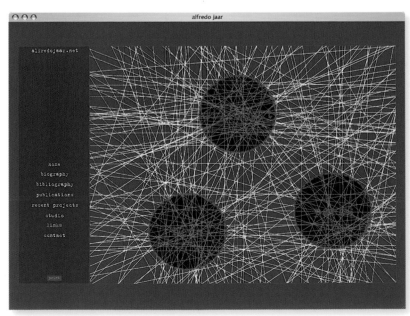

www.alfredojaar.net
D: alfredo jaar C: joonyoung suk P: alfredo jaar
M: realpictures@aol.com

www.xebius.com/taurusfolio
D: manuel camino
A: xebius M: xebius@xebius.com

www.nudeemotions.com
D: azlan kassim
A: nudeemotions M: azlan@nudeemotions.com

www.SaeedFathiRowshan.com
D: saeed fathi rowshan
M: saeed@saeedfathirowshan.com

315

www.prosciutteriaitaliana.info
D: alberto cavazzano
A: alberto cavazzano M: alberto@cavazzano.com

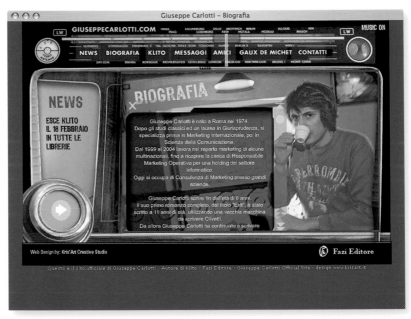

www.giuseppecarlotti.com
D: cristiano michelangeli
A: kris'art creative studio M: krisart@krisart.it

www.enzofiorentino.com
D: gabriele punzo C: maurizio cappabianca
A: cantine grafiche M: info@cantinegrafiche.com

www.apluz.be
D: wim van reeth
A: apluz . development M: wim.van.reeth@apluz.be

www.mindshape.de
D: sebastian erlhofer
M: knut@hansen.com

www.xyarea.com
D: fx. marciat, j.veronesi
A: xy area M: xy@xyarea.com

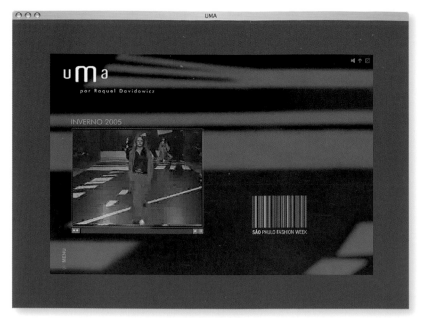

www.uma.com.br
D: vitor maradei C: fabio dias P: vitor maradei
A: vad M: vitor@vad.com.br

www.p16design.de
D: koopmann sebastian C: andreas bux P: koopmann sebastian
A: p16design M: info@p16design.de

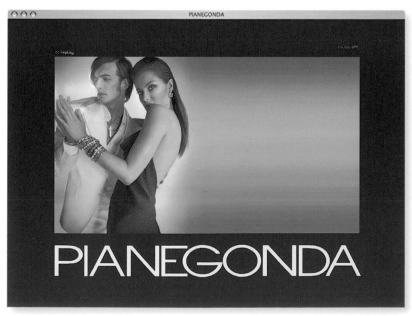

www.pianegonda.com
D: acktel s.r.l
A: acktel s.r.l M: dellera@acktel.com

www.fotodesign-gebler.de
D: michael klees C: michele P: michael klees
A: mediaflashix multimedia service M: info@klees.tv

www.rootmagazine.org
D: diego vallarin C: diego vallarin P: _root.
A: dinamic processing M: diego@dinamicprocessing.com

www.propagandabuero.com
D: sebastian onufszak, timo böse C: sebastian onufszak
A: propagandabuero M: onufszak@propagandabuero.com

www.guworld.com
D: willeit gustav
A: guworld M: mail@guworld.com

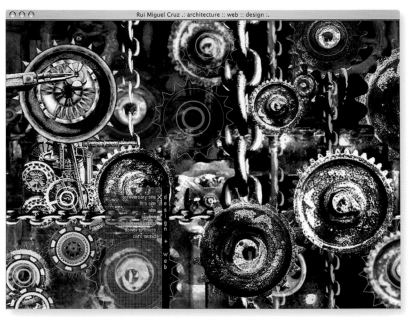

rcruz.no.sapo.pt
D: rui cruz
M: rui_cruz@net.sapo.pt

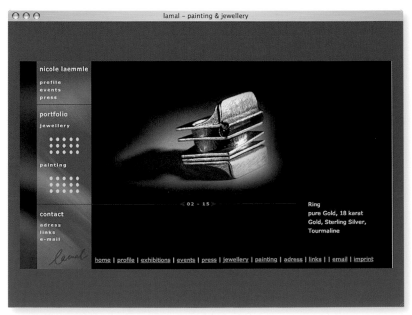

www.lamal-art.com
C: núria blay P: lamal
A: b-mediadesign.com M: blay@b-mediadesign.com

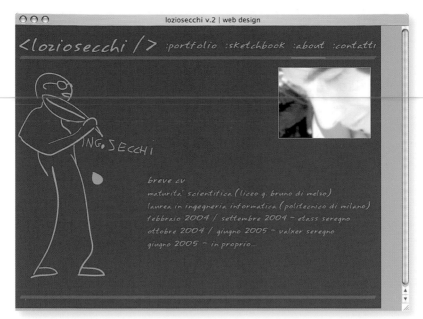

www.loziosecchi.it
D: orietta boatto, marco secchi C: marco secchi P: marco secchi
A: marco secchi M: loziosecchi@gmail.com

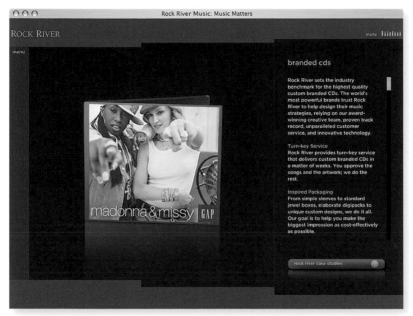

www.rockrivermusic.com
D: destin young
A: pyrogendesign M: pyrogen@mac.com

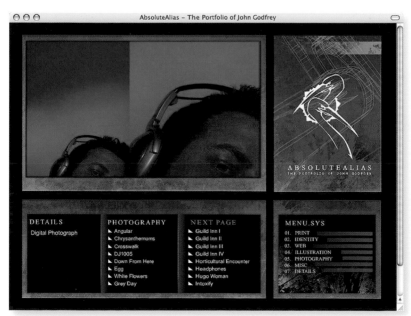

www.johngodfrey.net
D: john godfrey C: mike mates P: john godfrey
M: john@johngodfrey.net

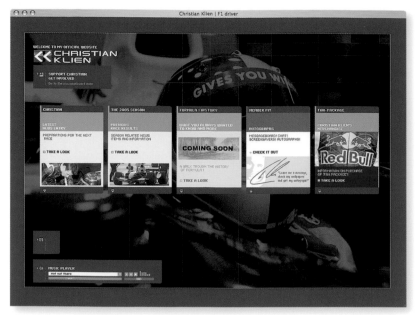

www.christian-klien.com
D: gln roberscheuten C: wesley ter haar P: mediamonks
A: mediamonks bv M: gin@mediamonks.com

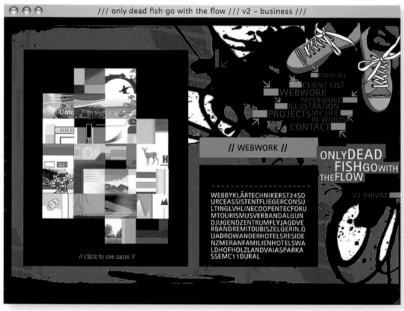

www.vzwei.com
D: verena jung
M: v2@vzwei.com

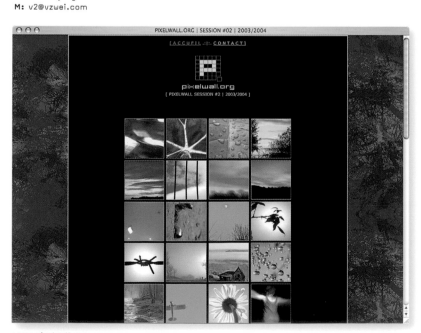

www.pixelwall.org
D: david roussel
A: david roussel M: david@pixelwall.org

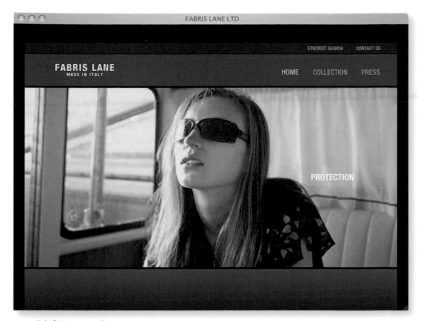

www.fabrislane.co.uk
D: david marks C: david marks P: sarie gilbert
A: digit M: www.digitlondon.com

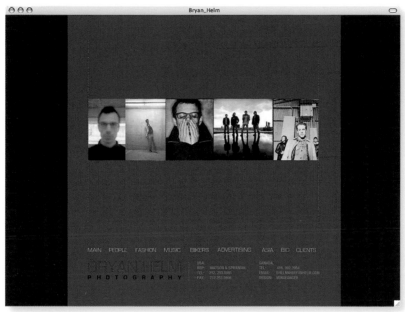

www.bryanhelm.com
D: durothethird
A: www.vengeance9.com M: duro3@sympatico.ca

www.bardenasreales.com
D: david alegria
A: david alegria design M: www.davidalegria.com

www.otradesign.com
D: jozias dawson
A: otra design M: joziasdawson@otradesign.com

anab13.free.fr/rouelibre/
D: ballot anastasia
A: roue libre films M: anastasiab13@wanadoo.fr

www.steffenlay.de/bilbao/bioindex.html
D: steffen lay
M: email@steffenlay.de

www.creativedna.com
D: darren kirk
A: creativedna M: darren@creativedna.com

www.first8.org
D: clockwork
A: clockwork M: ineke@clockwork.nl

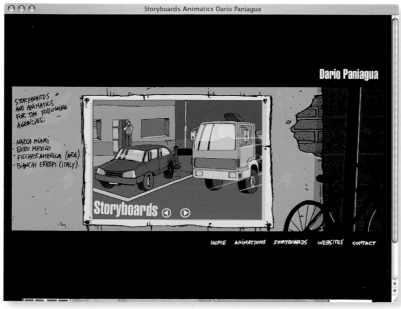

www.fumetti.itgo.com
D: dario paniagua
M: dario_paniagua@hotmail.com

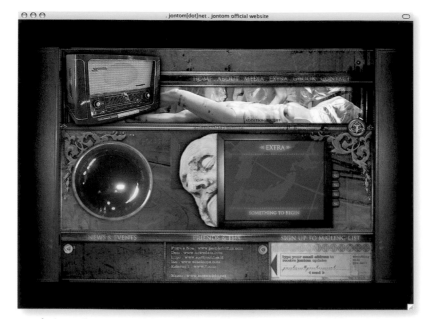

www.jontom.net
D: jontom C: fulvio corsini, jontom P: jontom
A: jontom M: info@jontom.net

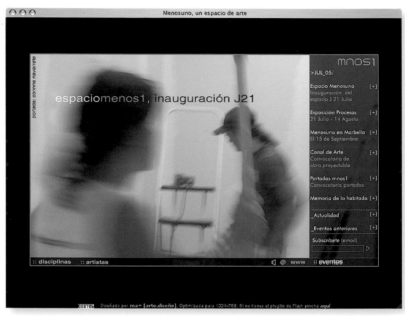

www.menos1.com
D: maite camacho pérez C: mario gutiérrez cru
A: ma+ (arte.diseño) M: info@estudiomamas.com

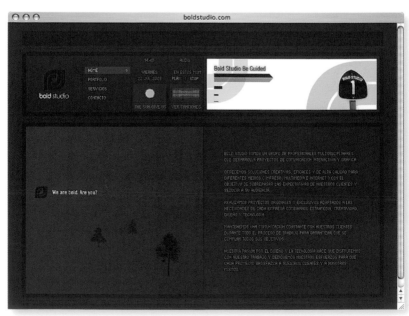

www.boldstudio.com
D: bold studio barcelona
A: bold studio barcelona M: info@boldstudio.com

www.letinmotion.com
D: yoshiki lai
A: letinmotion M: info@letinmotion.com

www.derofe.com
D: murat canbaz, selcuk safci C: d4d
A: d4d digital brand solutions co M: murat@d4d.com.tr

www.symor.com
D: pierre nelwan
A: pi-air M: info@pi-air.com

www.ensoph.it/ensoph_beta.html
D: paco zane
A: ohkaunit M: paco.zane@gmail.com

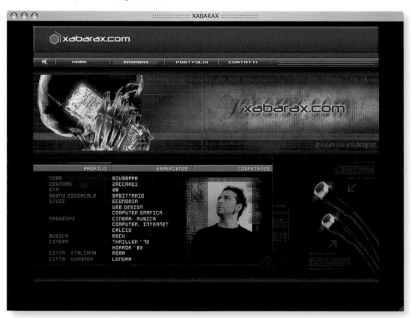

www.xabarax.com
D: giuseppe zaccardi
M: xabarax@katamail.com

www.code77.com
D: ezekiel
A: code77 M: eflores@code77.com

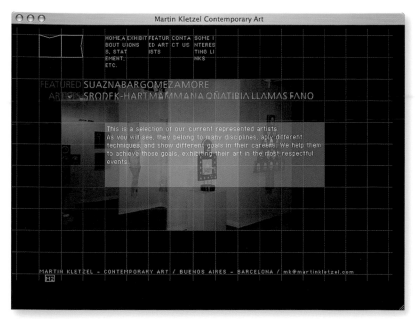

www.martinkletzel.com
D: marcelo mammana C: marcelo mammana
M: mmammana@yahoo.com

www.catering-eventos.com
D: cristiano teixeira C: cristiano teixeira P: andreia dias
A: ac-designers M: contactos@ac-designers.com

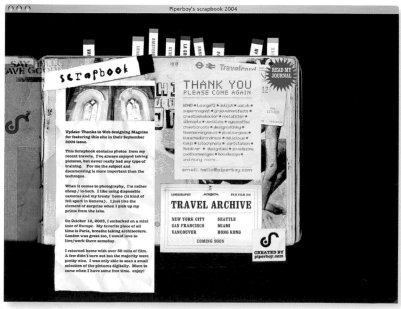

www.piperboy.com/scrapbook/scrapbook.html
D: edvin lee
A: commonbrand M: uncommonbrand@commonbrand.com

www.desigcreatius.com
D: jose peris & jose torres C: panoramicas3d P: jose peris & jose torres
A: desig creatius M: joseperis@desigcreatius.net

www.otzarreta.com
D: otzarreta
A: otzarreta M: silvia@otzarreta.com

www.zook.nu
D: oscar van beest C: robert hoogesteger P: gisela baele
A: interact network M: ovbeest@interactnetwork.nl

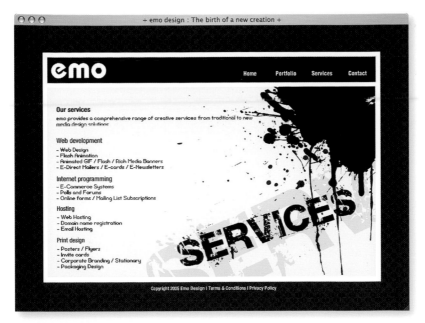

www.emo.com.sg
D: emo design
A: emo design M: terence@emo.com.sg

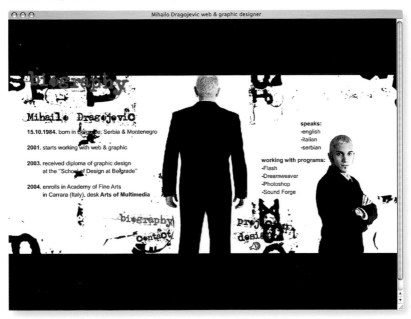

www.mihailo.net/english.html
D: mihailo C: mihailo dragojevic
M: mihailotattoo@yahoo.com

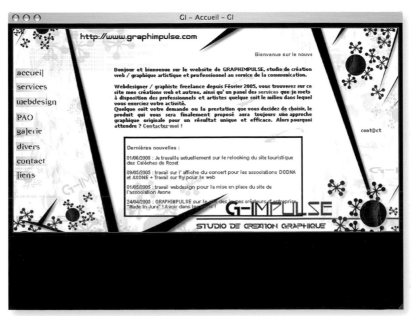

seb.charp.free.fr//graphimpulse/GI3/accueil/accueil.htm
D: charpiot
A: g-impulse M: seb.charp@free.fr

www.sweetyears.it
D: emanuele marchiori
A: mediastar corporate M: grafica@mediastarcorporate.com

www.gafasdesolcob.com
D: roberto rajó brea C: alejandro arce herrero P: visual publinet
A: visual publinet M: marta@visualpublinet.net

www.postvisual.com
D: euna seol C: byungrak song P: jungwon lee
A: postvisual.com M: info@postvisual.com

www.nanozoom.net
D: pablo pinasco
A: nanozoom M: info@nanozoom.net

www.junglepark.be
D: inés van belle
A: pinker M: info@pinker.be

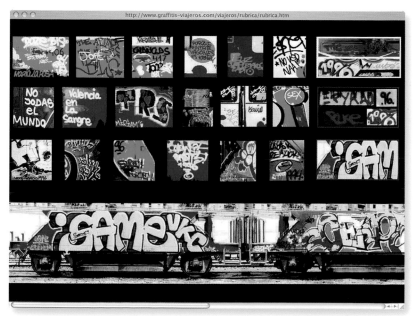

www.graffitis-viajeros.com
D: cesar soler C: j. luis real P: elojopublico
A: fotoarte M: graffitis_viajeros@fotoarte.org

www.winkelried.com
D: urs meyer
A: winkelried.com M: urs.meyer@winkelried.com

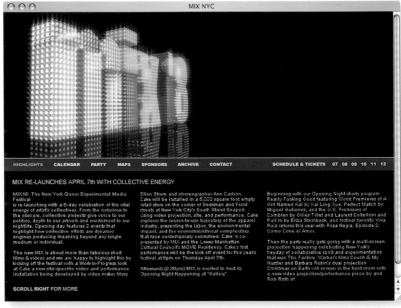

www.mixnyc.org
D: sven barletta
M: barletta@gmx.net

www.afritube.com
D: stéphan viennet
A: association afritube M: stephan.viennet@wanadoo.fr

334

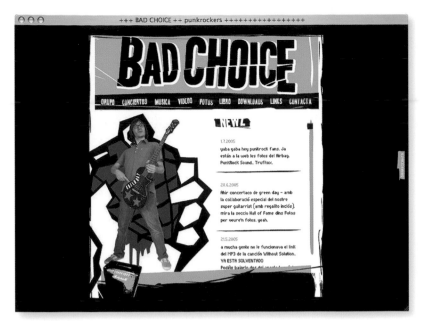

www.badchoice.net
D: joel abad
A: grafficants.com M: joel@grafficants.com

www.fireondesign.it
D: domenico catapano
A: fireondesign M: mee@fireondesign.it

fabiotrovato.net/sito
D: fabio trovato
M: llnyd@fabiotrovato.net

www.tomtykwer.com
D: hermann küpf
A: kader eins M: empfang@kadereins.net

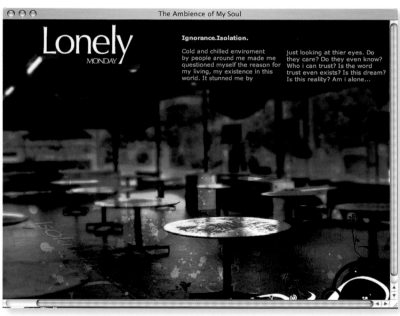

www.oneduasan.com/amb
D: mervin ng man meng
A: oneduasan M: air_bug@musicxpress.zzn.com

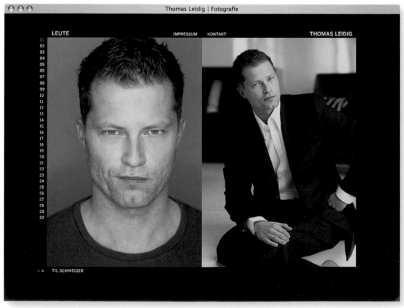

www.thomasleidig.com
D: christian brodack C: christian brodack P: thomas leidig
A: brodesign.net M: christian@brodesign.net

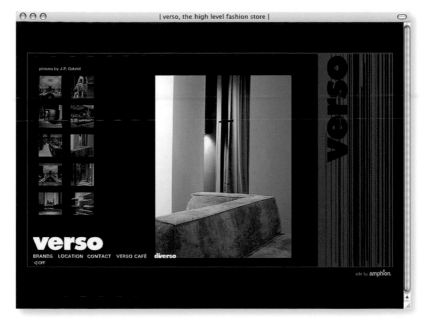

www.verso.be
D: amphion
A: amphion M: info@amphion.be

www.visualmatters.be
D: pieter tytgat
A: visual matters M: pietertytgat@hotmail.com

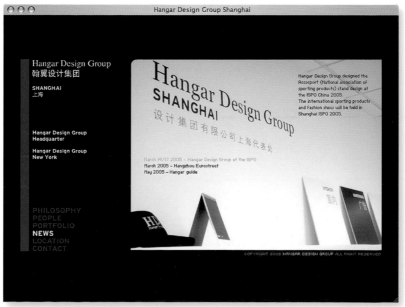

www.hangarshanghai.com.cn
D: margherita rui P: hangar design group
A: hangar design group M: hdg@hangar.it

337

www.manurodriguez.com
U: pedro j. saavedra macías P: irene novo rey
A: sit and die M: sitanddie@sitanddie.com

www.dreweuropeo.com
D: drew europeo
A: drew europeo M: talk@dreweuropeo.com

www.matthias-mertiny.com
D: pierre brost
A: radsolutions M: www.radsolutions.de

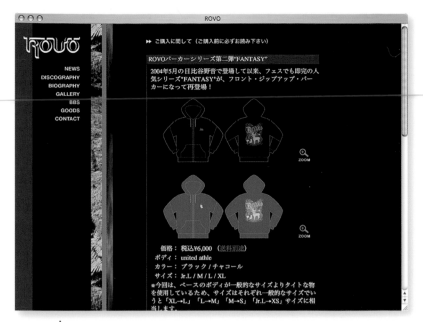

www.rovo.jp
D: usuke C: hiroshi yokoi P: yuki ohta
A: raf M: hy@raf-dl.com

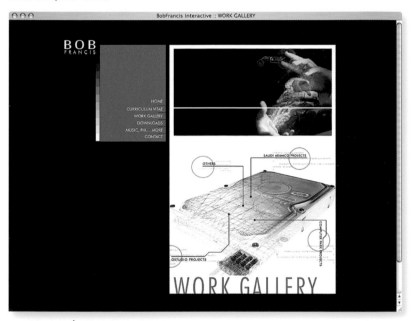

www.big-4.net/bobfrancis
D: bob francis
A: ostudio M: bobfrancis@ostudio.cc

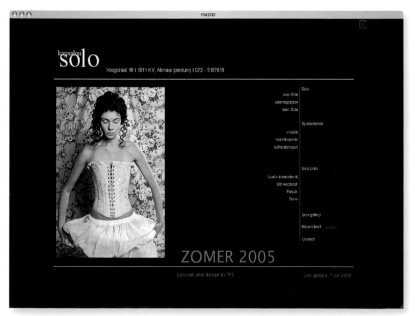

www.kapsalonsolo.nl
D: tony foti
A: foti.nl M: foti@hotnet.nl

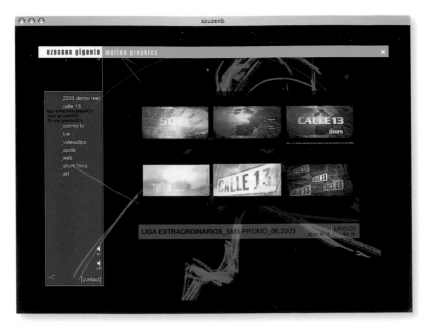

www.azuzen.com
D: azucena giganto
A: motion graphics M: a_giganto@wanadoo.es

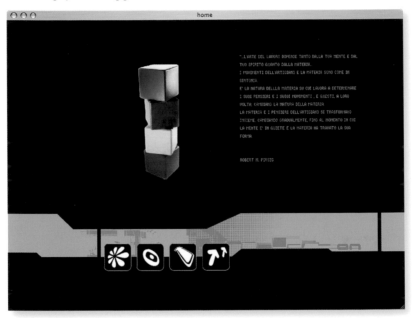

www.maridagostino.com
D: mariaclara d'agostino
M: maryka_79@katamail.com

www.crayonvc.be
D: dirk panier
A: crayon visual communication M: dirk.panier@crayonvc.be

www.nicolabellotti.it
D: nicola bellotti C: paolo bassini P: nicola bellotti
A: blacklemon M: n.bellotti@blacklemon.com

www.gmingenieria.com/desarrollo/index.htm
D: maika ballesteros
A: g&m ingeniería M: mmedia@gmingenieria.com

www.bloempot.nu
D: peter blaas C: wsite P: bloom! design
A: digiteurs M: info@bloempot.nu

www.heavens-doors.com
D: lourdes molina rando
A: spaincreative M: lourdesmolina@spaincreative.com

www.heartindustry.com
D: david yerga acedo C: carlos gonzalez P: david yerga acedo
A: heart industry M: info@heartindustry.com

www.coff.es
P: coff
M: clientes@aiccomunicacion.com

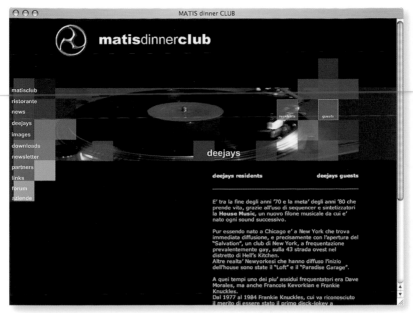

www.matisclub.it
D: daniele pascerini
A: fishandchips M: daniele@fishandchips.it

www.ramellaphoto.com
D: ubaldo ponzio C: ubaldo ponzio P: alberto ramella
A: ubyweb&multimedia M: ubaldo@ponzio.it

www.ile85.com
D: ilija veselica
M: admin@ile85.com

www.gillescrampes.com
D: sarou ender C: mr crampes P: noname
M: macadda@yahoo.fr

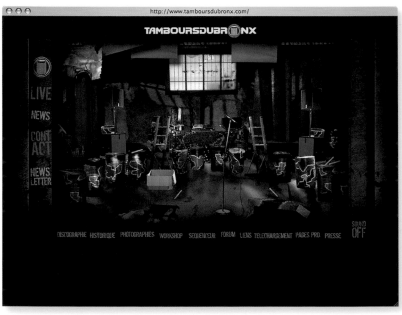

www.tamboursdubronx.com
D: gregory dayon C: olivier wavermans P: olivier wavermans
A: katana M: olivier.wavermans@wanadoo.fr

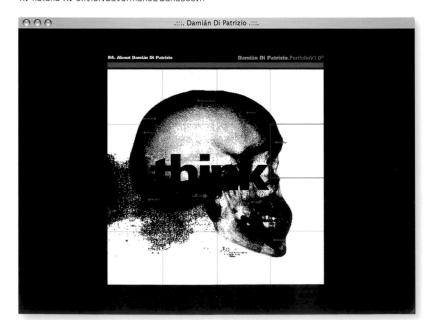

www.22-10-78.com
D: damián di patrizio
A: damián di patrizio M: dami@22-10-78.com

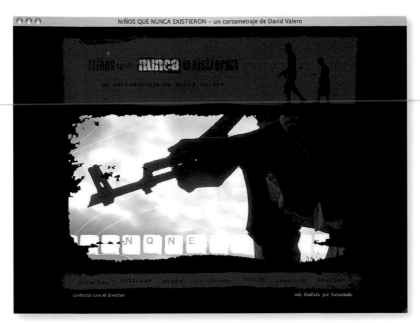

www.nqne.com
D: miguel esteve, leire ferreiro
A: kamestudio **M:** info@kamestudio.com

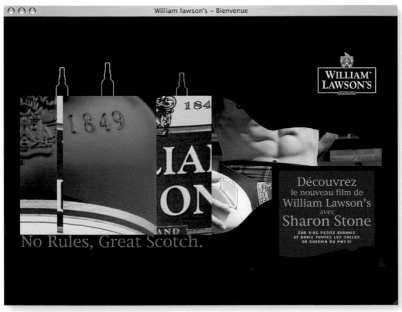

www.williamlawsons.be
D: sven nijs **C:** thomas huret
A: inspire **M:** sven@inspire.be

www.grupochango.com
D: diego
A: grupochango **M:** informate@grupochango.com

www.gamard.com
D: xavier encinas
A: rumbero design M: xavier@rumbero-design.com

megastorelife.com
D: guido cacialli, marco signorini C: flash P: casamercato
A: gc media M: info@gcmedia.it

www.2nous.be
D: els van de veire
A: 2nous multimediamakers M: www.2nous.be

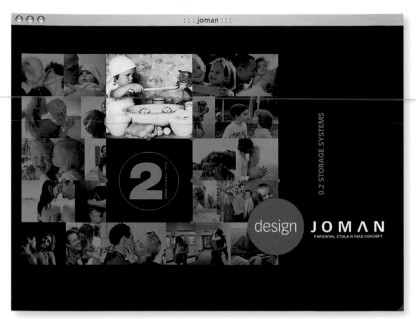

www.joman.com
D: otzarreta
A: otzarreta M: silvia@otzarreta.com

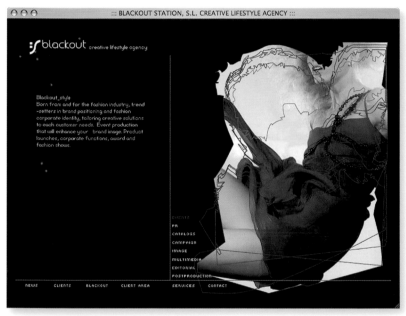

www.blackoutstation.com
D: ana montiel C: jose alfredo diaz P: claudia trimde
A: blackout station, s.l. M: jadcy2k@gmail.com

www.stephenblackman.com
D: stephen carpenter
A: sehdegeh lookzadeh M: info@stephencarpenter.com

www.politicalcomics.org
D: gianluca costantini
M: info@gianlucacostantini.com

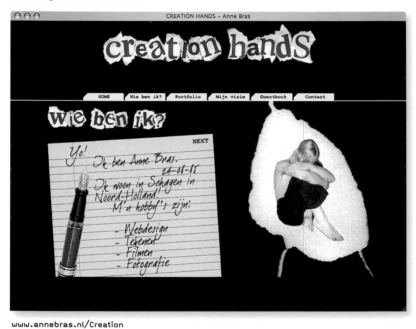

www.annebras.nl/Creation
D: anne bras
M: its_like_god@hotmail.com

www.andreamantello.com
D: paolo cagliero
M: cagliero@tiscali.it

Home | Archives | Download | Chroniques | Pictures | Contact

Chroniques ► D-Side - Juillet/Août 2003

Basé à Poitiers, Nicolas Albin alias Sludge compose seul dans son home-studio à l'aide d'une basse, quelques guitares, une groovebox et un PC. Le résultat oscille entre cold wave et touching-pop et prouve que Nicolas a un très bon sens de la mélodie.

Les huit compositions de Sludge sont toutes aussi réussies les unes que les autres et la reprise de "It Doesn't Matter" de Depeche Mode est tout simplement magique. Il se dégage des ballades de *The Nerves* comme un vague à l'âme qui vous poursuit et vous hante encore bien après l'écoute de cet excellent album. Dommage que la production soit encore un peu faible, un titre comme "Henry's Soul" y gagnerait tellement en puissance.

Yannick Blay

Retour

www.sludgeonline.com
D: n. albin
M: administrateur@sludgeonline.com

www.abestrategia.com
C: francisco javier rodríguez P: ignacio ruiz de azúa
A: ab.estrategia M: vitoria@abestrategia.com

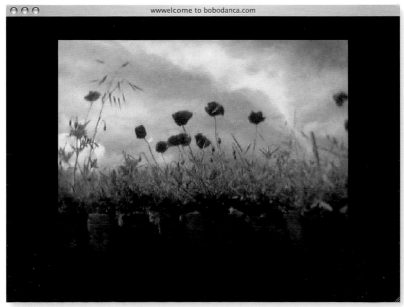

www.bobodanca.com
D: marjan andrejevic C: bogdan P: bobo
A: marjan andrejevic M: pavlaka_i_med@yahoo.com

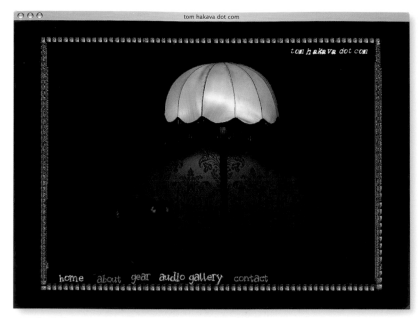

www.tomhakava.com
D: christian champagne
M: chris@midnightsunrecordings.com

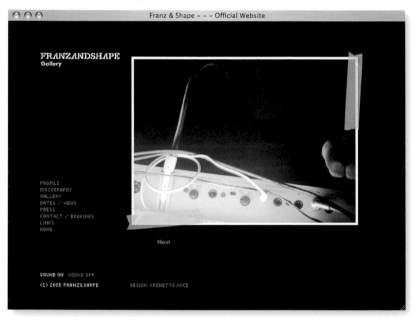

www.franzandshape.com
D: giovanni paletta
A: krghettojuice.com M: me@krghettojuice.com

www.beljon.com
D: joost van gorsel
A: beljon M: info@beljon.com

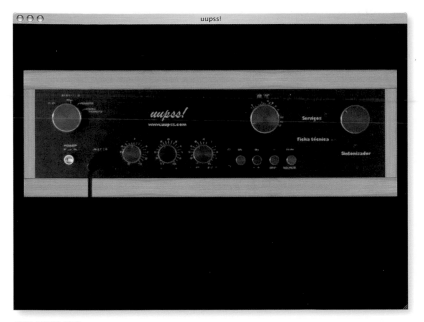

www.uupss.com
D: paulo dias C: joão alírio
M: joao.alirio@uupss.com

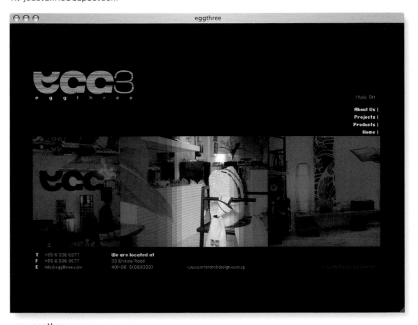

www.eggthree.com
D: gerard and agnes
A: junkflea M: www.junkflea.com

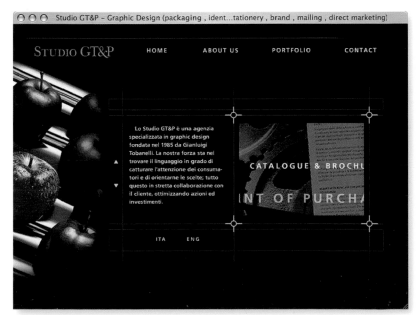

www.tobanelli.it
D: gianluigi tobanelli C: andrea tobanelli P: gianluigi tobanelli
A: studio gt&p M: into@tobanelli.it

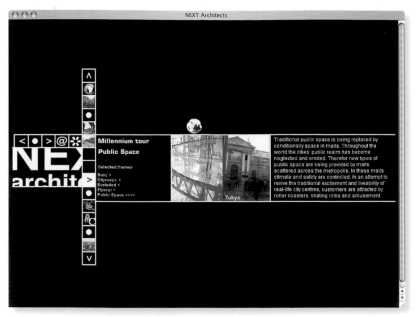

www.nextarchitects.com
D: remko vermeulen, michel schreinemachers
A: float design M: info@nextarchitects.com

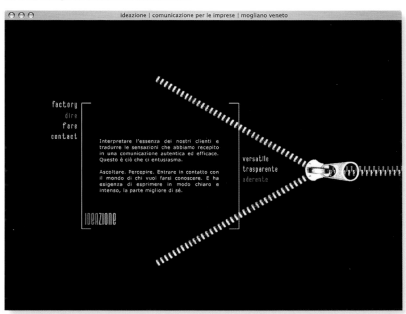

www.ideazione.tv.it
D: ideazione
A: ideazione M: info@ideazione.tv.it

www.umano.cl
D: yuri dekovic escobar
M: yurideko@hotmail.com

index

index

index

index

index

index

index

index

index

index

index